C000149579

The Military
Religious Orders
of the Middle Ages

The Military Religious Orders of the Middle Ages

The Knights Templar, Hospitaller and Others

F. C. Woodhouse

LEONAUR

The Military Religious Orders of the Middle Ages
The Knights Templar, Hospitaller and Others
by F. C. Woodhouse

First published under the title
The Military Religious Orders of the Middle Ages

Leonaur is an imprint
of Oakpast Ltd

Copyright in this form © 2010 Oakpast Ltd

ISBN: 978-0-85706-278-9(hardcover)
ISBN: 978-0-85706-277-2 (softcover)

http://www.leonaur.com

Publisher's Notes

The opinions of the authors represent a view of events in which he
was a participant related from his own perspective,
as such the text is relevant as an historical document.

The views expressed in this book are not necessarily
those of the publisher.

Contents

Beat your plough-shares into swords,
and your pruning-hooks into spears.

Joel 3, 10.

The old order changeth, yielding place to new,
And God fulfils Himself in many ways,
Lest one good custom should corrupt the world.
Tennyson.

Preface

Our little systems have their day;
They have their day and cease to be:
They are but broken lights of Thee,
And Thou, Lord, art more than they.

We have but faith: we cannot know;
For knowledge is of things we see;
And yet we trust it comes from Thee,
A beam in darkness: let it grow.

Let knowledge grow from more to more,
But more of reverence in us dwell;
That mind and soul, according well,
May make one music as before,
But vaster.

 Tennyson.

Geologists tell us that our earth has passed through long periods, and many and great changes; that it has assumed different aspects, and been covered with a flora and fauna utterly unlike what we see now. Thus, Hugh Miller says:

> The figures on a Chinese vase, or an Egyptian obelisk, are scarcely more unlike what now exists in nature, than are the fossils of the old red sandstone. . . . The possibilities of existence run so deeply into the extravagant that there is scarcely any conception too extraordinary for nature to realize.

But without going back so far, there have also been other great and wonderful changes in the world's history, since man lived and thought and worked and suffered upon it. The life depicted upon the temple walls in Egypt; the life described by Aristophanes and Horace; the life of Briton and Saxon in England itself;—how various all these are the

one from the other, and each from what we see and do today!

It requires much information, and research, and not a little effort of the imagination, to realize to ourselves in any degree the sort of life that men and women lived in the Middle Ages; we must strip ourselves of many common things that seem almost necessaries of life to us, and try and imagine how men and women, high and low, did without them.

There were no railways, or steamships; no carriages, no roads such as ours. A great part of England was forest or waste land. Towns were small and surrounded by walls. The whole population was hardly equal to that of London today. The country was full of deer and wolves, and other wild animals long since extinct. The feudal system prevailed, and the great middle class did not exist. The English language was not what it is now. The coinage was different; the prices of food and everything else were quite unlike what they are now.

Cotton and tea were unknown. There were no printed books, no newspapers, no telegraphs, no letter-post. The larger number of people could neither read nor write. There was but one religion all over England, and all over Europe. Constantinople was a Christian city; the Turks had not yet begun their conquests. America, Australia, and the West Indies had not yet been discovered.

If we can grasp the idea of European and English life and thought that all this implies, we shall see how much of present feeling and prejudice we must put away before we can be in a position to judge fairly of the age and the circumstances which gave rise to the Military Religious Orders, and to contemplate fairly the history of the Orders themselves.

The idea itself was certainly noble and grand. In those times the military and the religious life alone offered a promising field for great and energetic minds. But there would be men whose religious instincts drew them to the cloister, while their vigorous frames and fiery energy disposed them also to the soldier's life. It was a happy thought, therefore, that devised a method to combine these two vocations, and put a sword into the monk's hand who had little taste for the spade or the library.

The Christian calling is that of a soldier, and the exigencies of the times made it honourable to fight not only against spiritual but against human foes.

But in reality this idea, like all other great ideas, was one of gradual growth and development. It did not spring, Minerva-like, fully

equipped from the head of any.

The hardships that pilgrims to the Holy Places endured led to the formation of societies of men who devoted themselves to their relief and maintenance, while they remained at Jerusalem.

And thus the terrors and dangers of the road became known, and the cruel sufferings and indignities that pilgrims were made to undergo before they could set foot in the Holy City, till those who sheltered and succoured the pilgrim when he arrived at his destination saw that if their work was to be complete and thorough, they must protect him also on his way.

And so the nursing brother and the hospitable monk became an armed and fighting soldier.

Then as the Mahometan conquest advanced, and the birthplace of Christ, and the very tomb in which He had been laid, fell into the hands of the anti-Christian host, Christian men's blood boiled, and the cry went up from all Europe that this should not be. And so men bound themselves into bands and Orders for mutual support and to gain strength, and vowed to devote life and all to this great work, and to succeed, or to perish in the attempt.

So the work began, originating in the highest Christian instincts, and carried out with self-sacrifice and enthusiasm. It attracted many devoted men, and so grew and spread and flourished.

And then, when success had crowned the new scheme, men of all kinds favoured it and men fit and unfit enrolled themselves in the ranks of the soldier-monks. Then, too, those who did not join themselves desired to be sharers in the good work, and aided those who could by money and lands and privileges. And so there came worldly greatness and power and wealth, and with them, alas, their inseparable evils. Worldly men pressed in to the Order from worldly motives, and with unworthy aims.

And so scandals arose. And then envy and covetousness eyed the wealth and power, and uncharity spread tales, and those who desired Naboth's vineyard found no difficulty in persuading men that he was not fit to live. And then dispensation from hard and irksome rules was sought and obtained, and work was done by deputy, and the grand and holy aims of the Order were lost sight of and forgotten, and other and lower objects were desired and laboured for, and the blessing of God was withdrawn.

All things human pass away. As man has his birth, youth, full manhood, and then decay and decrepitude, so is it with his works and his

11

ideas. We may lament this, and yet let us be sure it is not all loss and waste. Men and institutions do their work and pass away, to make room for others; just as the leaf buds and develops and flutters its little lifetime in the breeze, and then withers and drops, because another and a new leaf is pushing on behind it.

To one who could have seen the vast forests of a past geological period growing, spreading, and dying; the weak stifled half-grown by the strong, not one seed in ten thousand ever becoming a full grown tree; there would have seemed waste. But now we know that all was designed, and that there was no waste; and the coal fields of today attest the wisdom and the purpose which a larger Mind could design and carry out.

Oh, yet we trust that somehow good
Will be the final goal of ill.

We read the past, we regard the present, we await the future with this conviction, and gain peace and rest and hope.

The Origin of Chivalry

A glorious company, the flower of men,
To serve as model for the mighty world,
I made them lay their hands in mine, and swear
To break the heathen and uphold the Christ,
To ride abroad, redressing human wrongs.
To speak no slander, no, nor listen to it,
To lead sweet lives in purest chastity.

Tennyson.

In a rude and primitive condition of mankind might constitutes right, and strength and daring give rank.

The aristocracy, therefore, will consist of the warriors, while the weak, the young, the old, and the women will occupy an inferior position. An uncivilized race is always at war. A system of mutual fear, hatred, and injury seems to be the normal condition of savage man, in all ages and in every part of the world.

As civilization progressed in Europe and Asia the use of the horse in battle led to another distinction. The warrior who fought on horseback was superior to him who fought on foot; hence the title of knight or *chevalier*, the soldier who fought on horseback, *à cheval.*

But though these facts may be noticed as general principles, the system of Chivalry or Knighthood properly so called can hardly be said to have existed till about the eleventh century.

The Roman and Greek civilizations were gone. The hordes of northern tribes had swept over Europe one after another, and with reckless waste had not merely sacked towns and murdered their inhabitants, but had levelled the noble monuments of antiquity, destroyed cities and temples, burned libraries, and reduced the fairest and most

civilized countries in the world to silent deserts. Impenetrable forests took the place of cornfields and vine-yards, and wild beasts roamed where the arts and sciences had been cultivated for centuries.

The strong will and powerful arm of Charlemagne had done something for the reconstitution of society, and the spread of Christianity was slowly working out its great and noble purposes. But in the meantime something that was not far removed from anarchy reigned. Each chief settled in some fortified place, and with his dependents defended himself as best he could against all comers. Everyman's hand was against his neighbour. Every one sallied out when he chose and attacked someone else, either to be slain in battle, or to return laden with booty. Merchants were waylaid, and their goods carried off to the stronghold, castles were surprised, the men killed in fair fight, the women made prisoners.

It was to remedy these miseries, and to introduce order and mutual trust, respect for the rights of others and mercy to the weak that, chiefly by the influence of Christianity, the system of Chivalry or Knighthood was created.

The German tribes had always been distinguished by a regard for truth and a respect for women, not commonly found among barbarous nations, and it was among their descendants that these principles were gradually developed by the gentle hand of Christianity into a system which saved Europe from barbarism, and laid the foundation of the civilization which we now enjoy.

First one powerful and virtuous prince and then another set himself to suppress robbery and violence in his own dominions, and to restrain the petty chiefs who were more or less subject to him.

It is impossible now to disentangle fact from myth in the story of King Arthur, but in the high purposes and noble aims that are ascribed to him by later writers, we see undoubtedly the sort of reformation that great and good men like him were ever and again attempting in all parts of Europe with greater or less success.

No historian has written the annals of these pioneers of civilization; they have passed away, and their good deeds are unrecorded, but their work remains, and we reap the fruit which they laboured and suffered to plant and to protect.

The feudal lord and the bishop, if they were such as we have described, conspired together to make the subject chieftains honourable men, who would restrain their lower passions by high and holy principles. They induced them to send their sons to be trained and

educated at the court till they attained full manhood. And so these bachelors, or has *chevaliers*, as they were called, being removed from the rude surroundings of their country homes, became acquainted, in the capital of their country, with all the highest knowledge and the gentlest manners that the times could boast. And when they came to man's estate they received their dignity as Knights with much ceremony, and with the sanction of religion.

The candidate fasted and prayed, confessed his sins, and received the Holy Communion. Then, in the church he was girded with his sword, and his spurs were buckled to his heels, and some old and noble Knight striking him with his sword, as he humbly knelt before him, admitted him to the rank of Knight, after he had solemnly sworn to be brave and true, to defend women, and to keep from violence and robbery.[1]

All this may seem to us to be strange and fanciful, but if we remember what the times were, and how great a step this implied towards all that we esteem and value, we shall appreciate the far-seeing wisdom of those who devised all this system and ceremonial, and understand that they did indeed that which was best for the age in which they lived and for those that were to come after.

A powerful prince may by main force suppress violence, and secure respect for law and justice as far as his arm can reach, and during his lifetime, but it is a far greater and more lasting achievement to teach other men to adopt and to insist upon these principles, and so become centres of light and order themselves.

By these means war was carried on with less ferocity; mercy to the vanquished and to non-combatants came to be esteemed as essential to the true Knight as courage and endurance, and courtesy and regard for truth as indispensable as strength of arm, and a firm seat upon the charger. The Knight scorned to take an unfair advantage of his enemy, and trusted alone to the justice of his cause and his own prowess for victory in the combat.

The savage deems any fraud or artifice legitimate that will give his enemy into his power, and when he has him he delights to torture him with every ingenious cruelty, but the Christian knight would fight only on equal terms, and would treat his prisoner with every

1. In some Orders the postulant was struck on the cheek, and addressed thus: "Remember that the Saviour of the world was buffeted and scoffed at before the high priest;" or thus: "Bear this blow, and never submit to another." Under the Romans slaves were struck in this way when they were made free.

15

courtesy. He fought for God and for his lady-love, and believed that crime and broken troth would be more fatal to his success than the might of his adversary.

Instead of the hideous and dreadful combats of the old world, when naked gladiators and wild beasts fought even in the presence of women, the Tournament was invented, in which skill in the use of the lance, and in the management of the horse, were as much required as courage and mere brute force.

Strict rules, the presence of ladies, and the absolute law of courtesy kept even hot blood from driving men to extremities.

There arose, too, the extraordinary phenomenon of Knight-Errantry.

Not satisfied with the combats and adventures that might fall in his way in war, or in his own country, the young and ardent knight would sally forth to seek fields for his prowess in unknown lands.

To right wrong, to avenge the oppressed, especially to protect or release ladies in distress or captivity, these were the objects of the Knight-Errant's quest. By these he desired to gain honour and fame, or to perish honourably in the attempt.

We know that all this was carried to excess, and degenerated into folly and extravagancies, till Cervantes covered it with ridicule in his Don Quixote, and, as it is said, brought it to an end.

But still it had its place in the history of European civilization and progress. It did its work, and then passed away; but whatever may have been its faults, it certainly had its good side, and helped to lift man from the savagery into which he naturally tends to degenerate, up towards the high and noble Christian ideal.

And if Chivalry did much for men, it did, if possible, more for women.

In savage life woman is a toy or a drudge. Even among the more civilized ancient nations she had but a mean place in the affairs of life and of the world. But Chivalry lifted her up into an ideal, and regarded her with a romantic devotion and respect, and woman so esteemed, esteemed herself, and all her beautiful and glorious attributes came into active and beneficent prominence. Not losing her natural modesty, she nevertheless exercised mighty influence by gentle and unobtrusive agencies, and more than repaid men for their gallantry by making them gentle and chaste and courteous.

Woman was no more a mere cipher in human life, but was felt to be an essential element in society, with her own peculiar duties and

functions which she alone could fulfil, and without whom civilization and true progress could not be hoped for.

Let anyone compare Achilles with the Chevalier Bayard, and it will be seen what strides had been made in true human elevation. Both are brave, with high animal courage, but while the former is vindictive and cruel, and displays all the faults of an overgrown child, the latter is generous and enduring, and is full of all the noble and supernatural qualities that Christ came into the world to display, and to teach men to imitate. In the one human infirmities are seen unelevated, uncorrected; in the other we see that some higher principle has been at work, and that while human nature has lost none of its good qualities, it has gained many new ones, and been taught to curb the evil, and to raise and convert the unworthy and the base.

The following were anciently held to be the necessary duties of every true Knight:—

It behoves every Knight to fear God, and with all his power to maintain the Christian faith.

To be charitable, and comfort those who are afflicted.

To serve faithfully, and to defend his prince and country courageously.

To forgive the follies and offences of other men, and sincerely embrace the love of friends.

To esteem truth, and without respect to maintain it.

To avoid sloth and superfluous ease.

To spend his time in honest and virtuous actions.

To reverence magistrates, and converse with persons of honour.

To eschew riot, and detest intemperance.

To frequent the wars, and use military exercises.

To eschew dishonest pleasures, and endeavour to do good to ethers.

To accommodate himself to the humour of honest company, and be no wrangler.

To shun the conversation of perverse persons, and behave himself modestly.

To be sober and discreet, no boaster of his own acts, no speaker of himself.

To desire no excessive riches, and patiently endure worldly calamities.

To undertake just enterprises, and defend the rights of others.

To support the oppressed, and help widows and orphans.

To prefer honour before worldly wealth, and be both in words and deeds just and faithful.

PART 1.

THE KNIGHTS OF ST. JOHN OF JERUSALEM, OR KNIGHTS HOSPITALLERS.

Record we too, with just and faithful pen,
That many hooded cenobites there are,
Who in their private cells have yet a care
Of public quiet.
 Wordsworth.

Chapter 1

The First Crusade

Then blame not those who by the mightiest lever
Known to the moral world, Imagination,
Upheave, so seems it, from her natural station
All Christendom. They sweep along (was never
So huge a host!) to tear from the unbeliever
The precious Tomb, their haven of salvation.
 Wordsworth.

In the middle of the eleventh century Jerusalem was in the hands of the Sultan of Egypt.

Great multitudes of pilgrims came every year to visit the Holy Sepulchre, and the other Sacred Places both from the East and West, being required to pay for the privilege to the Mahometan masters of the Holy Land.

The Eastern Christians, or Greeks, many of whom were subjects of the Sultan, were permitted to build houses within the city, where they could lodge their countrymen during their stay in the city.

But the Western Christians, or Latins, had no such privilege accorded to them, and they were consequently subjected to great hardship and danger, and had the utmost difficulty in finding shelter of any kind within the city. The Mahometans would not admit them into their houses, through their hatred of Christianity; while the Greeks, on account of the schism between the Eastern and Western Churches, regarded them in much the same way that the Samaritans regarded the Jews in the time of our Lord.

It was at this time that some Italian merchants of Amalfi set themselves to provide some means to remedy this evil. Their business enabled them to gain access to the Sultan of Egypt, and by means of

presents to him and to his principal courtiers, they succeeded in obtaining permission to build a house for the shelter of Latin pilgrims in Jerusalem, near the Holy Sepulchre.

Having obtained this they lost no time in carrying out their charitable purpose. Partly from their own resources and partly by means of alms collected by them from others, they built a convent and church. The former was filled with Benedictine monks, the latter was dedicated to St. Mary ad Latinos.

To this convent were attached two great Hospitals, one for men and one for women, each with its chapel, the one dedicated to St. John the Almoner, the other to St. Mary Magdalene.

No sooner was it known that an Hospital had been founded at Jerusalem for the reception of pilgrims of the Latin Church, than many devout persons left home and country to devote themselves to the service of its inmates. Others collected alms in Europe, and sent them to the Benedictine monks, who fed, clothed, and nursed their guests, many of whom had been stripped, wounded, and otherwise ill-treated by robbers or Mahometans on their road to Jerusalem.

But this good work had only just become established when it was well-nigh destroyed.

The Turcomans, leaving their native plains in Tartary, were fired with a desire for conquest, and burst in vast numbers upon Asia, and everywhere carried havoc and desolation upon its towns and inhabitants.

In 1065, Jerusalem fell into their hands, and they committed the most terrible cruelties upon the Saracen and Christian population, almost all of whom were tortured and put to death. The buildings of the city were for the most part destroyed, the Holy Sepulchre being spared from mercenary motives, because permission to visit it might be made a fruitful source of revenue.

The miseries of pilgrims now became greater than ever. The permission to enter the city and visit the Holy Sepulchre could only be purchased for a large sum, the amount depending on the caprice or the covetousness of the chief who happened to be appointed to the charge for the time being; so that many unfortunate persons who had sold everything to enable them to make the pilgrimage to Jerusalem, after enduring the hardships of a long voyage and journey, sickness, robbery, and other dangers, often found themselves at the gates of Jerusalem without sufficient money to gain an entrance, and were obliged to return without a sight of the object of their arduous un-

dertaking, or even died in penury, uncared for, and friendless, without any reward for their labours and sufferings.

Tidings of all this were gradually brought to Europe and the East, and everywhere caused the deepest grief and the highest indignation. But still nothing was done, or even suggested, to remedy the terrible evil. Some man was wanted to concentrate the feelings of Christendom, and to point out a line of action.

This man was at last found in Peter the Hermit. This remarkable man possessed the faculty, not given to many, of rousing enthusiasm and creating a popular and universal course of action.

He addressed himself first to the Patriarch of Constantinople, as being the most fit person to lead the Eastern Christians to rise for the defence of the Holy Places, and for the vindication of the right of Christians to visit them. But the Eastern Church, intimately connected as it was with the Eastern empire, shared also its weakness and lethargy, and Peter could do nothing at Constantinople.

Indeed, everything in the East pointed to coming ruin. Emperor after emperor was raised by faction, and put to death by violence; women and eunuchs ruled, and the successor of Constantine was but an ignoble puppet, without power, and without manliness.

Peter, therefore, turned his back upon Constantinople, and appeared before the Pope; and then traversed the greater part of Europe, visiting one king after another, and pleading the cause of the suffering Christians in the East, and everywhere arousing the greatest enthusiasm for his projects; till, in 1095, the Councils of Placentia and Clermont brought matters to a definite issue, and the first Crusade was determined upon.

CHAPTER 2.

The Cruelties Inflicted on Pilgrims by the Mahometans

Therefore, friends,
As far as to the Sepulchre of Christ,
Whose soldier now, under whose blessed cross
We are impressed, and engaged to fight.
Forthwith a power of English shall we levy.
Whose arms were moulded in their mother's womb
To chase these pagans in those holy fields,
Over whose acres walked those blessed Feet,
Which, fourteen hundred years ago, were nailed,
For our advantage, on the bitter Cross.

Shakespeare.

In order to understand in any degree the meaning and object of the Crusades which drew so many of the best and noblest of Europe to fight, to suffer, and to die in the East for century after century, we must know something of the history of the Holy Places which drew them there.

In almost all ages and all countries, wherever at least religion in any form has been vigorous, and has held real sway over men's minds, either by devotion or superstition, there we find certain places esteemed sacred, and thither men have resorted.

The Egyptians possessed temples that were specially honoured, either on account of events in their sacred history which were believed to have taken place upon their site, or because they enshrined relics or images to which were attributed peculiar sanctity.

The greater temples of Greece and Asia Minor attracted pilgrims

from distant parts.

The Temple at Mecca was a place of pilgrimage long before Mahomet was born.

In India thousands of pilgrims for ages have wended their way to the temples of Juggernaut, Elephanta, Ellora, and others.

In China and Tartary, there are sacred places to which the devout Buddhist has gone for centuries.

The divine religion of the Jews, by its fundamental principles, not only encouraged but actually enforced a system of pilgrimage. There was but one Temple for the whole country, and thither every Israelite was bound to resort three times every year at the least, however distant his home might be from this, the centre of his devotion.

It is not wonderful, therefore, that an idea and a practice that seem to be so innate in the soul of man, and which, to say the least, have not been discouraged by divine revelation, should find a place in the Christian system.

The sepulchres of the great have ever been honoured. It was especially the practice of the Jews to reverence the tombs of their prophets and their ancestors. The Cave of Machpelah, where the bones of Abraham still rest, has never been lost sight of, during all the chequered history of his descendants.

The tombs of kings, from those of Egypt, to those of our own day, have ever been esteemed worthy of respect and care.

It was to be expected, therefore, that those places that were connected with the life and death of Christ, the Saviour of the world, would be remembered and honoured; and that His disciples and followers in succeeding generations would wish to visit them, and excite or gratify their devotion by the sight of the spots where events of such interest to them and to the world had transpired.

Nor would the tombs of apostles and martyrs be forgotten. St. Augustine, in his *City of God*, says that the sepulchre of St. Stephen, the protomartyr, attracted a multitude of pilgrims. St. Chrysostom speaks of the tombs of the apostles as frequented by a host of visitors, while the tombs of the mightiest emperors and kings were deserted and silent. St. Jerome despairs of being able to enumerate the kings, bishops, and great men, who ever since the Ascension of our Lord have gone to Jerusalem, persuaded that their religion was deficient and their Christian life incomplete, so long as they had not worshipped their Lord in the very spots where His doctrine had been enunciated and His Church founded.

From all this we may rest assured that the tomb of Joseph of Arimathea, in which the sacred Body of our Lord rested from Good Friday till Easter morning, would not only never be lost sight of, but would be esteemed holy and venerable by the Christians of the first age. Its solid and durable character would assist its preservation, for we know that it was a cave hollowed out of the live rock, near the place of our Lord's Crucifixion.

We do not know how the Holy Sepulchre was treated when Jerusalem was taken in the year A.D. 70, by the Emperor Titus. But as the city was by no means entirely destroyed, and many Christians as well as Jews continued to live there after its capture, we may be quite sure that the site at least would be remembered. The Romans would have no interest in destroying it then, and without deliberate and laborious effort it could not be injured.

In A.D. 134, the Jews again revolting, were more severely punished, their restored buildings were ruined, and they were forbidden to live in Jerusalem by the Emperor Hadrian. Three years after, a temple of Jupiter was built upon the site of the Holy Sepulchre.

This remained till the year 327, when Helena, mother of the Emperor Constantine, pulled down the temple, and searched beneath it for the Cross upon which our Lord had suffered, which tradition reported had been buried there. This Cross was said to have been found, and its history is closely connected with that of the Holy Places and the Crusades. Helena is said to have also rediscovered the Holy Sepulchre, and to have built a church over and around it, cutting away some of the rock, and encasing the rest with marble.

An immense impulse was given to pilgrimage by these events. St. Jerome, in his epitaph for St. Paula, mentions that she had visited the Holy Sepulchre, and we know that he himself lived at Bethlehem, in the vicinity of the grotto of the Nativity, which Helena also enclosed in a beautiful church. St. Augustine speaks of Christians collecting and preserving with veneration the very dust from the Holy Sepulchre.

Helena's church was destroyed by Chosroes and his Persian host in 614, but another church was soon after built, following the plan of its predecessor.

Then came the Mahometan invasion, and the capture of Jerusalem by the Saracen Caliph Omar in 637. The places venerated by the Christians were respected, and pilgrims allowed to visit them, but fines, fees, and exactions, began to be levied, and robberies and outrages were committed upon the unfortunate pilgrims, when on their

way to or from Jerusalem. Many of them were poor, and many fell sick with the fatigues and hardships of their long journey, and from the heat of the country. This led pious and charitable persons to establish hospitals in which to receive the sick and poor, some of which, as we shall see, became the cradles of Religious Orders.

It must not, however, be supposed that all this could go on without evils and abuses. Pilgrimage was not always undertaken from pure and religious motives. A love of change, curiosity, loss of character at home, all these sometimes induced men to set out to the Holy Land.

Pilgrims did not always bear a good reputation. The word *saunterer*, an idle strolling vagabond, was derived from *Sainte Terre*, for those who had visited the Holy Land often wandered about for years afterwards, living by begging, and by relating their adventures, real or feigned, rather than by honest and steady labour.

And in still earlier days sober men had lifted up their voices in protest against the growing fashion of making pilgrimage, and the abuses that followed in its train. Thus St. Augustine, in one of his sermons, says:

> Our Lord never said, go to the east to find righteousness, travel to the west to obtain pardon. Do not think of making long journeys; believe, and stay where you are; He who is everywhere present is found by loving, not by travelling.

St. Gregory of Nyssa speaks in the same strain, and especially warns women of the perils they will encounter by the way. He adds that Jesus Christ is not more in one place than in another, and complains that those who live at Jerusalem, always in sight of the holy places, are often themselves unholy in their life and conversation. St. Jerome, too, though he himself made a pilgrimage to Jerusalem, and finally settled down for life at Bethlehem, protests that the gate of heaven is in Britain as truly as in the most sacred localities, and that multitudes of holy men and women had lived and died without seeing Jerusalem.

But pilgrimage assumed a new phase when, in the eleventh century, the Turks became masters of Palestine. Their capture of Jerusalem was followed by a massacre of its inhabitants, and by most cruel tortures inflicted upon the Christian clergy; the pilgrims were ill-treated on their way, and if they reached Jerusalem alive, they were often mutilated, or murdered soon after. Those who survived returned to Europe, and spread far and wide the report of the miseries and indignities to which they had been subjected. Indignation spread and grew,

and when Constantinople was threatened by the Turks, and the Emperor appealed to the Pope against these enemies of civilization and of Christ, Pope Gregory VII. bestirred himself to arouse the princes of Christendom to unite to defend their faith from the destruction that seemed to be imminent.

Then came the mission of Peter the Hermit, and the enthusiasm which his preaching excited, and finally at the Council of Clermont, 1095, the first Crusade was determined on, and its acceptance carried by the acclamations of the multitude, who cried, "God wills it!"

CHAPTER 3

Jerusalem in the hands
of the Crusaders

*Parmi les contradictions qui entrent dans le governement de ce monde, ce
n'en est pas une petite que cette institution de moines armées qui font voeu de
vivre là a fois en anchoretes efc en soldats.*—Voltaire.

After the capture of Jerusalem by the Crusaders in 1099, the work
of the Hospitallers of St. John was greatly increased and developed.
Many wounded soldiers were received and carefully tended, and the
self-denying devotion of Gerard, who was then the administrator of
the Hospital, and his brethren, excited the admiration of all who vis-
ited it. Several men of noble birth, who had joined the Crusade, laid
aside their arms, and devoted themselves to the care of the sick and
the pilgrims in the Hospital. Others endowed the Hospital with lands.
Among the first of these was Godfrey de Bouillon himself, who gave
his estates in Brabant.

The increase in the number of persons attached to the Hospital,
and the acquisition of so much property, made it desirable that some
corporate union should be formed for the better administration of
the whole scheme. The members were therefore formed into a con-
fraternity of brothers and sisters, taking the usual three monastic vows,
and assuming a black habit, with a white cross of eight points on the
left breast.

The institution was subsequently confirmed by the Pope, Paschal
II, who also exempted the Hospital from the payment of tithes, con-
firmed all the grants of property made to it, and gave the Hospitallers
the power to elect their own superior after the death of Gerard.

Jerusalem being now in the hands of the Christians, the number of

pilgrims largely increased; multitudes from every part of Christendom wended their way to visit the Holy City and its Sacred Places, and found in St. John's Hospital a welcome and a home. Gratitude followed charity, and benefactions were freely bestowed upon the brethren who had proved themselves such true friends of the stranger and the homeless. Larger buildings were erected, together with a magnificent church dedicated to St. John Baptist, who seems to have been gradually associated with St. John of Jerusalem as a patron of the Order.

The work was also extended to other places besides Jerusalem. Hospitals were founded in the principal seaports of Europe, where pilgrims were received on their way to Palestine, their passage secured in suitable vessels, and guides provided for them.

It was during the reign of Baldwin II., King of Jerusalem, that Gerard, the father and virtual founder of the Order of the Hospitallers, died. He had attained a great age, and in spite of this and his constant activity in carrying out the work of the Order, superintending all its details, and extending its sphere of usefulness, he enjoyed to the last the use of all his faculties, and exemption from most of the infirmities that befall the aged. There was scarcely any illness; the venerable man died peacefully and gently in the arms of his brethren, being gathered like some fruit fully ripe, A.D. 1118.

By a unanimous vote of the Knights and members of the Order, Raymond Dupuy was elected to succeed Gerard in the government of the Hospitallers. He was a member of a noble and ancient family in Dauphiny, and proved himself worthy of the dignity to which he was called. To him the Order owed its distinctly military character, and that wonderful organization, combining the care of the sick and poor with the profession of arms, which characterized the Knights of St. John during all their subsequent history.

Soon after his election he called the members of the Order together to deliberate with them on the schemes which had for some time been thought over in his own mind.

The Latin kingdom of Jerusalem at this time was but a small and isolated territory, surrounded on all sides by enemies. Constant attacks were made upon its towns and fortresses, either by the Turcomans or the Saracens, and the most horrible outrages and cruelties were committed. Bands of half savage men frequently surprised and entered the Christian strongholds, putting the men to death, and carrying off women and children into miserable and shameful slavery.

Dupuy detailed to his assembled brethren the sad tale of all this misery and violence, and then proposed that they should resume the arms they had laid aside when they devoted themselves to the care of the inmates of their hospitals, and become soldiers of the Cross, and the champions of the poor and helpless.

The proposal filled the brethren with surprise. They alleged that they had put off their armour and sheathed their swords, with no intention of ever resuming them, that they had taken the monk's cowl, and vowed themselves to the perpetual service of the sick, the poor, and the pilgrim, and that they could not go back from their engagement.

In this difficulty recourse was had to the Patriarch of Jerusalem, and the scruples of the brethren were submitted to his judgment.

The Patriarch had no hesitation in dispensing the Hospitallers from their renunciation of the use of arms, and gave his sanction to the proposed extension of the plan and work of the Order.

A new and revised constitution was drawn up, by which it was provided that there should be three classes of members.

First, the Knights, who should bear arms and form a military body for service in the field against the enemies of Christ in general, and of the kingdom of Jerusalem in particular. These were to be of necessity men of noble or gentle birth.

Secondly, the Clergy or Chaplains, who were required to carry on the services in the churches of the Order, to visit the sick in the hospitals, and to follow the Knights to the field, and undertake ministration to the wounded.

Thirdly, the Serving Brethren, who were not required to be men of rank, and who acted as esquires to the Knights, and assisted in the care of the hospitals.

All persons of these three classes were considered alike members of the Order, and took the usual three monastic vows, and wore the armorial bearings of the Order, and enjoyed its rights and privileges.

As the Order spread and the number of its members and convents increased, it was found desirable to divide it further into nations or *Langes*, of which there were ultimately seven, *viz.*, those of Provence, Auvergne, France, Italy, Aragon, Germany, and England.

The habit was a black robe with a cowl, having a cross of white linen of eight points upon the left breast. This was at first worn by all Hospitallers, to whichever of the three classes they belonged; but Pope Alexander IV. afterwards ordered that the Knights should be distin-

guished by a white cross upon a red ground.

Dupuy also obtained statutes and a constitution for his Order, by which its government was vested in the hands of a council, of which the Master was president. The council appointed senior Knights to manage the estates of the Order, and to superintend its affairs in the several countries and provinces where they had possessions and convents. These officers held their posts solely during the pleasure of the council, and were named Preceptors.

The ceremonies for the reception of a Knight were very solemn and impressive.

The following account of them is given by a modern author:—

The postulant presented himself with a lighted taper in his hand, and carrying his naked sword. After blessing the sword, the priest returned it to him with these words:

Receive this sword in the name of the Father, and of the Son, and of the Holy Ghost, Amen, and use it for thy own defence, and that of the Church of God, to the confusion of the enemies of Jesus Christ and of the Christian faith, and take heed that no human frailty move thee to strike any man with it unjustly.

Then he replaced it in the sheath, the priest saying, as the Knight girded himself:

Gird thyself with the sword of Jesus Christ, and remember that it is not with the sword, but with faith that the saints have conquered kingdoms.

The Knight then once more drew his sword, and these words were addressed to him:

Let the brilliancy of this sword represent to thee the brightness of faith; let its point signify hope, and its hilt, charity. Use it for the Catholic faith, for justice, and for the consolation of widows and orphans, for this is the true faith and justification of a Christian knight.

Then he brandished it thrice, in the name of the Holy Trinity.

The brethren then proceeded to give him his golden spurs, saying:

Seest thou these spurs? They signify that as the horse fears them when he swerves from his duty, so shouldest thou fear to depart from thy post or from thy vows.

Then the mantle was thrown over him, and they pointed to the

cross of eight points embroidered on the left side, and said,:

We wear this white cross as a sign of purity; wear it also within thy heart as well as outwardly, and keep it without soil or stain. The eight points are the signs of the eight beatitudes which thou must ever preserve, *viz.*, 1. Spiritual joy. 2. To live without malice. 3. To weep over thy sins. 4. To humble thyself to those who injure thee. 5. To love justice. 6. To be merciful. 7. To be sincere and pure of heart. 8. To suffer persecution.

Then he kissed the cross, and the mantle was fastened, whilst the ministering knight continued,:

Take this cross and mantle in the name of the Holy Trinity, for the repose and salvation of thy soul, the defence of the Catholic faith, and the honour of our Lord Jesus Christ. I place it on thy left side near thy heart that thou mayest love it, and that thy right hand may defend it, charging thee never to abandon it, since it is the standard of our holy faith. Shouldest thou ever desert thy standard, and fly when combating the enemies of Jesus Christ, thou wilt be stripped of this holy sign, according to the statutes of the Order, as having broken the vow thou hast taken, and shalt be cut off from our body as an unsound member.

On the mantle were embroidered all the instruments of the Passion; each of them was pointed out to the new-made Knight, with the words:

In order that thou mayest put all thy hope in the Passion of Jesus Christ, behold the Cord whereby He was bound; see, too, His Crown of Thorns; this is the Column to which He was tied; this is the Lance which pierced His Side; this is the Sponge with which He was drenched with vinegar and gall; these are the Whips that scourged Him; this is the Cross on which He suffered. Receive, therefore, the yoke of the Lord, for it is easy and light, and will give rest unto thy soul; and I tie this cord about thy neck in pledge of the servitude thou hast promised. We offer thee nothing but bread and water, and a simple habit and of little worth. We give thee and thy parents and relations a share in the good works performed by the Order and by our brethren now and hereafter throughout the world. Amen.

He was then received with the kiss of peace.

Richard Coeur de Lion

O God, the heathen are come into Thine inheritance, Thy holy temple have they defiled, and made Jerusalem an heap of stones.

The dead bodies of Thy servants have they given to be meat unto the fowls of the air, and the flesh of Thy saints unto the beasts of the land.

It was not long before the new Order found a field for the exercise of its arms.

The city of Antioch was hard pressed by the Turcomans, and its small garrison was altogether unequal to cope with their overwhelming forces.

Petitions for aid were sent to Jerusalem, and Baldwin's army was reinforced by a contingent of the Knights of St. John, together with a large body of serving brothers and hired troops who fought on foot. The arrival of this force soon turned the tide of war in favour of the Christians. The Knights were everywhere in the front of the battle, and the enemy was beaten off, and Antioch relieved.

From this time the Hospitallers were always found in the ranks of the Christian army in every battle that was fought with the Moslems, and the fame of their gallantry and bravery soon spread far and wide, and attracted fresh recruits to their ranks from the noblest families of every country of Europe.

They became the right hand of the King of Jerusalem, and the most trusty defenders of the Holy Land against its Mahometan enemies. Speaking of them the Pope at this time said, "The Hospitallers make no difficulty to expose daily their own lives to defend those of their brethren. They are the firmest support of the Christian Church in the East, and are fighting every day with distinguished courage against the infidels. But as their substance is not sufficient to maintain

an almost continual war, we exhort you to supply them out of your abundance, and we recommend them to the charity of the people committed to your pastoral care."

Such appeals were amply responded to, and wealth flowed in apace upon the Order, which, unfortunately, led to consequent evils.

The great possessions of the Knights stirred up the envy of many, and gave rise to accusations of cupidity and luxury, which were probably not altogether without foundation.

Another cause of dissatisfaction was that the Pope had declared himself the protector of the Order, and had exempted them from all Episcopal jurisdiction—a fruitful source of trouble and dissension between the Knights and the bishops of the various sees where there were convents or preceptories of the Order.

The position attained by the Order also led to the selection of some of its members as ambassadors in important negotiations. Thus Joubert, a Knight Hospitaller, was appointed by the King and Patriarch of Jerusalem to visit the courts of France and England, to arrange a marriage between the Princess of Antioch and William, Count of Poitiers.

The fame and reverence which the Order attained by its valiant deeds, and by the defence of the Holy Land which it had undertaken, and which seemed to depend almost entirely upon it, led many persons who were unable actually to join it, to associate themselves with it in some other way. Some left estates to it in their wills; others purchased the privilege of being buried in the habit, and within one of the churches of the Order; which was done not only by noblemen and gentlemen, but by princes and kings.

Alphonsus, King of Navarre and Aragon, having no children, went so far as to leave his crown to the Hospitallers and other military Orders, A.D. 1131. This will was, however, set aside after his death.

But, notwithstanding, the prowess of the Hospitallers, and of the Templars,—who by this time had been founded, and had grown to power, and were everywhere distinguishing themselves in the wars with the Moslems,—the Christian cause was declining in the East.

Godfrey de Bouillon, the two Baldwins, Fulk of Anjou, the renowned Bohemund, the brave Tancred, the Courtenays, the Count of Toulouse, and all the early heroes of the Latin kingdom were gone. The enervating influences of Asia were telling upon their successors; no more conquests were made; it was difficult to retain what had been gained with so much labour and bloodshed, and not unfrequently

losses were sustained, and territory ceded to the enemy.

Those who retained the old spirit bestirred themselves, and the second Crusade was the result of their endeavours. The disappointing results of that expedition are matters of history, and need not be repeated here. Doubtless the intrigues and jealousies of the principal leaders, and the excesses and debaucheries of a large portion of the armies, made success impossible. Such Crusaders, though inspired by St. Bernard, and accompanied by St. Louis, did not deserve to succeed; and they failed ignominiously and completely.

The military Orders alone seemed to possess manliness and courage; and upon them, after all, rested all the weight and all the responsibility of protecting the Holy City, and keeping back the numberless hordes of Moslems that hemmed it in on every side, and only waited for a favourable opportunity to rush in and make it their own.

At the death of Raymond Dupuy, Anger de Balben, a French knight of great age, and the highest character, was unanimously elected Grand Master. He retained his office only two years, and died in 1163, and was succeeded by Arnaud de Comps, also a native of France.

It would only be tedious to give a list of the successive Grand Masters, and even to detail the battles and interminable conflicts that form the history of the Latin kingdom of Jerusalem, in all of which the Hospitallers took an active part.

The latest enemy was Saladin, who was everywhere victorious. At Tiberias a terrible defeat was inflicted upon the Christians, thousands were slain, and a large number of Templars and Hospitallers were taken prisoners. These were offered their lives on condition of apostasy; but to a man they refused, and died martyrs for the faith of Christ.

Other victories soon followed, till nothing hindered Saladin's advance upon Jerusalem, which he besieged.

The defence was bravely and obstinately conducted by the enfeebled garrison; but there was no hope of final resistance, the city capitulated, and the Crescent once more surmounted the Cross.

All Latins were required to leave the city; but in such estimation were the Hospitallers held even by their enemies, that Saladin ordered that they should retain possession of their convent and hospital for another year.[1]

1. Among the many legends related of Saladin, the following may not be out of place as illustrating the reputation which the Hospitallers earned by their self-denying and unreserved charity to the inmates of their hospitals.

It is said that Saladin was much impressed with what he heard (cont. next page.)

Thierry, grand preceptor of the Templars, writing to Henry, King of England, gives the following account of this event:—

Know, great king, that Saladin has taken the city of Jerusalem, and the tower of David; the Syrian Christians are allowed to guard the Holy Sepulchre only till the fourth day after next Michaelmas, and the Hospitallers are permitted to stay a year longer in their house, to take care of the sick. The Knights of that Order who are in the castle of Beauvoir distinguish themselves every day by their various enterprises against the Saracens.

They have lately taken two caravans from the infidels, in the first of which they found the arms and ammunition which the Turks were transporting from the fortress of La Fere, after they had demolished it. Carac, in the neighbourhood of Mount Royal, Mount Royal itself, Sapheta of the Temple, another Carac and Margat, which belongs to the Hospitallers, Castelblanco, Tripoli, and Antioch, still hold out against the efforts of the Turks, Saladin has caused the great cross to be taken down from the dome of the church that was built on the ground of Solomon's Temple, and for two days together it was dragged ignominiously through the streets, trampled underfoot, and defiled with dirt.

They have washed the inside and outside of that church with rose-water by way of purification, in order to make a mosque of it, and there they have solemnly proclaimed the law of Mahomet. The Turks have laid siege to Tyre ever since Martinmas; a great number of military engines play upon it night and

of the marvellous kindness of the Knights to poor patients of all nationalities and creeds; he therefore disguised himself, and obtained admission to the great Hospital at Acre. When there he declined all food, and being pressed to eat, and told that he might have anything he desired, he said that he had a strange fancy, and that there was but one thing that he could eat, but that it was useless to name it, for it could not be obtained. Being still urged to say what he desired, he at length confessed that he longed for the forefoot of the Grand Master's charger, and that it must be cut off in his presence. They then went and told the Master; and he at once ordered his noble steed to be sacrificed. But when it was led into Saladin's presence, and a man took up an axe to cut off its foot, he cried out that it was enough, and he had changed his mind.

The legend goes on to say that Saladin ever after paid an annual premium to the Hospital at Acre in admiration of the noble and wonderful charity of the Knights of St. John.

day, throwing in continually square stone of vast bigness. Young Conrad, son of the Marquis of Montserrat, has shut himself up in the place, and makes a gallant defence, being well seconded by the Knights of St. John, and the Templars. On the eve of St. Silvester seventeen Christian galleys, with those brave friars on board, sailed out of the port with ten Sicilian vessels, commanded by General Margarit, a Catalan by nation, and attacked the fleet of Saladin in a manner before his eyes.

The infidels were defeated. The great admiral of Alexandria and eight *Emirs* were made prisoners. They took eleven ships, and a great number ran aground on the coast, which Saladin set on fire, and burnt to ashes for fear they should fall into the hands of the Christians. That prince appeared the next day in his camp, mounted on the finest of his horses, whose tail and ears he had cut off, making thus a public acknowledgment of the defeat he had received, and of the trouble it gave him.

Soon after this Guy de Lusignan formally renounced the title of King of Jerusalem, The news of these misfortunes caused the greatest distress and consternation in Europe. The Pope is said to have died of grief. The Cardinals made a vow to renounce all recreations, to receive no presents, and never to mount their horses so long as the Holy Land was trodden underfoot by the infidels, to be themselves the first in the Crusade, to go to the holy war on foot, and to subsist on alms on the road. It is to be feared, however, that these heroic resolutions were not carried into effect.

Another Crusade was preached throughout Europe, and such as would not themselves join were compelled to pay a tax towards the cost of the expedition, which came to be called the *Saladin tithe.*

Spain alone was unable to join, having her hands full in fighting the Moors and Saracens, who had invaded and kept possession of the finest provinces of the peninsula. The Princess Sancha, however, daughter of Alphonsus, King of Castile, founded a convent for ladies of the Order of St. John at Sixenne, in memory of the many Knights of the Order who had fallen in Palestine, and to receive those nuns of the Order who had been driven from their cloisters by the loss of the Holy Land.

Richard I. of England was the principal leader in this Crusade, and the capture of Acre, after a long siege, was the most important success that was obtained.

When Richard returned to England, he made over his conquest to

the Knights of St. John, who thus became a sovereign Order for the first time. Jerusalem being no longer in Christian hands, the Knights established their headquarters at Acre, which, in honour of their patron saint, they now called St. Jean d'Acre.

The city of Acre, as it was at this time, has been thus described:

Beautiful as it is, even in our own day, it was yet more beautiful when, seven centuries ago, it was the Christian capital of the East. Its snow-white palaces sparkled like jewels against the dark woods of Carmel, which rose towards the south. To the east there stretched away the glorious plain, over which the eye might wander till it lost itself in the blue outlines of hills, on which no Christian eye could gaze unmoved, for they hid in their bosom the village of Nazareth, and the waters of Tiberias, and had been trodden all about by the feet of One whose touch had made them holy ground. That rich and fertile plain, now marshy and deserted, but then a very labyrinth of fields and vineyards, circled Acre also to the north; but there the eye was met by a new boundary, the snowy summits of a lofty mountain range, whose bases were clothed with cedar; while all along the lovely coast broke the blue waves of that mighty sea, whose shores are the empires of the world.

And there lay Acre among her gardens; the long rows of her marble houses with their flat roofs, forming terraces, odorous with orange-trees, and rich with flowers of a thousand hues, which silken awnings shaded from the sun. You might walk from one end of the city to the other on these terraced roofs, and never once descend into the streets; and the streets themselves were wide and airy, and the shops brilliant with the choicest merchandise of the east, and thronged with the noblest chivalry of Europe.

It was the gayest, gallantest city in existence; its gilded steeples stood out against the mountains, or above the horizon of those bright waters that tossed and sparkled in the flood of southern sunshine, and in the fresh breeze that kissed them from the west. Every house was rich with painted glass, for this art, as yet rare in Europe, is spoken of by all writers as lavishly employed in Acre, and was, perhaps, first brought from thence by the Crusaders. Every nation had its street, inhabited by its own merchants and nobles, and no less than twenty crowned heads kept up within the city walls their palaces or courts. The Emperor of Germany,

and the Kings of England, France, Sicily, Spain, Portugal, Denmark, and Jerusalem, had each their residence there; while the Templars and the Teutonic Order had establishments as well as the Hospitallers, and on a scarcely less sumptuous scale.

CHAPTER 5

Charges against the Order

And on his brest a bloodie crosse he bore,
The deare remembrance of his dying Lord,
For whose sweete sake that glorious badge he bore,
And dead, as living, ever Him adored.
Upon his shield the like was also scored,
For sovereign hope which in His help he had;
Eight faithful true he was in deed and word.

Spenser.

The death of Saladin, 1193, raised the hopes of the Christians.

That remarkable man, when he found himself near his end, ordered the officer who carried his standard in battle, to hoist, instead of it, his winding-sheet, and to carry it through the streets, crying, "See here, all that the great Saladin, conqueror of the East, carries off with him of all his conquests and treasures."

After his death, his dominions were divided among his eleven sons, whose contests with one another, and with their uncle, Safadin, effectually hindered any attacks upon the Christians.

This period of quietude enabled the Grand Master, Alphonsus of Portugal, to devote his attention to many matters of internal discipline that needed reformation in the Order.

Many of those who had served as mercenaries under the Knights, when their term of service was over, continued to wear the cross of the Order, and often brought disgrace upon it by their evil lives. This was henceforth forbidden; and those only who were in the actual service of the Knights were permitted to wear its insignia.

The Grand Master further curbed the growing tendency to luxury in the Order, himself setting the example, and reducing his household

and personal retainers to the most modest limits.

Many of the Knights, however, rebelled against the extreme asceticism imposed upon them; and so much dissatisfaction arose, that the Master deemed it best to resign his office and retire to his native country.

Famine was now added to the troubles of the Christians in the East.

"We are forced," writes the Grand Master, "to buy everything at an exorbitant price, as well for the subsistence of the Knights as for the troops which are in the pay of the Order, which has obliged us to contract considerable debts, greater than we can pay, without the supply we expect from our brethren in the West."

Nevertheless, the Order was at this time very wealthy, more so than some sovereign princes. Matthew Paris asserts that it possessed nineteen thousand manors in different parts of Europe. The same author also asserts that there were great jealousies and feuds between the Hospitallers and the Templars, and that they even came to open hostility; but as no other author supports these statements, they must be received with great caution.[1]

In the meantime, another Crusade had been fitted out in France, under the Marquis of Montserrat, and by the aid of Dandolo, Doge of Venice. The army landed in Dalmatia, and wintered there.

Just when the expedition was about to sail in the spring, another of the many revolutions that occurred at Constantinople took place, and Alexis, son of the deposed Emperor, appealed to the leaders of the Crusade to divert their army to recover his rights; the consequence of which was that Constantinople was besieged by an army and fleet under the aged Dandolo.

Gibbon thus describes this expedition:—

A similar armament, for ages, had not rode the Adriatic; it was composed of one hundred and twenty flat-bottomed vessels, or *palanders*, for the horses; two hundred and forty transports filled

1. Matthew Paris describes the departure of a body of Hospitallers from England to join their brethren in the wars of the East.

He says, "There went from the Hospitallers' house of Clerkenwell in London, a great number of Knights with banners displayed, preceded by brother Theodric, their Prior, a German by nation, who set out for the Holy Land, at the head of a considerable body of troops in their pay. These Knights passing over London Bridge sainted with their capuche in hand all the inhabitants that crowded to see them pass, and recommended themselves to their prayers."

with men and arms; seventy store-ships laden with provisions; and fifty stout galleys, well prepared for the en- counter of an enemy.

While the wind was favourable, the sky serene, and the water smooth, every eye was fixed with wonder and delight on the scene of military and naval pomp which overspread the sea. The shields of the Knights and esquires, at once an ornament and defence, were arranged on either side of the ships; the banners of the nations and families were displayed from the stern; our modern artillery was supplied by three hundred engines for casting stones and darts. The fatigues of the way were cheered with the sound of music; and the spirits of the adventurers were raised by the mutual assurance that forty thousand Christian heroes were equal to the conquest of the world.

They gazed with admiration at the capital of the east, or, as it should seem, of the earth, rising from her seven hills, and towering over the continents of Europe and Asia. The swelling domes and lofty spires of the five hundred palaces and churches were gilded by the sun and reflected in the waters; the walls were crowded with soldiers and spectators, whose numbers they beheld, of whose temper they were ignorant; and each heart was chilled by the reflection that, since the beginning of the world, such an enterprise had never been undertaken by such a handful of warriors.

But the momentary apprehension was dispelled by hope and valour, 'And every man,' says the Marshal of Champagne, 'glanced his eye on the sword or lance which he must speedily use in the glorious conflict.'

After a brief siege, the city fell into the hands of the Latins, and was sacked by them in the most, ruthless manner. Churches were gutted; priceless statues, brought from Greece and Rome, were wantonly destroyed; palaces, convents, and warehouses were pillaged; outrages of every kind wore perpetrated; and libraries, containing the learning of the ancient world, became the prey of the flames, and were for ever lost.

After some delay, Baldwin, Count of Flanders, was set up as Emperor.

The Hospitallers were invited to take up their abode in the new Latin empire of the East, to aid in its defence; and they received considerable estates, and many privileges, and had a church and convent

in Constantinople.

The Knights also, about this time, acquired the island of Cyprus, which had formerly been held by the Templars.

In 1209, the Order was invited to defend Armenia from the invasion of the Turcomans, and received possessions in that country as a reward for their services.

At the same period the Knights were waging war with the Moors in Spain; so that in every part of the world the Order was known and honoured, and its influence felt in the management of the affairs of the time.

Nor does their greatness seem to have destroyed the ancient spirit of the Order, for the King of Hungary thus describes his impressions, after visiting some of the principal houses of the Knights:—

Lodging in their house, I have seen them feed every day an innumerable multitude of poor, the sick laid in good beds and treated with great care, the dying assisted with an exemplary piety, and the dead buried with proper decency. In a word, the Knights of St. John are employed sometimes like Mary, in contemplation, and sometimes like Martha, in action; and this noble militia consecrate their days either in their infirmaries, or else in engagements against the enemies of the cross.

The next event in the history of the Order was the expedition against Egypt, and the siege and capture of Damietta.

It was hoped that this might lead to the recovery of Jerusalem; but these hopes were doomed to be disappointed, and the army had to retire from Egypt, having sustained heavy losses.

An attempt was made to fix a charge of treachery upon the Order in connection with this failure; but the Knights laid the matter before the Pope, and their integrity was amply vindicated, the Pope publishing a Bull in their favour, in which he says.

We will require you to honour, love, and cherish them as the noblest defenders of Christianity.

A similar Bull was issued by Pope Clement IV., in 1267, in which he says:

The brothers of the Hospital of St. John of Jerusalem ought to be regarded as the Maccabees of the New Testament. Those noble Knights have generously renounced the pleasures of the world, and abandoned their country and estates, and fortunes, to take up the cross, and put themselves under the banner of Jesus

Christ; they are the instruments which the Saviour of mankind makes use of daily to purge His Church of the abominations of the infidels, and they bravely expose their lives to the greatest dangers for the defence of pilgrims and Christians.

But, in the meantime, the Christian cause in the East was steadily declining. Notwithstanding the Crusades under Louis IX. of France, and Edward I. of England, town after town fell into the hands of the Moslems, and the surviving inhabitants took refuge in Acre, the last stronghold of all the conquests of Godfrey de Bouillon and his successors, which remained in Christian hands.

But Acre was threatened on all sides, and her doom was felt to be near.

Earnest appeals were sent to Europe to try and rouse again the crusading spirit, and defend and retain at least this one city upon the soil of the Holy Land. The Grand Master himself went personally to the courts of the Christian kings, to plead the urgency of the cause, but in vain; they were all too much occupied in their mutual quarrels, jealousies, and intrigues for advancing their ambitious designs, to listen to him; and he returned distressed and disgusted to fight and to die.

In 1291, the army of Melec Seraf appeared before the city, numbering 160,000 infantry, and 60,000 cavalry. To meet this great force, the Christians had but 12,000 men. There were about two hundred Hospitallers, and as many Templars.

The contest immediately began, and was continued without intermission, and with terrible slaughter.

A deep ditch, filled with water, proved the greatest difficulty in the way of the besiegers. They endeavoured to drain it and to fill it up with stones and earth, but without success. During one attack, we are told, the Sultan became furious at the hindrance which this ditch presented to his advance, and actually commanded a body of his troops to throw themselves into it, so as to fill it up with their living bodies; and such was the fanaticism of these men that they did not hesitate for a moment, but with a shout flung themselves headlong into the yawning abyss, making a pathway for the feet of the next detachment, who rushed over their palpitating bodies to place ladders against the walls!

The unequal conflict was continued; mines were dug under the fortifications, and great breaches were made in the walls; sorties were made by the besieged; but bravery itself was ineffectual against overwhelming numbers, and the city was taken.

No quarter was given; neither age nor sex were spared. Sixty thou-

sand Christians were put to death. A convent of nuns, of the order of St. Clare, fearing the violence of the soldiery, "disfigured themselves," as the chronicler says:

>with more care than the women of this age take to set themselves off. Some cut off their noses; others made terrible gashes in their cheeks; all of them had their faces besmeared with blood, and in this frightful condition the infidels, seeing no objects but such as gave them horror, massacred them without mercy, and, by their death, put those chaste spouses of the Saviour of the world out of the reach of their insolence.

The city itself was utterly destroyed, and left without inhabitants; and thus the last possession of Christendom in the Holy Land was for ever lost.

CHAPTER 6

Rise of the Turks

The earth quakes and trembles because the King of Heaven hath lost His land, the land whereon His Feet once stood. The foes of the Lord break into His holy city, even into that glorious tomb, where the virgin Blossom of Mary was wrapt in linen and spices, and where the first and greatest Flower on earth rose up again.—St. Bernard.

The Hospitallers were once more homeless. The handful that escaped wounded and penniless from Acre, landed in Cyprus (1291). The Grand Master, who was one of the six survivors, immediately sent out letters to the heads of the houses of the Order everywhere summoning the knights to a general chapter at Limisso, to consider what should be done.

In a short time almost every knight of the Order was in Cyprus. The greatest unanimity prevailed, and it was at once determined to continue the policy which had been followed by the Order for two hundred years. The recovery of the Holy Land, the defence of pilgrims, the care of the sick and poor, these were once more asserted to be the aims of the Order, and every knight swore to devote himself to these objects under the guidance of the Grand Master and his chapter.

The Grand Master, in his address to the knights, said,:

Your diligence in observing our orders, and the courage that seems to animate you, convince me, in spite of all our losses, that there are still true Hospitallers in the world capable of repairing them. Jerusalem, my dear brethren, is fallen—fallen, as you know, under the tyranny of infidels. A barbarous but formidable power has forced us by degrees to abandon the Holy Land, For more than an age past we have been obliged to fight as many battles as we have defended places. St. John D'Acre is

a late witness of our last efforts, and almost all our knights lie buried in its ruins. It is for you to supply their places; it is from your valour that we expect our return into the Holy Land, and you carry in your hands the lives, the fortunes, and the liberty of your brethren, not of the Order only, but of the vast number of Christians that are groaning under the chains of the infidels.

The senior commanders replied, one by one, that they were ready to sacrifice their lives for the land of their Saviour; while the younger knights testified their zeal and impatience to vindicate their courage by meeting the foe.

But before anything else could be done, it was necessary to form a new home and centre for the Order.

Limisso was a defenceless town, the fortifications having been destroyed by the Moslem pirates; and many of the knights, despairing of holding it against them, were in favour of retiring to Italy; but the nearness of Cyprus to Palestine prevailed with the majority, and it was determined to fix the headquarters of the Order there, in spite of all the difficulties and objections that stood in the way.

The town was rebuilt, the central Church and Convent of the Order were erected, and with due regard to the fundamental principles of the body, a noble Hospital was provided, to receive pilgrims and the sick.

But the exigencies of their position led to a new development of their schemes. The Mediterranean was infested with piratical ships, belonging to the Moslems of Egypt and Barbary, and the knights found that their island home would not be safe, nor their work prosperous, unless they met their enemies upon the sea.

Ships were immediately fitted out, armed and manned by the knights, which began to cruise between Palestine and European ports, conveying pilgrims, rescuing captives, and engaging and capturing the enemy's galleys.

Such was the beginning of the naval greatness of the Knights of St. John. The loss of Acre was almost compensated by the wonderful successes which, for four hundred years, attended the arms of the Order, and rendered its flag paramount in the Mediterranean.

The successes of the Order upon the sea soon roused the anger of the Sultan of Egypt. His vessels were attacked, sunk, or taken; prisoners were released; and the enemy whom he had supposed was forever crushed at Acre, was seen to be, not only still active and formidable, but inaugurating an entirely new career at Cyprus.

The Sultan fitted out an expedition, therefore, to attack the island, which, in the present defenceless position of the towns, would have been irresistible; but, happily, dissensions in his own dominions prevented his setting out, and his death shortly after relieved the knights from their apprehensions.

The danger, which they had so narrowly escaped, impressed upon them the necessity of guarding against a repetition of it, and the Grand Master immediately set about fortifying the city of Limisso.

He found it necessary, also, to renovate the discipline of his Order. The enervating climate of the island tended to introduce sloth and luxury; and the booty daily brought in by the galleys, enriched the knights and led to extravagance and display.

All these evils were attacked by sumptuary laws, and by reviving the more strict observance of the original rules and constitution of the Order.

A sudden and unexpected event restored, for a time, the hopes of the Hospitallers that they would once more regain their home in Jerusalem.

A new horde of Tartars appeared under Gazan, who solicited the aid of some of the Christian princes against the Saracens; and the Knights of St. John were once again within sight of Jerusalem.

But these successes were short-lived, and the Christian army retired from Palestine.

About this time, a scheme was proposed by the Pope for the union of all the Military Orders into one body. On investigation, however, it was found not to be desirable, and it was abandoned.

Another important event in the history of the Knights of St. John was now coming on. The island of Cyprus was found unsuitable in many ways for the home of the Order. The king refused to allow the knights to acquire land and other property; and demanded payment of taxes, from which they were exempted by the privileges long ago conferred upon them; and in many other ways interfered with the liberty and progress of the Order.

The Grand Master, Villaret, had for some time been looking out for a more suitable locality, and finally fixed upon the island of Rhodes.

The scheme was privately laid before the Pope and the King of France, and received their approval; and to obtain aid for the enterprise without divulging the secret, a Crusade was preached, without mention of the locality of its destination.

Men and money flowed in; the women giving their jewellery to

swell the funds.

Villaret now sent envoys to the Greek Emperor, Andronicus, to acquaint him with his designs upon Rhodes, and to request his concurrence in them.

Andronicus, however, refused to give up his claim upon Rhodes. The island had, indeed, once formed part of his empire, but had for some time been practically severed from it, and independent.

Its inhabitants were partly Greek, and partly Saracen; and were notorious pirates and robbers, infesting the neighbouring seas and coasts, and capturing trading vessels, and making raids upon the unprotected towns.

The island was fertile and beautiful, and an admirable climate rendered it productive of all kinds of grain and fruit. Its name is said to be derived from the roses which bloomed in profusion everywhere, and nearly all the year round.

In ancient times, the inhabitants were industrious miners, manufacturers of arms, and sculptors. The famous Colossus was one of the wonders of the world. There were also academies and schools, and many learned men were trained in them. The Rhodians were also famous in navigation.

But all these arts of civilization had decayed under the feeble rule of the Greek Emperors, and the savage incursions of the Saracen pirates.

Villaret effected a landing on the island, but met with a determined resistance from the inhabitants, who united themselves against a common enemy.

Most of those who had joined the expedition, believing its destination to be Palestine, gradually retired, and the knights found themselves dependent upon their own resources. Money was borrowed in Florence and elsewhere, and men and supplies were contributed by the houses of the Order throughout Europe; but it was found that a regular siege would be necessary before the principal city could be taken.

The defence was continued with great obstinacy, and with considerable losses on both sides; but on August 15, 1310, the place was carried by storm, and Rhodes was in possession of the Knights of St. John, who thenceforth became known as the "Knights of Rhodes."

Villaret began at once to secure himself in possession of his new dominion. He fortified the city of Rhodes, and sent expeditions to take possession of the neighbouring small islands, which were neces-

sary to his strategetic position, as they afforded shelter to the vessels of the piratical Saracens, and enabled them to make sudden descents upon the main island.

Some of the larger islands were covered with valuable timber; others produced grapes, from which excellent wine was made; others had quarries of beautiful marble. All these islands, and many smaller ones that were little more than rocks, were easily conquered and taken possession of; and castles, watch towers, and lighthouses were erected upon them.

Nor were other matters neglected. Rhodes was constituted a bishop's see, clergy were appointed, and churches built on this and the neighbouring-islands. Steps were also taken for the promotion and protection of industry, for the administration of justice, and for the regulation of all the other requirements of a stable Christian government.

But, in the meantime, a new enemy was gathering strength, and was soon to be formidable, not only to the Knights of Rhodes, but to every Christian power.

Othman was, at this time, the leader of the latest band of Tartars that had invaded Europe, and who were afterwards known as the Turks, whose dominion threatened, at one time, to blot out the Christian religion from the earth, and to reduce Europe to Asiatic barbarism.

To Othman, the Moslem fugitives from Rhodes betook themselves, and solicited his aid to drive out the knights.

The Turkish conqueror readily accepted the invitation, which promised further extension to his dominions; and he speedily fitted out an expedition against Rhodes.

Hitherto his army had never suffered defeat, but, although the fortifications of Rhodes were incomplete, and the whole island in a defenceless condition, such was the bravery of the knights, and so well was their army manoeuvred, that Othman could not effect a landing, though he continued for a long time to make attacks upon Rhodes and the other islands.

It was at this time that the Order of the Templars was dissolved, its members put to death with every device of cruelty, and its possessions confiscated.

Philip the Fair, King of France, was the first mover in this terrible episode, and it is believed that he intended to have included the Hospitallers also in his scheme of confiscation; but the absence of the Grand Master from France, the subsequent conquest of Rhodes, and the suc-

cess of the Order against the Turks, seem to have sheltered them from the fate of the Templars, whose vocation appeared to be gone when Palestine was lost, and whose wealth and power aroused the jealousy and covetousness of the princes who regarded them as rivals.

Some portion of the possessions of the Templars was made over to the Hospitallers, and this, together with the territorial dominion of Rhodes and the other islands, left the Knights of St. John without a rival among the military Orders.

But wealth and power have always their accompanying dangers, and the Order of St. John, with its high aims and admirable rule, was not altogether proof against them.

The Grand Master maintained the state of a sovereign prince, and his brethren, who were of the noblest families in Europe, could not brook his haughty and overbearing manners; while the strict and ascetic members complained of the relaxation of the ancient rule, the introduction of luxury, the loss of discipline, and the general degeneracy of the Order.

So great was the discontent, that a large portion of the knights called upon Villaret to resign the Grand Mastership, and even nominated another, Maurice de Pagnac, in his place.

Schism was now added to the misfortunes of the Order, and two Grand Masters divided the allegiance of the knights,

In this dilemma it was resolved to lay the matter before the Pope, John XXII. Both parties repaired to Avignon, where the Pope then resided, and urged their claims before the tribunal.

It was found a difficult case to determine, but the death of Maurice de Pagnac, and the resignation of Villaret, enabled the Pope to appoint a new Grand Master, Helion de Villeneuve, and so to put an end to the disputes (1323). Under the administration of Villeneuve, order and unanimity were restored, and many reforms were introduced, by which a return was made to the primitive principles of the Order; so that no further charges of luxury and negligence were heard, but the knights were respected and honoured, and their authority everywhere confirmed and established.

It was at this time that the Order was divided into separate nationalities, or *Langes*, each with its own officers and duties.

Great exertions were also made to enlarge and strengthen the navy of the Order, not only for the protection of their dominions, but also to exterminate the pirates of the Mediterranean, and to resist the growing power of the Turks upon the sea, against whom many expe-

ditions were made.

The most important of these resulted in the occupation of Smyrna, which the knights held for nearly thirty years, in spite of the efforts of the Turks to displace them; and by their hold of this place, the conquest of Constantinople by the Turks is believed to have been retarded several years.

The continual advance and conquests of the Turks were now filling Europe with anxiety, and the Pope was anxious that the knights should abandon Rhodes, and make their headquarters either in Greece or Asia Minor, with a view to being a bulwark against the Turks. But, happily, wiser counsels prevailed, and the island stronghold was retained.

At this time the navy of the knights was the finest that was afloat, so that, when the Pope determined to leave Avignon and return to Rome, it was in the galleys of the Order that he and his suit embarked; and a contemporary writer, who was on board, describes the Grand Master, Heredia with his white beard, holding the rudder of the largest galley, with the Pope on board, surrounded by his knights; and though a tempest arose and scattered the fleet, he brought his ship safely into Ostia.

On his return to Rhodes, Heredia fell in with the Venetian fleet on its way to try and drive the Turks out of Greece, and joined his forces to theirs.

At Corinth the Grand Master was unexpectedly surrounded by a superior force, and was taken prisoner; and when hostages and money were offered by the knights for his release, he nobly replied, "Let me alone, my dear brethren; suffer a useless old man, that cannot live much longer, to die in prison, and do you who are younger, preserve yourselves to be serviceable to the Order." Nor would he allow any ransom to be paid out of the treasury, but left it to his family and relations to find the money.

CHAPTER 7

Battle of Nicopolis

The flower of the nobility of Europe aspired to wear the cross, and profess the vows of these Orders; their spirit and discipline were immortal.

Gibbon.

The schism in the Papacy which caused so many evils, induced a schism in the Order of St. John; two Grand Masters having been appointed by the sections of the Order who adhered respectively to the rival Popes.

These troubles prevented to a considerable extent a due regard to the terrible advance and successes of the Turks. A large portion of Asia Minor was already theirs, and an opportunity now occurred of making advances into Europe.

The Eastern empire was as usual distracted by faction and revolution, and one of the rival candidates for the Imperial dignity actually sent his Christian daughter to the *harem* of the Sultan Orchan as a bribe to induce him to support his claim to the throne.

The Turks speedily vanquished the weak and effeminate Greeks, and city after city was taken from the Eastern empire never to be regained. Adrianople itself became the Turkish capital, and the successor of Constantine found himself surrounded by ever advancing enemies, while his dominions melted away year by year, and were incorporated into the new empire of the Turks.

But successful as the Turks had been under their early leaders, Bajazet inaugurated a new and more extensive era of conquest. Both in Europe and Asia his arms were everywhere victorious; one Christian country after another was subdued, their churches destroyed, their clergy massacred, and the unhappy captives sold into slavery, or offered the alternative of apostasy or death.

Christendom being at last delivered from the schism, was aroused to the danger that threatened her, and a Crusade was preached. An army of sixty thousand cavalry, with a proportionate body of infantry, under the command of the Count do Nevers, marched to the defence of Hungary, and met the Turkish army at Nicopolis (1395).

At first all went well with the Christian army. The cavalry carried all before them; even the famous *Janizaries* were broken and forced to retreat, and the Turkish horse fared no better. The victory seemed to be won, and the knights wearied their horses with pursuing their flying foes.

But Bajazet had not yet brought all his forces into the field; a reserve of forty thousand troopers, led by himself, suddenly emerged from behind a hill and fell upon the Christian army, fatigued, scattered, and not expecting an enemy.

In a few moments the battle was converted into a rout. The Knights of Rhodes and a few others rallied and stood their ground for a time, but, being overwhelmed by numbers, most of them were slain where they stood, the rest were taken prisoners. Next day ten thousand prisoners were led out into the presence of Bajazet, and there murdered in cold blood, in revenge for the death of some Turks who, it was alleged, had been put to death by the Christians.

This victory left Bajazet without an enemy to oppose his progress. It was proposed to make over Greece to the Hospitallers, but the jealousy of the Greek Christians against the Latins prevented the conclusion of the arrangement which might have saved the country from the dominion of the Turk. Instead of this, Athens was taken by the armies of Bajazet, and Constantinople itself besieged.

In this extremity the Emperor Palaeologus sent to ask the aid of the Tartar chieftain Tamerlane. This extraordinary man had pursued a career of victory and slaughter almost unparalleled in the history of mankind. He invaded Turkestan, Russia, Hindostan, Syria, Anatolia, Armenia, and Georgia, with no idea of establishing an empire, but only apparently from love of conquest, slaughter, and rapine. Pyramids of human heads alone marked the sites of populous cities which he had utterly destroyed. It was his usual saying that, "A monarch was never safe, if the foot of his throne did not swim in blood!"

It was this monster that a Christian Emperor invited into Europe!

Tamerlane readily accepted the invitation, and with 800,000 men marched against Bajazet.

On his way he sacked Aleppo and Bagdad, and erected on the ruins

of the latter a pyramid of 90,000 human heads; and, finally, encountered the hosts of Bajazet at Angora (1402).

Seldom has there been so tremendous a battle. In the midst of it some of Bajazet's Tartar soldiers went over to the side of their countrymen, and, seizing Bajazet himself, delivered him up to Tamerlane.

No sooner was Tamerlane master of his enemy than he turned away, after his usual custom, to seek fresh conquests,

Smyrna naturally attracted his attention, being the only city in the hands of the Christians. Tamerlane offered terms to the Knights of Rhodes, who defended it, but, although they had no hope of ultimate success, they refused to capitulate, and the siege was begun.

The besiegers began to fill up the ditches with earth, while their archers shot showers of arrows against the garrison who, ever and anon, made sallies to hinder their works. Mines and wooden towers erected against the walls were tried, and a bar was made across the harbour to prevent succour from the sea.

After a brave but hopeless defence, the city was taken, and, as usual, everyone was put to death, and a pyramid of skulls was erected.

The Grand Master having thus lost his fortress on the mainland, devoted his attention to strengthening the fortifications of Rhodes and the adjacent islands.

Nor did the Order forget its original object as a helper of those who were in sickness, distress, and captivity. Great efforts were made to rescue or redeem Christian slaves from the hands of the Turks and other Moslems. One of their island castles was called *St. Peter of the Freed*, because many of these unfortunates were constantly received there.

It is said also that dogs were trained to search for runaway slaves who might have fallen down exhausted, or who had lost their way, and many stories are told of the instinct of these creatures, and of the good service they performed in saving lives.

The Order continued also to develop its maritime power. There were constant encounters with the pirates and Turkish vessels, generally ending in victory to the knights; the vessels captured being added to the Hospitallers' navy.

Vertot says, "The Grand Master was at that time considered the most powerful Christian prince in the East, and the Order never had braver officers, nor a greater number of them. The convent was generally peopled with a thousand knights; most of the islands called Sporades depended on it, and the sea was covered with their fleets. At the

same time the Rhodian merchants, under the protection and convoy of the vessels of the Order, grew rich by their commerce; there was not a corsair that durst venture near the seas of Lycia, and we may affirm that the arms of the Order were as terrible to the infidels, as its valour was generally esteemed by the princes of Christendom."

Expeditions were also made from time to time against places in possession of the Turks or the Saracens, either by the knights alone or in conjunction with the Venetians or the Genoese, who were the great naval powers of the period.

Tripoli, Berytus, Lydda, and other places were attacked; no place was ever secure from the daring and sudden onslaught of the Knights of Rhodes, and a vessel could hardly venture out of port into the seas about Cyprus without being snapped up by their galleys.

So intolerable did all this become that the Sultan sent an ambassador to Rhodes to endeavour to arrange some terms with the knights.

Naillac, who was Grand Master at that time, agreed upon a temporary truce; but, true to the spirit of his Order, he required in return that he should be permitted to build a wall round the Holy Sepulchre; that he should have always six knights in Jerusalem with liberty to entertain others for a time, that they should be free from all tribute taxes; that pilgrims should have access to the Holy Places; that the Order should have power to redeem any Christian captives by paying the same money that they cost their masters, or by giving a Moslem in exchange; that there should be free commerce between the Order and the Sultan; that there should be knights maintained at Jerusalem, Rama, and Alexandria, to act as consuls to protect Christians from the exactions to which they were exposed; and that there should be free export of corn from the Sultan's dominions.

The very advantageous character of these terms, in return for nothing but a cessation of hostilities, is the best proof of the power of the Order at this time, and the dread with which it had inspired the Moslem ruler.

There was, however, an internal element of weakness through the schism in the Papacy. As the countries of Europe were divided, some following one Pope and some the other, so the knights of those countries were divided. The convent of Rhodes, the knights of the East, with those of France, Castile, Scotland, and part of Germany, acknowledged the authority of the Grand Master who adhered to Benedict XIII., successor to Clement VII.; whilst the Popes that succeeded

Urban VI. had, in order to retain in their obedience the Arragonian, Italian, and English knights, as well as those of the kingdoms of the north, Bohemia and Hungary, appointed Italian commanders to be their superiors under the title of Lieutenants of the Grand Mastership; and who, as if that great dignity had not been filled up, governed those portions of the Order without having the least intercourse with the Grand Master of Rhodes.

It is easy to understand what injury this must have inflicted upon the Order, which saw its forces divided, and received for a long time no contribution from the Priories and Commanderies that had separated themselves from the main body of the Order.

There was, however, one happy feature of unity in Rhodes. There alone the union between the Greek and Latin Churches was maintained, and the two rites were used side by side without jealousy or conflict.

The Council assembled at Pisa with a view to putting an end to the Papal schism, which was inflicting such injury upon Christendom and bringing all religion into contempt, only ended in creating worse confusion; for the two Popes being deposed, and a new one elected, the two refused to acknowledge the power of the Council; and so there were now three Popes instead of two, each claiming to be the Vicar of Jesus Christ, each anathematizing the other two, each declaring all acts, consecrations, and ordinations of the others void and sacrilegious!

At the death of Alexander V. Cardinal Baltazer Cossa was elected by the cardinals of one faction to be Pope. This infamous man had been a pirate, and had turned ecclesiastic only from sordid motives, his life being still scandalously wicked. He contrived to be appointed Archdeacon of Bologna, and, still ambitious, he set out for Rome, telling his friends, "I am going to the Popedom." Bribery, intrigue, and poison were freely and unscrupulously used by him, and with success, for he obtained the object of his ambition, and was actually elected Pope, and took the title of John XXIII.

His conduct continued to be regulated by the same vile principles after his elevation, and the Knights of Rhodes suffered among others from his wickedness. He sold a Commandery and appointed a boy of fourteen to it. In another case, in consideration of a heavy bribe, he caused a natural son of the King of Cyprus, a child of only five years old, to be admitted to take the vows of the Order, and to be collated to a rich benefice.

On various pretexts also he seized upon the Priories as they became vacant, and sold the office of Prior to the highest bidder.

These and a thousand other and worse crimes at last roused the whole of Christendom; the Council of Constance was convoked, the three Popes were deposed, and once more unity was restored by the election of Martin V.; and, after some difficulties, delays, and controversies, the Order of St. John was again united, and all the Knights of every *Lange* acknowledged the authority of the Grand Master.

The Sultan of Egypt now made an attack upon Cyprus, and the Knights of Rhodes went to the assistance of the king. The war proved long and bloody.

At last there came a battle, the particulars of which we are not acquainted with. We only know that the Christians lost it, and that a great number of Cyprian lords and gentlemen, and many Knights of St. John were slain, the great Commandery of the Order in the island was ravaged, the houses demolished, the trees cut down, the vines rooted up; so that this, the richest establishment of the whole Order was utterly ruined.

Nor was this the only misfortune that fell upon the Order at this time. The wars with the English in France had impoverished the Commanderies in that country, and they could contribute little or nothing to the common fund; Bohemia, Moravia, and Silesia were engaged in civil war; Poland was fighting the Teutonic Knights, and so, one way or another, small help came to Rhodes for maintaining the Order in its conflict with the Moslem hosts.

At this juncture the Sultan of Egypt, who owed the knights a grudge for their aid to Cyprus against him, fitted out a fleet and attacked Rhodes (1440).

He was unable, however, to effect a landing, and not being provided with appliances for a regular siege, was therefore obliged to retire to one of the neighbouring islands. Hither the galleys of the knights followed him, and a battle ensued, which, though not decisive, prevented his making any further attempt upon Rhodes at the time.

In 1444, however, another attack was made upon Rhodes, and the city was actually besieged forty days; but so strong were its defences, and so brave its defenders, that the Egyptian forces were once more obliged to retire without attaining their object.

Siege of Constantinople

The ways of Sion do mourn, because none come to her solemn feasts, all her gates are desolate, her priests sigh, her virgins are afflicted, and she is in bitterness. Her adversaries are the chief, her enemies prosper.—Jeremiah.

But a more terrible siege was now at hand, and a more disastrous defeat for the Christian cause.

The Turks had gradually been extending their dominions, and had left but a very small territory indeed to the Greek Emperor at Constantinople. Even that little was now to be wrested from him, and the last remains of the Roman Empire in the East were to be absorbed into the vast possessions of the successor of Mahomet.

The Greek Emperors had long ceased to be powerful; faction and fanaticism reigned, and the Emperors were generally the mere puppets set up and put down by the prevailing party of the moment.

The jealousy also between the Eastern and Western Churches rendered the European Powers almost indifferent to the dangers that were evidently gathering round Constantinople; while the Greeks declared they would rather see the Turk himself in their city than agree to submission to the Pope.

In 1451, Mahomet II. had succeeded to the Ottoman throne, and he at once resolved to possess Constantinople.

In violation of all treaties and all remonstrances a strong fortress was built within five miles of the city, the stones of ruined churches being used for its gigantic walls.

Cannon of enormous size were cast at Adrianople, capable of throwing a stone shot of six hundred pounds weight; and when all his preparations were completed, Mahomet threw aside all the pretences with which he had endeavoured to conceal his intentions, and, in

1453, he marched upon Constantinople and commenced the siege.

The siege and capture of Constantinople form an era in history. The event stands midway between medieval and modern civilization, and was fraught with far-reaching consequences. It broke the last link that held the world to the old Roman civilization; it sent into the west the learning and literature of the east; and paved the way for the revival of learning, and for the Reformation.

During the siege the old methods of warfare were used side by side with the new ones which followed upon the discovery of gunpowder. Cannon thundered while arrows flew; and stones were hurled against the walls, sometimes by the same engines as were used by the Romans at the siege of Jerusalem, and sometimes by guns, which were so little understood, that they were nearly as dangerous to their owners as to the enemy.

Armour was still worn; boiling oil and Greek fire were in use as warlike weapons; while moveable wooden turrets, covered with raw hides, were relied upon as valuable aids to attack.

Only once during the siege came there any help from without. A small fleet, principally consisting of Genoese vessels, fought their way through the Turkish navy and brought seasonable aid in men and provisions to the besieged.

But nothing could resist the energy and determination of Mahomet.

Finding it difficult to approach the city with his vessels, on account of the chain across the harbour and the opposing fleet of the enemy, he transported a number of lighter ships across ten miles of hilly ground, and launched them inside the barrier and close to the city.

Meanwhile, famine and petty quarrels were doing his work within the city, and, after forty days' siege, it was evident that the end was not far off. A tremendous assault was made; breaches were opened in the walls, the hosts of the Sultan rushed in; and Constantinople was taken. A multitude had taken refuge in the great church of St. Sophia, only to meet with death or captivity:

> Senators were linked with their slaves, the prelates with the porters of the church, and young men of the plebeian class with noble maids, whose faces had been invisible to the sun and their nearest kindred. In this common captivity the ranks of society were confounded, the ties of nature were cut asunder, and the inexorable soldier was careless of the father's groans, the tears of the mother, and the lamentations of the children. Above

sixty thousand of this devoted people were transported from the city to the camp and fleet, exchanged or sold, according to the caprice or interest of their masters, and dispersed in remote servitude through the provinces of the Ottoman empire.

The churches, rich with the oblations of ages, were stripped or destroyed; the libraries, filled with the noblest productions of history, science, and literature of all preceding ages were ruthlessly scattered to the winds by the conquerors, who despised learning.

Works of art without number, statues, paintings, mosaics, were dashed to pieces by the iconoclastic violence of those who could only rejoice in destroying in a moment that which years had been required to produce, which centuries had admired and valued, and which can never be replaced.

So fell Constantinople, and Europe trembled.

Palestine was gone; Asia Minor, Egypt, and Northern Africa were all possessed by the Turk; Spain seemed to be going; Austria and Italy were threatened. There seemed reason to fear that the total destruction of civilization and of Christianity was at hand, and that an enemy more ruthless than the hordes that overran the ancient Roman Empire, was preparing to reduce the world to a desert, and blot out all that was noble and precious, the result of the labour and thought and endurance of centuries.

In these sad times the hopes of Christendom centred to a great extent in Rhodes. It stood out as a bulwark against the advances of the Turks westward; and the pre-eminence of the navy of the Knights in the Mediterranean was some security for the integrity of the countries upon its shores.

Mahomet saw this, and soon after the capture of Constantinople he sent some of his officers to Rhodes to demand the submission of the Knights of St. John to his sway.

The Grand Master replied that his Order could not yield to the Sultan; that they had been organized for the defence of the Christian Church and the Catholic faith; that they had for centuries maintained their principles, and that they intended to do so to the last.

Such bold words irritated Mahomet beyond endurance, and he determined at once upon the siege of Rhodes, and the destruction of the Order of St. John.

But he was not yet prepared for so serious an undertaking, and was forced to content himself for a time with less difficult conquests. He sent out a fleet which fell upon the smaller islands and laid them

waste. Albania also still held out against him, under the brave Scanderbeg, and, till it was subdued, he could not spare his whole army to attack Rhodes. Lesbos also maintained an obstinate resistance under the command of some of the knights of the Order, and would probably not have been taken but for the treachery of the governor, who betrayed it into the hands of the besiegers. The Turks put the garrison to death with horrible tortures, sawing many asunder alive.

Huniades in Hungary also bravely contended with the advancing Turks, and did his part in saving Europe from their dreadful dominion.

The Sultan next sent an expedition against Trebizond on the Black Sea, where a Greek dominion had been established, after one of the many revolutions at Constantinople. After a siege of thirty days the city was in his hands.

The outbreak of the plague at Constantinople further hindered the designs of Mahomet against Rhodes, and gave the knights respite.

In the meantime, however, a dispute arose between them and the Venetians; in consequence of which the latter fitted out an expedition against Rhodes, and besides blockading the port, inflicted many injuries upon the inhabitants of the island; a very grievous event, at a time when all Christian powers ought to have been united in the assistance of the Order in their preparation for the great struggle with the whole Turkish power which every cue knew was rapidly approaching.

The Knights, however, exercised a noble revenge; for when, sometime after, Negropont, a dependency of Venice, was attacked by the Turks, they immediately came to its aid.

Erizzo, the commander of the island, made a gallant defence; but, at last, being without food and ammunition, and most of his soldiers being wounded and disabled, he was forced to capitulate. He would not, however, do this till the Sultan had given his word of honour to spare his life. That prince swore by his own head that Erizzo's should not be touched; but no sooner did he get him into his power than he ordered him to be sawn in two, and, mixing raillery with cruelty, he said that he had indeed given Erizzo assurance for his head, but that he had never meant to spare his body.

The gallant Venetian had a beautiful daughter, and fearing a dreadful fate for her, entreated his executioners to put her to death before they despatched him; but they replied that she was reserved for the Sultan. They led her to him, and he was charmed with her beauty, and desired to add her to his *harem*, making rich presents and great prom-

ises to win her consent. But nothing could move her resolution; and Mahomet, more proud than sensual, cut off her head with one blow of his sword, thus fulfilling "the wishes of the Christian maiden, who preferred death to dishonour and apostasy."

It would be difficult to describe the cruelties executed by the Turks after the taking of Negropont. The island, we are told, was covered with slaughter and horrors, and every species of violence and torture was inflicted upon the inhabitants without respect of sex or age till death released them from their miseries.

Such ever has been the treatment that the vanquished have received at the hands of the savage Turks from their first appearance as a military power even down to our own day. They never spare, they never change, they are never civilized. They are still the Asiatic barbarians they were at the beginning, and if ever they have power they can but destroy and lay waste.

It is a heavy debt of gratitude that Europe owes to the Knights of St. John, by whose persistent resistance and dogged courage the flood of Turkish desolation was held back so long, and who stood almost alone and single-handed, with bold front and unconquered spirit, when the princes of Christendom either basely gave way, or occupied themselves in selfish schemes, or miserable squabbles' between themselves.

A touching incident is mentioned as occurring at this time, by one of the chroniclers of the Order.

The Turkish governor of Lycia came to Rhodes, offering to restore certain captive knights and other Christian prisoners on payment of a large sum of money. The Grand Master had good reason to suspect the motives of the Turk, having had sad experience of the treachery and bad faith of his countrymen, and feared that the real object of his mission was either to obtain money by a pretended offer which would never be fulfilled, or to take an opportunity of acting the spy upon the fortifications of Rhodes, and so to obtain information which would be only too useful in the coming attack.

The negotiations were therefore protracted and carried on with extreme caution; but, ultimately, they were brought to a successful issue, and a number of knights and others were redeemed from the most miserable slavery.

A scene that moved the spectators even to tears occurred, when the captives were landed, worn and emaciated with ill-usage and starvation; bearing the marks of their chains, and the wounds and bruises

of the cruel blows which they had received, these soldiers of the no-blest families in Europe could scarce believe their happiness in finding themselves once more free men and among friends and Christians.

It was enough for them that they enjoyed life and liberty, of both of which they had lost hope, but it was too much to be overwhelmed with the congratulations of friends, and the kindnesses of all classes who deemed it an honour to be allowed to minister to their neces-sities and supply their wants. They saluted the Grand Master as their father and saviour, while he replied:

> It is to the Order, my friends, that you owe your thanks and gratitude, not to myself, and I only beg of you to make it a due return, by exerting your well-known valour against the enterprises of Mahomet, who daily threatens us with a siege and extermination.

This was perfectly true, for the Order had spies at Constantinople, and even in the Sultan's palace itself, and the plans and preparations of the intended expedition were no secret.

It was known, too, to the Grand Master that the Venetians were secretly negotiating a treaty with the Turks for the protection of their commerce; that the Persians, who had for some time been the most successful opponents of the Turks, were no longer engaged in active hostilities; and that the princes of Europe were even tearing each oth-er to pieces; he felt, therefore, that the time was drawing near when the Sultan would have leisure and opportunity to attack Rhodes, the one obstacle in his way to the conquest of Europe, and especially of Italy, which had long been the chief object of his ambition and cov-etousness.

CHAPTER 9

The Sultan's Designs Upon Rhodes

A true knight,
Nor yet mature, yet matchless; firm of word,
Speaking in deeds, and deedless in his tongue,
Not soon provoked; nor, being provoked, soon calmed;
His heart and hand both open, and both free.

Shakespeare,

For some time past, preparations had been going on for the expected attack upon Rhodes; provisions, stores, and ammunition had been laid in in great abundance, and a general chapter of the Order was held to arrange all the details of the campaign.

The Grand Master, at this time, was Peter D'Aubusson, one of the greatest and most able of those who rose to that office during the history of the Order. He is said to have been a universal genius; a first-rate engineer; a practical chemist, manufacturing his own gunpowder; a brave soldier; a skilful general; an admirable financier; and, not least, a clever physician and surgeon in the wards of the hospitals of the Order.

He now issued a summons to all the houses of the Order throughout the world, commanding the knights, one and all, to repair to Rhodes, bringing with them money and supplies of all kinds.

In the course of a long letter, he says:

In the midst of the greatest dangers with which Rhodes is threatened, we have thought that no succour was more to be depended on than a general summons and a speedy assembly of all our brethren. The enemy is at our gates. The proud Mahomet sets no bounds to his ambitious projects; his power becomes more formidable every day; he has an innumerable

66

multitude of soldiers, excellent captains, and immense treasures; all this is designed against us; he is bent upon our destruction, I have the most certain advices of it. His troops are already in motion; the neighbouring provinces are full of them; they are all filing down towards Caria and Lycia; a prodigious number of vessels and galleys wait only for the spring and the return of fine weather, to pass into our island.

What do we wait for? Can you be insensible that foreign succours, which are generally very weak, and always uncertain, are at a distance from us? We have no resource but in our own valour, and we are ruined if we do not save ourselves. The solemn vows that ye have made, my brethren, oblige you to quit all to obey our orders. It is in virtue of these holy promises, made to the God of Heaven, before

His altar, that I now summon you. Return, without losing a moment, into our dominions, or rather, into your own. Hasten, with equal courage and zeal, to the succour of the Order. It is your mother that calls you; it is the tender mother, that has nursed and brought you up in her bosom, that is now in danger.

Is it possible there should be found one single knight unnatural enough to abandon her to the fury of the barbarians? No, my brethren, I have no apprehensions of that kind. Sentiments so mean and impious are not at all agreeable to the nobleness of your extraction, and are still more inconsistent with the piety and valour that you profess!

This letter, despatched to every part of Europe, at once aroused the spirit of the Order. Everywhere the knights set themselves to obey the summons, and to convey to Rhodes a good supply of men and money.

But, as the Grand Master expected, little was done by the Christian princes to aid his cause, which was not so much his as that of Christianity, civilization, and the integrity of the kingdoms of Christendom.

Louis XI. of France alone bestirred himself at all; and the Pope gave his blessing to all who should aid in the defence of Rhodes.

The Sultan was not pleased with these preparations; and as he himself was not yet ready for the attack, he endeavoured to throw the Grand Master off his guard by opening negotiations for peace.

The ambassador chosen for this purpose was a renegade Greek, Demetrius Sophian, one of the many who had unhappily apostatized

from Christ to take service under the successful enemy of his religion.

D'Aubusson, knowing the real secret of the whole scheme, received the envoy with respect, listened with attention to his proposals, and, to gain time to enable his knights to assemble at Rhodes, agreed to a truce and to some commercial relations with the Sultan.

In the meantime the Sultan of Egypt and the Bey of Tunis were almost equally alarmed at the prospect of the conquest of Rhodes by Mahomet.

Though themselves Moslems, they knew well that Mahomet would soon attack them, and take away their independence, if he should succeed in his enterprise against Rhodes,

One after the other, therefore, they sent to the Grand Master to solicit his friendship, and to offer him aid. So that, what the Christian kings of Europe failed to give was actually offered by Mahometan states.

Great numbers of knights had now arrived, and D'Aubusson called a general chapter, and addressed them as follows:—

Generous knights, an occasion has at last presented itself for you to show your zeal and courage against the enemies of the faith.

In this holy war, Jesus Christ Himself will be your leader; He will never, my brethren, abandon those who fight in His service.

In vain does Mahomet, that impious prince, who acknowledges no Deity but his own power, brag that he will extirpate our Order. If he hath more numerous troops than we, they are composed only of a vile set of slaves who are forced into his service, and who expose themselves to death only to avoid a death threatened them by their officers; whereas, I see none in your illustrious body but gentlemen of noble birth, educated in virtue, resolute either to vanquish or to die, and whose piety and valour are sure pledges of victory.

The assembled knights responded bravely to these words, and declared themselves ready to shed their blood for the defence of the Order, and of the Catholic Faith; and then, by a unanimous vote, called upon the Grand Master to undertake the absolute control of the affairs of the Order, setting aside the usual council, and appointing him a sort of Dictator during the coming conflict.

D'Aubusson was most unwilling to accept the honour and respon-sibilities thus thrust upon him; but the assembly was of one mind in the matter, and he had no choice but to undertake the onerous charge laid upon him.

His first step was one that must have given him great pain, and which nothing could justify but the cruel exigencies of war, and the peril to which the Order was exposed.

The island had been brought into the highest state of cultivation under the wise and liberal government of the Order; but now it was laid waste; trees were cut down, crops destroyed, houses and even churches levelled to the ground, lest they should afford shelter and cover to the attacking forces.

Every landing-place was surveyed; walls and forts were built or strengthened, and provision was made for the reception into the city of all those who were deprived of their homes in other parts of the island.

In the meantime, the Sultan was not idle. He no longer thought it worthwhile to conceal his designs, but openly boasted that he intend-ed to capture Rhodes, as it stood in the way of other conquests which his ambition considered essential to the realization of his schemes of glory and greatness.

His plans were seconded, and their attainment aided by his Grand *Vizier*, Misach Paleologus. This man, like many others in the service of the Sultan, was a renegade and an apostate Greek Christian. He was of the family of the late Emperor of Constantinople, and when other prisoners taken at the capture of the city had accepted death rather than the denial of his Lord, this man had readily embraced the doc-trines of Mahomet to save his life.

From this time, he had gradually risen in the service of his new master, and thought he could not ingratiate himself more safely and quickly with him, than by showing himself at all times the cunning and implacable enemy of his former friends and co-religionists.

Through his contrivance, therefore, plans of the fortifications of Rhodes were in the hands of the Sultan before the expedition sailed, and spies were employed, who kept him informed of almost all that went on in the island.

It was by the end of 1479 that the advanced guard of the expedi-tion sailed, and effected a landing in a remote part of the island. They were, however, immediately attacked by some of the knights, and were driven back to their ships with considerable loss.

Palaeologus, who commanded, finding he could do nothing against Rhodes till the main body of the army arrived, employed himself during the next few months in making raids upon the smaller islands which belonged to the Order.

Terrible Cannonade

From shore to shore of either main
The tent is pitched, the Crescent shines
Along the Moslem's leaguering lines;
And the dusk Spahi's bands advance
Beneath each bearded Pacha's glance;
And far and wide as eye can reach
The turbaned cohorts throng the beach;
And there the Arab camel kneels,
And there his steed the Tartar wheels;
The Turcoman hath left his herd.
The sabre round his loins to gird;
And there the volleying thunders pour,
Till waves grow smoother to the roar.
The trench is dug, the cannon's breath
Wings the far hissing globe of death;
Fast whirl the fragments from the wall,
Which crumbles with the ponderous ball;
And from that wall the foe replies,
O'er dusty plain and smoky skies,
With fires that answer fast and well
The summons of the Infidel.

<div align="right">Byron.</div>

On May 23, 1480, the lookout upon the island discerned the Turkish fleet, under sail, making for Rhodes.

There were no less than one hundred and sixty ships of the largest size, besides a countless multitude of smaller vessels of every description. The land forces amounted to 100,000 men, and the expedi-

tion was furnished with all that was necessary for the conduct of the siege.

The city of Rhodes was built on the side of a hill overlooking the sea. It was protected by a double wall all round, which was further strengthened by towers at intervals, and by a deep ditch. There was a double harbour; the first was protected by Fort St. Elmo, the second by two works called St. John and St. Michael. The tower of St. Nicholas also defended another part of the port.

Two miles from the town there was the strong fortress of St. Stephen. It was near this point that the Turks effected a landing, not without opposition and loss; but their numbers were so overwhelming, that while part were engaged, other detachments were disembarked; and so, by degrees, the whole army, and the siege-train of heavy guns, were landed.

The first battery was constructed to attack the Tower of St. Nicholas, and consisted of three heavy guns. To meet this, guns were planted by the besieged. Sallies also were made by the garrison, and sharp skirmishes were fought on the ground between the city and the enemy's camp.

But the besiegers, foreseeing the difficulty they would have in capturing a place so strong, and defended by such well-known and veteran soldiers, determined to use artifice as well as force.

A German engineer, who was in the service of the Sultan, presented himself at the outposts of the knights as a deserter from the Turks. When conducted to the Grand Master, he declared that he was a Christian, and that it was his religion that made him take the first opportunity of escaping from his Moslem masters. He spoke with great freedom of the enormous number of the Turkish troops, the power of their artillery, and of their determination to capture the city at any cost. In order to gain the confidence of the knights, he gave them some information respecting the plan of the attack, and advised them to adopt certain precautions.

Some, however, of the more experienced among the knights maintained that the man was a traitor and a spy, and consequently he was constantly guarded and closely watched. By this means it was gradually discovered that he was trying to communicate with the enemy, and that he had already acted as a spy on several former occasions, and in the end he was executed before he had done much harm.

All this time the attack on Fort St. Nicholas was continued with the greatest vigour. Hundreds of stone shot were hurled against its

walls, which were gradually battered down or shaken, especially on the land side, where they were not so strong as towards the sea.

On the 9th of June, a general attack was made by sea and land. A vast body of troops poured themselves upon the shattered walls, and, by means of ladders, were soon upon the battlements.

But they were not unopposed. The knights were there, headed by the Grand Master in person, and a tremendous hand-to-hand conflict ensued. The Grand Master was wounded in several places; his helmet was knocked off by a shot, but he quietly took that of a common soldier, and continued at his post. The knights entreated him to retire, but he refused, declaring that the post of danger was the post of honour.

The battle was fierce and obstinate, and the greatest bravery was displayed on both sides. At the breach stood the knights, an iron wall bristling with lances and swords; as ladders were placed against the walls, they were seized and hurled backwards, or crushed with masses of stone toppled down upon them; fire, and burning pitch and oil were poured upon the attacking party, who replied with musket shots and flights of arrows, and tried to drag down the defenders with hooks fastened to long ropes; no sooner were gaps made in the ranks, than others rushed forward to take their places.

In the end, however, the besieged retained the advantage, and prevented the enemy from entering the fortress.

The next attack was directed against the city itself, in two places at the same time.

Palaeologus evidently had information as to the weaker portion of the defences, and, therefore, erected batteries which played upon the walls of the Jews' quarter.

Foreseeing that a breach would be made, the grand Master ordered a number of houses to be pulled down, and a deep ditch to be dug on their site; and behind that a new wall was constructed with the greatest rapidity, the work being continued night and day without intermission, knights and civilians, men, women, and children labouring side by side; even the nuns coming from their convent to lend their aid.

The artillery of the Turks, however, not only shattered the walls, but inflicted terrible injury upon the town and its inhabitants. The cannonade was heard distinctly at a distance of one hundred miles.

It was found necessary to remove the women and children to the other side of the town, and to construct retreats for them of huge masses of timber which might protect them from the vertical fire of

the mortars, which threw heavy stone balls into almost every part of the city.

An attempt was made by two spies to procure the assassination of the Grand Master, by promises of great rewards and honours; but the temptation was resisted, and the spies given up to punishment.

The Turkish engineers next constructed a floating bridge, to facilitate a second attack upon Fort St. Nicholas; but, during the night, an English sailor, named Rogers, swam out and cut the cable, so that the bridge drifted away and was lost.

Notwithstanding this, a night attack was made upon the fort with the greatest fury, and with enormous slaughter on both sides; but the defenders were able to keep the enemy from getting possession of the work.

The Turks now seemed to be exhausted with their efforts, or discouraged by their failures and losses, and for three days no further attack was made.

The Grand Master, however, feared that some new design was being prepared, and was ceaseless in his vigilance; and, it is said, that he seemed never to take any sleep, but might be seen at all hours of the day and night, sitting upon his horse reconnoitring, his armour glittering as the sun or the moon shone upon it; giving orders; and superintending the workmen and soldiers, who laboured incessantly to repair or strengthen the battered and crumbling defences.

At this time, some of the knights began to despair of maintaining the defence, and seeing the dilapidated condition of the walls, and the filling up of the ditches by the stones that had fallen from them, proposed that terms of capitulation should be offered to the Turkish commander, lest the place should be taken by assault, with all its terrible consequences.

When this came to the ears of D'Aubusson, his distress and indignation were great. He called together the knights, and addressed them thus:

Gentlemen, if any of you think yourselves not safe in this place, the port is not yet so closely blockaded, but that you may find means to get out." And then he added, with a stern expression and measured tones, "but if any of you think fit to stay with me, speak no more of capitulation; for if you do, your lives shall pay for it.

The resolution of their leader restored the confidence of the wa-

verers, and no more was heard of surrender.

The Turkish general, finding the capture of the place so much more difficult than he expected, himself proposed terms of capitulation. He sent a flag of truce by some officers, urging the Grand Master to save further bloodshed, and to give up the town on honourable terms, rather than expose the inhabitants to the destruction which he declared was inevitable and near.

D'Aubusson replied that he had no thought of surrender, and no fear of capture, and simply declined to consider for a moment any proposal of the enemy.

Soon after this, another and more determined attack was made. Great secrecy was observed, and before the knights were aware of it, a large body of troops was in possession of the walls and outer defences. It was a moment of imminent peril, and demanded all the bravery of the defenders to meet it. The Grand Master immediately marched at the head of the knights to meet the assailants.

A most desperate encounter ensued, in which each side strained every nerve, knowing that everything depended upon the issue of the day. D'Aubusson fought hand to hand with the enemy, and was wounded in several places. The Turkish forces seemed numberless; as soon as one body retired unsuccessful, another came on, and the wearied and wounded knights had to renew the battle with fresh and vigorous enemies. The end, however, was the same as before. The city still held out, though the ranks of the knights were sadly thinned, and the Grand Master himself had to be carried to his bed to be healed of his wounds.

This defeat filled the Turks with despair, and they determined to raise the siege and retire.

It is said that 9000 had been killed, and 15,000 wounded. After three months' fruitless effort, therefore, they embarked in their ships and sailed away, to the great joy of the brave defenders of this outpost of Christendom.

Thanksgivings were offered up in the churches, rewards were liberally distributed to those who had distinguished themselves, and all Europe rejoiced that the bravery and endurance of the Knights of St. John had maintained a bulwark to shelter them from the dreaded yoke of the Mahometan conqueror.

Had Rhodes been taken, Italy would speedily have been overrun. As it was, the city of Otranto was seized and held by the Turks, and if forces had been available, the whole of the long-coveted peninsula,

from the Alps to Sicily, would have become Turkish. What that means we can understand when we see what other fair countries have become under the same circumstances; and we can perhaps imagine what would have been the injury to civilization if Italy, with all its cultivation, had fallen under the blighting sway of the Moslems in the fifteenth century.

' Mahomet was furious when he heard that his army had failed to take Rhodes. He determined, however, to make another attempt, and this time to command in person.

He immediately set about collecting forces, and before long he was at the head of 300,000 men. But his ambitious designs were frustrated by the hand of death. He was seized with illness on his march towards the coast, and died May 3, 1481, almost the last words upon his lips being "Rhodes."

Death of D'Aubusson

O that we now had here
But one ten thousand of those men in England
That do no work today!

Shakespeare.

Mahomet left two sons, Bajazet and Zizim, and they speedily began a civil war for the acquisition of the throne of their father. A long series of battles and intrigues followed, which ended in the defeat of Zizim, who was obliged to flee for his life.

In this extremity, he took the resolution of giving himself up to the Knights of Rhodes, whose honour he knew he could trust. He was accordingly conducted to Rhodes, and was received with consideration by the Grand Master, and suitably entertained.

Bajazet tried by threats and promises to induce the knights to give him up to them, but in vain; and he was sent into France, and afterwards to Rome. where he died; poisoned, as was believed, by the infamous Pope Alexander VI.

This Pontiff, among the many evil deeds of his life, set himself to interfere with the independence of the Order of St. John. Claiming to have the right to dispose of all the dignities of the Order, he appointed his nephew to a commandery in Aragon, although the Grand Master had already nominated an illustrious knight of that province.

D'Aubusson wrote immediately to the King of Aragon to solicit his aid in resisting this attack upon the privileges of the Order; and the king, who depended chiefly upon the knights in his wars with the Moors, readily lent him his assistance. Accordingly, he wrote to the Pope, representing that there was no state in Christendom but held the Knights of Rhodes in veneration; that they were the defenders of

all Christians who sailed upon the Mediterranean; that they protected and conducted pilgrims to the Holy Land; that they used their wealth and power solely to defend Christendom against the Turks; that they spent their revenue, their blood, and their lives in these services; that many knights had already died in battle, and many more were wounded; that it was in consideration of and by way of acknowledgment for these important services that most of the sovereigns of Christendom had given estates to the Order, and that they would not sit still while these possessions, which had been acquired by so many fatigues and dangers, were alienated from their rightful owners, and given away to strangers.

These remonstrances convinced the Pope that he had gone too far, and he made what amends ho could by nominating the Grand Master general of the army which had just been raised by the Emperor, the Venetians, and some other powers, to oppose the onward march of the Turks.

Little came of this league: the Venetians shortly concluded a peace, on their own account, with the Sultan; international wars called the other armaments home; and, in the end, the knights found themselves, as they had so often been before, left alone to defend the frontiers of Christendom from its deadly foe,

D'Aubusson, being relieved from the pressure of an enemy at his gates, turned his attention to the internal discipline of his Order, which the troublous times had somewhat relaxed.

He revived the ancient strictness in respect of clothing, ornaments, and eating, and had the happiness to find that the old spirit of the Order still existed, and that his reforms were welcomed and thoroughly carried out.

But the end of this great man was drawing near. He had governed the Order for an unusually long period, and had brought it through most perilous times with safety and honour; and now the weight of eighty years, and the toils of an active and anxious life, brought him to his well-earned rest.

Feeling his end approaching, he called the knights about his bed, and earnestly pressed upon them to adhere to the true and fundamental principles of their Order; to avoid luxury and internal jealousies; to keep up their warfare for Christ; and to befriend the poor and defenceless.

"Thus died," says Vertot, "at above eighty years of age, Peter D'Aubusson, Grand Master of the Order of St. John of Jerusalem, one

of the greatest captains of his age; a man revered by all the princes who lived in his time; the darling and delight of his knights; the father of the poor; the redeemer of Rhodes, the sword and buckler of Christendom; as eminently distinguished by his unfeigned piety as by his singular valour."

The funeral was conducted with the greatest pomp; but the evident sorrow of all classes was his truest honour.

The death of D'Aubusson, 1503, was the signal for fresh energy on the part of Bajazet. His navy was constantly making attacks upon the islands belonging to the Order, but no great successes were obtained; indeed, the power of the Turks made no advance during his reign, and they received one important reverse in the loss of Otranto, the only place they could ever hold in Italy, which was stormed and taken by the Duke of Calabria.

Many worthy exploits were performed by the Knights of the Order. The Turks frequently landed upon some of their islands to cut timber for their navy, and many battles ensued.

The island of Leros was thus attacked during the illness of the governor, an old knight. In this crisis the command devolved upon a young knight only eighteen years old, named Paul Simeoni, who had scarcely any soldiers in the castle.

He determined, nevertheless, not to surrender, and had recourse to a stratagem to deceive the enemy as to the real strength of the garrison.

He caused the fishermen and peasants of the island, and even their wives, to be dressed in the cloak of the knights with its white cross, and marshalled them upon the battlements, in sight of the enemy, who, astonished at the apparent strength of the defenders of so small a place, thought it prudent to retire.

On another occasion, two ships of an Egyptian squadron, having outsailed their companions, were surprised and taken by some galleys of the Order. The rest of the Egyptian vessels being still out of sight, the captured ships were manned and armed, and made to lay to, and wait for the others to come up. This they presently did, having no suspicion that their consorts had in the meantime changed hands. Then other vessels of the knights came out from their hiding-places, and the whole fleet fell an easy prey to them.

It had been a custom for many years for a very large ship to be despatched annually from Alexandria to Constantinople, with a valuable cargo of silks, spices, and other merchandise. This ship was so enor-

mous that the top of the masts of ordinary vessels only reached to its deck, and it required the united arms of six men to clasp its mainmast. It was manned with a thousand men, and carried one hundred guns.

Several attempts had been made by the galleys of the Order to take this magnificent prize; but she had always proved too strong, and seemed invincible.

The Chevalier de Gastineau, commander of Limoges, resolved once more to make the attempt. By the skilful manoeuvring of his ship, he managed to rake the decks of the enormous vessel, and by a sudden and well-directed fire killed the captain and so many of the crew that a panic seized the rest, and they surrendered. An enormous amount of treasure and costly merchandise fell into the hands of the captors, which was spent chiefly in strengthening the fortifications of Rhodes. The huge vessel itself was added to the navy of the Order, and did much good service, especially in an engagement with the whole Egyptian fleet, off Cyprus, when fifteen ships were taken and the rest sunk.

In the meantime, Bajazet had died, and had been succeeded by Selim, who, though the youngest of his three sons, had managed, by persuasion and artifice, to secure his appointment as Sultan, and to get rid of his brothers and nephews by poison and assassination. No sooner was he seated on the throne than he commenced a career of conquest. In less than four years, he invaded and subdued Persia, Egypt, Syria, and a great part of Arabia. He then returned to Constantinople, much elated with his victories, and immediately subjected the unhappy Christians there, who had hitherto been barely tolerated, to fresh exactions and indignities. Every church was taken from them and turned into a mosque, and they were only allowed to meet for worship in temporary wooden buildings.

Death put an end to his further schemes, in 1520. His only son, Solyman II., succeeded him at the age of only twenty years; but by his energy and the glory of his reign, soon earned for himself the title of "the Magnificent." At the beginning of his reign the Mameluke princes, who had been deposed from the government of Egypt by Selim, after holding possession of it for upwards of two hundred years, made a determined effort to regain their power, and sought the assistance of the Knights of Rhodes against Solyman.

The war continued for some time, but in the end the Turks were victorious; and Solyman determined to punish the Order by driving them from Rhodes.

Indeed, he had inherited this task from his father, who had strictly enjoined him before his death to undertake this and the capture of Belgrade.

Solyman set himself to effect the latter first. He marched with a large army and laid siege to Belgrade. The knights, knowing the importance of the place as an outpost of Europe, in accordance with the spirit of their Order, joined in the defence of the place.

The other Christian powers, as usual, were inert, or occupied in their own disputes and wars, and no aid came to the beleaguered garrison, so that, in August, 1521, this great Christian city fell into the hands of the Turks; its inhabitants were massacred or enslaved; and its churches turned into mosques. Thus another important post was lost to Christendom, and added to the vast dominions of the Mahometan power; to the dismay of all thoughtful men in Europe, who saw the Crescent ever advancing and swallowing up the hard-earned conquests of the Cross, and trembled as they looked on to what seemed to be coming in the inevitable future.

It was evident that no reliance could be placed on Princes and Emperors for the common defence of Christendom, since their own private affairs were always found to interest them more.

Thus the Emperor Charles V. allowed Belgrade to fall without a single effort to save it, though its capture opened a passage for the Turks into the hereditary dominions of his family, rather than make peace with the King of France, or draw any detachment from his armies in the field against that prince, to send to the succour of his ally, the King of Hungary.

A vacancy having occurred in the Grand Mastership, Philip de Villiers de L'Isle Adam, was elected, January, 1521.

This appointment was entirely agreeable to the vast majority of the knights, and his subsequent noble career fully justified their choice.

But, unhappily, there was one knight to whom the election was not only distasteful, but the sad cause of odious treachery, hitherto unknown in the history of the Order. Andrew d'Amaral, Chancellor of the Order and Grand Prior of Castile, not only considered that his rank and past services entitled him to look for the post of Grand Master, but some disagreements that had on a former occasion taken place between him and L'Isle Adam, made the election of the latter intolerably galling to him. He was heard to declare that he should be the last Grand Master of Rhodes; and, in revenge for his own disappointment and wounded pride, he secretly set himself to compass the

downfall of the whole Order.

He commenced a traitorous correspondence with the Turks, in which he informed them of the weakest part of the defences, which were just then under repair, and strongly urged that an expedition should be immediately despatched, promising to aid it from within the city.

In the meantime, a curious correspondence was taking place between Solyman and the Grand Master. The former made loud professions of respect and peace, while, at the same time, he boasted of his capture of Belgrade, and intimated that those who did not submit to his sway would in like manner fall before his arms.

But no one was deceived as to his real intentions; all the world knew that he intended to attack Rhodes, and that he was only waiting to do so till his armaments were complete.

The Grand Master strained every nerve to prepare for the coming conflict. As on the occasion of the former siege forty years before, the country districts of the island were laid waste, and all buildings were pulled down. The fortifications were strengthened, stores were laid in, troops were enlisted, and the older knights were appointed to posts of trust and importance.

Among these, unfortunately, was D'Amaral, whose treachery was still unsuspected, and who, it is said, used his office to prevent the laying in of a sufficient store of gunpowder, the want of which ultimately led to the loss of the city. He nearly succeeded, also, in preventing the purchase of provisions, representing that the stores were sufficient; but this was investigated, and the required supplies were obtained in time.

As on former occasions, urgent entreaties for aid were sent to the various Christian kings, but as usual without success. Charles V. and Francis I. were still at war, and the rest were looking on, waiting to gain some advantage for themselves; and no one could spare men or money for the defence of Rhodes.

The Order was, however, fortunate in enlisting the co-operation of Gabriel Martinengo, a Venetian engineer of great ability. He offered his services as a volunteer, but his government refused to allow him to leave the country. He contrived, notwithstanding, to escape in disguise, and was received with great joy at Rhodes, where the Grand Master immediately placed the works that were in progress on the fortifications under his superintendence.

During his residence at Rhodes he was much struck with the or-

der, discipline, and devotion of the knights, who were preparing themselves for the coming siege, and for possible death, by constant attendance upon the ordinances of religion. These things made so deep an impression upon him that he solicited admission into the Order. With the consent of the knights, he was elected, and joined their ranks at a time when they sorely needed brave and true men.

A misunderstanding unhappily occurred at this critical time between the Grand Master and the Knights of the Italian *Lange*. The Pope had again been interfering with the appointments to commanderies in Italy, and the Italian knights desired to go in a body to the Pope, to represent to him the injustice of this invasion of their rights. The Grand Master, however, was unwilling that any of the Order should leave Rhodes at a time when it might be attacked any day by the Sultan. The Italian knights resented this, stirred up, it is said, by the traitor D'Amaral; and finally left, in opposition to the orders of the Grand Master, and sailed to Candia.

Upon this the council met, and separated all the disobedient knights from the Order. On hearing of this the Italians repented, and returning to Rhodes acknowledged their insubordination, and were readmitted.

Other vexations occurred to distress and perplex the councils of the Order. Not only were the various European kings and the Pope unwilling to send material aid to the defence of Rhodes, but they contrived to throw difficulties in the way of the commanders and bailiffs of the Order in their respective countries when they desired to furnish their contingent in compliance with the orders of the Grand Master. So it was, therefore, that there were in Rhodes no more than six hundred knights, and about four thousand five hundred soldiers, to meet the overwhelming forces of the Turks.

The townsmen, however, were drilled, and duties assigned to them; the peasants were employed as labourers; mills were repaired, ovens built; the port was protected by new chains, one at its mouth, another further in. Several ships, laden with stones, were sunk at the entrance of the bay, and new guns were put into position upon the ramparts and batteries.

What D'Aubusson had been in the former siege, that L'Isle Adam was found to be in this second time of danger and difficulty; so vigorous was the Order after many hundred years of existence, and so capable was it of producing fit men to carry out its principles and do its work, whenever occasion required.

Chapter 12

Conviction and Execution of D'Amarel

This day hath made
Much work for tears in many an English mother,
Whose sons lie scattered on the bleeding ground.
Many a widow's husband grovelling lies,
Coldly embracing the discoloured earth.

<div align="right">Shakespeare.</div>

The city of Rhodes at this time was divided into two parts; the higher town containing the residence of the Grand Master, the convent of the Order, and the houses of the several *Langes*; and the lower town belonging to the secular population. The whole formed a sort of crescent of buildings, standing upon the slope of the hills of a bay, and reaching down to the shore.

There were two ports. At the entrance of the larger stood the Tower of St. Nicholas, a strong work, well provided with artillery of a large size, joined to a bastion towards the city, and connected with it by a curtain which protected one side of the harbour.

On the other side was the Castle of St. Angelo, at about one hundred yards distant from the former,, and built upon the rocks where, it is said, the famous Colossus had formerly stood.

There was also a bastion connected with this fortress, mounted with nine guns, whose fire completely covered the entrance to the harbour.

The smaller port was naturally protected by rocks that ran out from the shore, and artificially by the Castle of St. Elmo, and by a chain drawn across its narrow mouth, which only one ship could pass

at a time.

There was also a tower with a ditch and three cannon directed towards the entrance.

There were many churches in the city, the principal of which was that of St. John, a magnificent building, enriched with most costly decorations, and conspicuous from afar by its lofty steeple. This church still exists; but its ornamentation has all been, destroyed, and it is used as a mosque. Many of the houses of the knights and other public buildings also remain nearly as they were, bearing still the coats of arms of their noble occupants.

Thus Rhodes stood one of the finest cities of the east, surrounded by a double, or as some say, a triple line of fortifications, strengthened at intervals with thirteen large towers; and outside all was a deep ditch, while at all points were batteries commanding the approach on every side.

The names are preserved of those who were entrusted with the command of the fortresses of the respective *Langes*, Nicholas Hussey being the English knight; the Grand Master himself taking the command of the weakest, and leaving his palace to reside in this post of danger. There were also four knights called adjutant-captains, to whom were entrusted reserve forces, which were to move to the support of any part that needed assistance; the first of these being D'Amaral, who had as yet successfully concealed his treachery, and was not suspected by any.

At this time a letter was received from the Sultan in which he said:

The continual robberies with which you infest our faithful subjects, and the insults you offer to our Imperial Majesty, oblige us to require you to deliver up to us immediately the island and fortress of Rhodes. If you do it readily, we swear by the God who made heaven and earth, by the six and twenty thousand prophets, and the four *musaphi* that fell from heaven, and by our great prophet Mahomet, that you shall have free liberty to go out of the island, and the inhabitants to stay there, without the least injury being done to you; but if you do not submit immediately to our orders, you shall be all cut to pieces with our terrible sword; and the towers, bastions, and walls of Rhodes shall be laid level with the grass that grows at the foot of all those fortifications.

This letter was read in a full assembly of the Order, and it was unanimously resolved to send no answer.

In the meantime the Greek and Latin bishops, who were in perfect harmony, exhorted the faithful of their respective communions to give themselves to fasting and prayer; and special services and processions were organized to seek the help of God in the approaching distress; in all of which the Grand Master took part, setting an example to all in his piety, as he did also by his courage and untiring exertions.

It was on June 26, 1522, that the Turkish fleet came in sight.

The feast of St. John Baptist, June 24, was always kept with great devotion by the Order and the people of Rhodes, and its services were continued for some days. The people were at church, therefore, when tidings came of the enemy's approach. The Grand Master having joined in the service, briefly addressed the assembled multitude, and then dismissed all to the stern duties that now devolved upon them.

The following description is given by an anonymous writer of the subsequent events of that memorable day:—

As the Grand Master returned to his palace, word was brought him that the enemy's fleet was close at hand. He heard the news with his usual tranquillity, and only ordered the city gates to be closed.

An hour afterwards the palace gates were thrown open, and there rode out a brilliant and gallant train. Many knights in armour and scarlet surcoats, the three standards floating over their heads, each borne by chosen men, to whom they had been solemnly delivered in charge; and one, whereon the white cross was quartered with the arms of the Grand Master, was carried by a young Englishman, who found an early death at the very beginning of the siege.

L'Isle Adam, in golden armour, was at their head; and as the procession came along, and the trumpets sounded with a loud triumphant flourish, such a thrill of glad and glorious enthusiasm stirred through the crowd as banished fear; and they rushed to window and terraced roof, to watch the coming of the Turkish fleet, and almost to welcome its advance.

What a magnificent spectacle! In the streets below, that gorgeous chivalric procession, the finest steeds, and the brightest armour, and the gallantest hearts in Christendom! Suddenly, and as though by some preconcerted signal, on every rampart

and battlemented wall, from the inns of the various Languages, and all the posts of separate command, there wave a thousand flags. Each nation has its own proud ensign and its own representative among the Knights of Rhodes.

There you may see the golden lilies of France, floating not far from the royal lions of England; there is the plain cross of Savoy, first borne in honour of the Order; there are the white flag of Portugal, and the time-honoured banners of Castile and Auvergne; and you may know that beneath the silken folds of each are posted brave and gallant hearts, who will add fresh glory to their old renown. Look out over the port to the tower of St. Nicholas, the key of Rhodes; twenty Provençal knights are there, claiming, as Provence ever would, the post of danger and glory.

The rest of the French you may distinguish, drawn up with admirable regularity from the tower of France, to the Ambrosian Gate; and thence to the Gate of St. George, stand the Germans—you may tell them by the Imperial standard. Spain and England stand together; the banner of the Turcopolier, Sir John Buck, waves out over their heads; only nineteen English are there, but every man is a hero, and ready for a hero's death. The Grand Master will head them himself; for it is thought the English bastion will bear the hardest brunt; but his ordinary post of command, when not in action, will be opposite the Church of our Lady of Victories.

It stands below you, a stately and noble building; but Rhodes has many such, though none equal to St. John's, whose delicate tapering spire, 'buried in air, and looking to the sky, the deep blue sky' of Rhodes, catches the eye when you are miles off at sea, and seems to place the glittering cross that crests its summit half way 'twixt earth and heaven.

If you watch you may see the four chief Grand Crosses, and their companies of relief, as they are termed, going the rounds of the ramparts. There is an hourly inspection of the defences day and night; and when the Grand Crosses are not there, six hundred men take it by turns to make the circuit, under two French and two Spanish knights.

All this you may see as you look clown upon the city. But glance over the ocean, and another spectacle awaits you—the blue line of the Levant, sparkling in the summer sunshine, and kissed into

life and motion by a northern breeze, and on its heaving bright expanse three hundred Turkish sail, gathered from every coast that owns the Ottoman rule—from Egypt, Syria, and every part of Asia—and having on board, in addition to the regular crews, 8000 chosen soldiers, and 2000 pioneers; whilst 100,000 men, under Solyman himself, are advancing along the western coast of Asia Minor.

Alas for Rhodes, and its 6000 defenders! We may well be pardoned this glance at her as she stands in the last hour of her power and beauty. The 26th of June sees her indeed magnificent to the eye, and in all the pomp and pride of chivalry, and warlike show, but soon that gay and martial music will be exchanged for the thunder of artillery, and those battlemented bannered walls will be crumbling to the dust.

The Turks were fully occupied for some days in landing the troops, artillery, and ammunition, and then further time was spent in deciding upon the best method of attack. But foraging parties were sent out and returned much disappointed, with no supplies, and the report that the country was absolutely denuded of everything, and that parties of the enemy were posted in every direction to watch their movements, and attack them if they ventured far.

This was serious intelligence to the Turks, who had relied upon victualling their soldiers with the supplies of the island, and had consequently brought but little provision.

This soon became known, and a mutinous spirit began to manifest itself among the troops, so that the officers were obliged to hurry on the attack with all possible speed. Trenches and approaches were accordingly made, and guns got into position, but no sooner did they open lire than the batteries of the city dismounted and silenced them, and the sallies of the besieged made havoc among the occupants of the trenches.

But treachery nearly accomplished what mere force failed to do. There was a Turkish slave in Rhodes who conceived the idea of aiding her countrymen by setting fire to the city. She communicated her scheme to others, and managed to let the Turkish general know of it, and arranged with him to set fire to the city in several places at the same time that an attack should be made from without. Happily, however, the plot was discovered, and the authors of it punished before the mischief was accomplished.

Solyman was kept well informed of all that occurred, and hear-

ing these reports of mutiny and failure, determined to go to Rhodes himself, and appear suddenly in the midst of the army.

This he did, surrounded by a large body of well-seasoned troops upon whom he could thoroughly rely.

Next day he caused a throne to be erected, and seating himself upon it, commanded his guards to surround the mutinous regiments and disarm them.

He sat in grim and frowning silence for some time, during which the prisoners momentarily expected the order for decimation or general slaughter.

At last breaking silence, he said:

Were I to have addressed myself to soldiers, I would have caused you to appear before me with your arms; but since I am forced to direct my discourse to wretched slaves, weaker and more faint-hearted than women, and who cannot stand before the mere shouts of their enemies, it is not fitting that such cowards should dishonour our arms and the characteristics of valour.

I would gladly know if upon landing in this island you flattered yourselves that the knights would prove greater cowards than yourselves, and in a dread of your arms would bring you their own, and come in a servile manner to offer their hands and feet to the irons with which you should be pleased to load them.

In order to cure you and undeceive you of such a ridiculous mistake, know that in the person of these knights, we are to fight with the flower of the Christian world, with brave men trained up from their infancy in the profession of arms; we are to fight with cruel and fierce lions, greedy of the blood of Mussulmen, and who will not quit their haunt but to a superior force.

It is their courage which has excited our own. I imagined that in attacking them I should meet with an enterprise and dangers that were worthy of my valour; and is it from you, base and effeminate soldiers, that I am to expect a conquest?—you that are flying from the enemy before you have looked him in the face, and who would have deserted but for the sea that encompasses you?

But before such a disgrace shall happen to me, I am resolved to exercise such exemplary justice on the cowards, that the severity of their punishment shall keep such in their duty as might be tempted to imitate them.

He then ordered his guards to draw their swords. Upon this the unhappy mutineers fell upon their knees, and begged hard for mercy; the generals also drew near to the Sultan, and declared that these men had hitherto been brave and had never failed in their duty, and that they would answer with their heads for their good conduct in the future.

After much entreaty, and great appearance of reluctance, Solyman then said to the officers,:

> I suspend at your request the punishment of the guilty; but let. them go and seek their pardon in the bastions and upon the bulwarks of our enemies.

This show of severity and clemency had a great effect, and an entire change manifested itself at once in the operations of the besiegers. The trenches were advanced by relays of men working without intermission night and day, while the fire of the batteries was kept up incessantly.

Finding his approaches overlooked by the great height of the steeple of St. John's Church, Solyman directed the fire of one of his batteries against ii, till it was destroyed; and in order further to increase the effect of his artillery, he caused two great mounds to be raised upon which to plant his guns, disregarding the terrible slaughter that occurred every day, as his men were obliged to expose themselves without any protection to the guns of the city, while they carried the earth, stones, and timber to form these works. The vast army at his command rendered him reckless, while the knights found themselves obliged to discontinue their sallies, because of the losses which they entailed upon their limited forces. The attack upon Fort St. Nicholas was altogether unsuccessful; the rocky nature of the ground making it impossible to approach by trenches, and the damage to the walls being repaired by the defenders as fast as it was made.

A terrible difficulty, already alluded to, began now to manifest itself; the stock of gunpowder was found to be running low, and it was found necessary to use it sparingly. The Turkish mines also were found to have been extended not only under the walls, but actually into the city itself, and serious breaches were made in the walls by the springing of some of them which Martinengo had not discovered and countermined.

The Grand Master was at vespers when an explosion occurred; the choir, indeed, was just chanting the response, "God, make speed to

help us!" L'Isle Adam said quietly to the knights near him, "I accept the omen; let us go, my brethren, and exchange the sacrifice of our praises for that of our lives;" and he rose from his knees, and, armed as he always was, led the way to the breach.

It was time he was there. The Turks were already swarming in; a tremendous hand-to-hand fight ensued which lasted some hours, during which no less than three thousand Turks were slain, and the Christians sustained serious and irreparable losses.

Another tremendous attack was made in the night of September 13, with similar results; and on September 17, a still more formidable assault took place, when the attention of the besieged was divided by a double attack of two forces at the same time.

But, though it cost the knights dearly, they always managed to beat back the enemy at last; and in every engagement L'Isle Adam was in the thickest of the fight, general and combatant at once; indeed, his enemies declared that "he was in every place at the same time," and wherever he was, their efforts were always unsuccessful. Another traitor was discovered at this time. A Jew was caught sending messages into the enemy's camp attached to arrows.

On September 24, the most severe and dangerous attack that had yet been made was effected. The whole Turkish army moved to the front and, after a fierce cannonade, rushed upon the city from every side.

The scene that followed is thus described by the writer already quoted:

On they come under cover of a shower of arrows and the fire of their side batteries; they reach the walls, and are received by hissing streams of boiling oil, and fireballs that fill the air with a thick and noisome smoke. The bastions of England, Provence, Spain, and Italy are the quarters of attack; but the bloodiest fight is on that of England, and thither the Grand Master hastens, his presence in itself being like a very host of succour.

The scaling-ladders are thrown down, and the ditch below is choked with prostrate Turks; the cannon are pointed at the dense masses, which they rend and tear with a terrible carnage; charge after charge is made by the maddened infidels, but the English will not yield; priests, monks, even children, join in the defence, and tiny hands may be seen hurling stones and sticks upon the advancing stormers with an audacity which nothing will appal. All about the town the women may be seen running

from bastion to bastion, carrying water to the wounded, whom they even bear off upon their shoulders.

At one time forty Turkish standards are waving on the ramparts; but in a moment they are torn down, and the cross is planted in their room. The assault is repulsed from England, and the cry is now, 'Spain! Spain!' Glancing in the direction of the Spanish bastion, L'Isle Adam sees the green flag and the crescent of the infidels on the topmost summit of the walls.

In a moment he is on the spot. 'Auvergne to the rescue!' rings from the ranks of the French, as the Grand Master stands among his countrymen and with his own hands points the cannon of that bastion down upon the breach of Spain. The Turks dare not advance to secure their victory; and in another moment the Commander de Bourbon, at the head of the French chivalry, is on the platform, and his knights are seen tearing down the colours, and clearing the ground at the point of their swords.

But the Aga of the *Janizaries*, who leads on that spot, is not to be so easily repulsed; he rallies his men, and charges through the thick of the fire with mad impetuosity, when he is met by L'Isle Adam and his guards, and a conflict ensues, so long and desperate, that far out to sea the blue waters are dyed with streams of blood, and the breach of Spain becomes a heap of dead and dying.

Six hours it lasted; and then a reinforcement from St. Nicholas decided the day in favour of the Cross. Solyman himself was compelled to give the signal for retreat; and the masses of his troops fell back broken and disordered, leaving 20,000 corpses on those unconquerable walls.

Solyman, like a true oriental despot, ordered the immediate execution of the officers who had conducted the attack, and determined to abandon the siege, and some of the baggage was even put on board the ships. His spies, however, brought him word that the walls of the city were utterly ruined; that there was scarcity of ammunition; and that the place could not hold out much longer.

It is believed that the traitor D'Amaral supplied similar information, and Solyman determined to sit down before the city to starve and weary the garrison into surrender. Mining was continued, and frequent encounters occurred; in one of which Martinengo the engineer, who had so ably conducted the defence, received a wound in the eye which incapacitated him from attending to his duties.

L'Isle Adam immediately sent the wounded man to his own palace, and took upon himself his duties, never leaving the fortifications, and only getting a little sleep upon a mattress under the walls.

In the month of October suspicion fell for the first time upon D'Amaral; one of his servants being caught in the act of sending a message to the enemy tied to an arrow. DAmaral was arrested, tried, and executed; though to the last he protested that he was innocent.

CHAPTER 13

The Order Suppressed in England

De tons les ordres qui prirent naissance a l'occasion des guerries de la Terre Sainte, celui de St. Jean est le seul qui, conservant l'esprit de sa première institution, a toujours continué depuis à défendre la religion.—Henault.

The eyes of all Europe were now upon Rhodes. This second siege had rivalled the first in its duration, in the terrible slaughter of the besiegers, and in the suffering and constancy of the besieged.

It was hoped that the Turks would retire a second time baffled and disappointed, and there is little doubt that it would have been so if reinforcements had been sent from Europe, But the Emperor was still employing all his forces to subdue France, and France required all hers to defend herself. The Pope made a show of sending help; but ultimately changed his mind. Some French knights of the Order were on their way, but were wrecked in a storm and never arrived, A similar fate befell the English knights under Sir Thomas de Newport, and the Spanish contingent fell in with a Turkish fleet and were so roughly handled that they too were of no use to Rhodes.

The Grand Master therefore and his faithful band, who had survived the six months' siege, were left alone.

Solyman now endeavoured to persuade or intimidate the garrison into surrender. He sent threatening messages that the town, if taken by assault, should be given up to pillage, and everyone knew by this time what horrors the Turks were capable of perpetrating upon those who were at their mercy. The townspeople also began to petition L'Isle Adam to come to terms on account of their present miseries, and of the greater and more terrible calamities which they feared for themselves and their wives and children, if the enemy succeeded in capturing the city by storm. This was no longer improbable; everywhere

the walls were broken down, breached, and weakened, and there were places on all sides where a surprise might enable the enemy to walk straight into the city.

The Grand Master, however, stood firm. He declared that his Order must fight and not make terms with the enemies of Christ; that he was ready to die at his post, but would not surrender.

The people nevertheless continued to plead with him day by day, till he was obliged to call the Grand Council together, and consider the question of capitulation. His knights were of one mind with him as to their duty, and were ready to sacrifice themselves; but they represented to the Grand Master that there was another question to be considered—whether they had a right to abandon their subjects to the cruelties that awaited them, if they themselves fell and could no longer defend them.

It was finally determined that if the Sultan offered honourable terms, they should be accepted.

Soon after, on December 10, proposals were received, but no agreement was come to, and hostilities were renewed. But finally, after one or two other unsuccessful attempts, a treaty was drawn up and signed. By this it was arranged that the city should be delivered up on the following conditions: that the churches should not be desecrated; that no children should be taken from their parents to be made *Janizaries*; that the Christians should enjoy the free exercise of their religion, and should be exempt from all taxation for five years; that all who chose to leave the island should have liberty to do so; that vessels should be furnished them by the Turks, if necessary; that twelve days should be allowed for embarkation; that all relics, church vessels, and ornaments, all the records and documents of the Order, and a sufficient number of cannon for the defence of the ships should be taken away; that the main body of the Turkish army should be removed to a distance till the evacuation had been completed, and only a body of *Janizaries* should occupy the city.

The Grand Master gave twenty-five knights as hostages during the execution of the treaty, and, after some hesitation, agreed to visit the sultan as he had demanded. He was kept waiting nearly a whole day in cold and snow, but at last admitted to Solyman's presence, where his noble bearing commanded respect. The Sultan gazed earnestly and silently at him for some time, and then beckoned him nearer, and consoled him for the misfortune that had overtaken him; and, finally, offered him the highest honours and dignities if he would enter upon

his service.

This, of course, the Grand Master firmly but respectfully told him was impossible; but he asked that time might be granted to the people to effect their peaceable departure.

When he took his leave, Solyman expressed his warm admiration for this great man, adding, "I cannot help being concerned, that I force this Christian at his age to go out of his house," and further spoke, with bitter contempt, of the Christian kings who had left this noble soldier without aid in his extremity. Never before had a Christian city received such favourable terms on its capitulation to the Turks as Rhodes received from Solyman, and they were doubtless granted out of that prince's admiration for the character of L'Isle Adam.

On January 1, 1523, the Grand Master and his followers, numbering nearly five thousand, embarked and quitted Rhodes for ever; the Order having held It for two hundred and twenty years.

The homeless fugitives were scarcely at sea before they were overwhelmed by a tremendous storm which scattered the fleet, and dismasted many of the vessels. They put into Candia, where the Grand blaster, to his great indignation, found a fleet of Venetian ships whose commanders had remained inert when they might have saved Rhodes, if they had come to its relief. After refitting his vessels he sailed to Messina where there was a convent of the Order.

Arrived there, "the Grand Master's first care," says Vertot, "was to provide lodging for the knights that were sick and wounded. He waited on them himself, assisted by the knights that were left unhurt.

"It was indeed a moving sight to see these men, who used to appear so terrible with their weapons in their hands, now animated only by a spirit of charity, devoting themselves to the meanest services, carrying broth to the sick, making their beds, and showing a disregard to everything but what might contribute to their relief and recovery."

His next duty was to summon a general council to inquire into the conduct of those knights who had not presented themselves at Rhodes in obedience to his orders. A strict scrutiny was instituted, but in the end, everyone seems to have given good and satisfactory reasons for his absence, and the Grand Master expressed his satisfaction with the result by saying, "God be forever praised, who in our common misfortune has given me the satisfaction of knowing that no one can ascribe the cause of it to the negligence of any of my brethren of the Order."

Shortly after this the plague broke out at Messina, and several of

the knights who had escaped the dangers of the siege at Rhodes fell victims to this terrible malady. The Grand Master, therefore, once more embarked, and landing near Naples, he formed a camp on the shore, where the sick soon recovered. He then went to Rome to confer with Pope Adrian VI., and was received with great honour. But the Pope soon afterwards died, and was succeeded by Clement VII,, who was one of the Medici family, and had at one time been a member of the Order of St. John. By this Pope's permission the Grand Master took up his abode for a time in the Papal city of Viterbo, 1524, and began to search for a new home for himself and his Order. Several places were thought of—Candia, Cerigo, Elba, Malta, and Tripoli. Objections, political or otherwise, presented themselves in every case; and, finally, the choice seemed to be confined to the two last.

Commissioners were sent therefore to examine the capabilities of these places, and to report to the Grand Master. In due time their report was received, and was found not to be very encouraging.

Vertot gives the following as the substance of it as regards Malta:

"The island," they said, "was only one continued rock of sandy stone, and might be about six or seven leagues long, three or four broad at most, and about twenty in circumference; that, upon the surface of this rock, there was not, at most, above three or four feet of earth, and that too, all stony, a soil altogether unfit to produce wheat and other corn; but that it abounded in figs, melons, and other fruits; that if they excepted a few springs, which they met with in the further part of the island, there was no such thing as spring water, nor indeed any well, so that the inhabitants were forced to supply that defect by cisterns; that there was the like scarcity of wood, so that they sold it by the pound, and that the inhabitants were forced to make use of cow-dung dried in the sun, or else of wild thistles to dress their meat; that the capital city was seated upon a hill in the midst of the island, and was of difficult access, by reason of the rocks that covered all the plain round about; that upon the south side of the island, there were neither ports, nor bays, nor roads, and that all the shore in that part was lined with vast rocks, against which ships, when caught in a storm, were often dashed to pieces; but that they discovered several points or capes on the opposite side, and places that formed a sort of road very proper to anchor in; that, besides the capital, there were about forty hamlets scattered up and down the country, and about 12,000 inhabitants,

who were most of them poor and miserable by reason of the barrenness of the soil.

"As for the island of Gozo, they said, it was separated from that of Malta by a narrow channel; that it was about eight leagues in circumference, three long, and one and a half broad; that they could find no port in it; that it was all surrounded by craggy rocks, so that there was no landing but with great difficulty; that however the soil seemed to be very fruitful; that there were about five thousand persons in it, who for their security against the *corsairs*, had built a castle situated on a hill, but that it was ill fortified, and of very little consequence."

The report with respect to Tripoli was still more unfavourable. The commissioners said that the place was seated on the coast of Barbary and had no fortifications about it; that it was almost impossible to raise any there because of the sandy soil and bottom full of water; that the fort and castle were commanded by a hill adjoining; that the place was surrounded by the territories of the King of Tunis who would not suffer the Christians to continue there long; and that corn was still scarcer than at Malta, by reason of the barrenness of the soil, which bore nothing but dates. From all which they concluded that if they undertook the defence of the place, they would be exposed to lose all the knights they might put in garrison there.

In the meantime the affairs of the Order were falling into confusion for want of a centre of government. Henry VIII. of England, on the plea that the Order had ceased to exist after the loss of Rhodes, took possession of the Commanderies in his kingdom; and a similar course was followed by the King of Portugal.

The Emperor Charles V. was flushed with his victories over Francis I. of France, whom he retained as a close prisoner, and paid scant attention to the petitions of the Grand Master,

The Pope was suspicious of the Emperor, and was full of apprehension of an invasion of his dominions.

But the patience and energy of the veteran L'Isle Adam were as serviceable in the midst of these troubles as they had been in the horrors of the siege of Rhodes.

In spite of the growing infirmities of age, he visited England, Portugal, Spain, and Rome, and everywhere, by his narration of the deeds of the past, and the simple majesty of his presence, restored the ancient respect and confidence which the Order had enjoyed for so many centuries.

And, indeed, the events of the times needed a wise head and a strong hand to guide the counsels of the Order.

Charles V. made war on the Pope, and held him prisoner just as he had done to Francis I. The French knights were thoroughly suspicious of the Emperor, and were averse to accepting Malta through his hands, while the Spanish knights were at one with the Emperor, and were anxious to enter upon the occupation of the island. Many knights were altogether opposed to the idea of settling at Malta, and urged that an attempt should be made to recover Rhodes.

Added to all these diversities of opinion, the constant wars between the kings of Europe rendered it impossible for the Grand Master to obtain supplies of men and money to carry out his plans; and it seemed as if the glory of the Order, having culminated in the heroic defence of Rhodes, was immediately afterwards to collapse and come to an ignominious end; so that L'Isle Adam exclaimed in the bitterness of his heart, "Must I survive the loss of Rhodes for no other end than to be a witness, and that at the end of my life, of the scattering, perhaps of the utter ruin, of an Order, whose institution is of so sacred a character, and whose government is confided to me?"

There can be no doubt that the personal influence of the Grand Master, and the unbounded respect and confidence that his high character commanded, were the means of keeping the Order together during this critical time, and giving it opportunity of gaining fresh honours in the new home which has given it the name by which it is best known in modern times.

It was determined by the council to accept the gift of Malta from the Emperor, if honourable conditions were attached to the gift, and commissioners were sent to Madrid to treat finally with Charles V. on the subject.

But no sooner was this done than new difficulties presented themselves. The proposed donation of Malta to the Knights of St. John had never really been a disinterested act of charity on the part of Charles. With all his professions of respect for the Order, and sympathy with their misfortunes, his secret motive in wishing to establish them at Malta was that they might convert that island into a bulwark to protect his possessions of Sicily and Naples against the advance of the Turks, But now he feared that, the Grand Master being at present a Frenchman, he might shelter the fleets of France at Malta in time of war. Besides this, he knew the Order was closely allied to the Popedom, and he was suspicious that the knights might interfere to free the

Pope from his captivity.

These and other considerations made the Emperor hesitate to confirm his promise; much delay occurred, and the Order still continued without a home.

At this time a scheme was projected for establishing the Order in Greece, in the city of Modon in the Morea, and an expedition was planned for surprising the place and taking it out of the hands of the Turks.

But soon after the Pope was liberated by the Emperor, and, a new treaty being settled between them, they became, outwardly at least, firm friends, and the Pope used his influence to bring about the cession of Malta to the Knights.

On March 24, 1530, a state paper was executed, in which the Emperor declared, that:

. . . .in consideration of the particular affection which he had always borne to the Order, and the important services which it had done for many ages to the Christian world, and to enable it to continue the same against the enemies of the faith, he had given and granted for ever, as well in his own name, as for his heirs and successors, to the most reverend the Grand Master of the said Order, and to the said Order of St. John, as a fief-noble, free and frank, the castles, places, and isles of Tripoli, Malta, and Gozo, with all their territories and jurisdictions, authority of judging in all pleas whatever, and power of life and death, with all other houses, appurtenances, exemptions, privileges, rents, and other rights and immunities; provided that for the future the Grand Master and the knights should hold these places of him and his successors in the Kingdom of Sicily, as noble, free, and frank fiefs, without being obliged to any service or acknowledgment, but that of a falcon every year on All Saints' day, and that in the vacancy of the bishopric of Malta, the Grand Master and the convent should be obliged to present to him and his successors three learned and pious persons, in order for his making choice of one of them to succeed to that dignity.

Thus the Order had once more a home and a place among the sovereign powers of Europe.

But many minor difficulties still stood in the way of their entering upon the full possession of their rights. The Viceroy of Sicily demanded heavy dues upon the exportation of corn to Malta; and many of

the knights, remembering the fertility of Rhodes, stoutly maintained that the Order could not exist upon an island so barren and incapable of producing the necessaries of life.

When the first detachment finally sailed they were overtaken by a violent storm, in which some of the ships were lost; and this misfortune, together with the sterile appearance of the island, and the poverty of its inhabitants, made an unfavourable impression upon the advanced guard of the knights.

On October 26, 1530, the Grand Master L'Isle Adam, and the main body of the Order, landed at Malta, took formal possession of it, and established themselves as well as they could in the castle of St. Angelo and elsewhere. They were in constant dread of the corsairs for some time, having no proper walls or fortifications; the gravest doubts were entertained as to the possibility of rendering the place habitable and capable of defence; and the idea was generally accepted that the Order could only remain at Malta till a more fitting place could be found for its headquarters.

In consequence of this an expedition was fitted out to endeavour to capture the city of Modon in Greece, which was still thought to be a more convenient and suitable home for the Order than Malta. By means of stratagem, entrance was obtained into the city; but, after much fighting, the Christians were unable to gain possession of the place, and were forced to retire. The Grand Master from this time seems to have given up all idea of abandoning Malta, and set himself to work in earnest to fortify the island and make it impregnable. This was the more necessary, because at that time every part of the Mediterranean was scoured by Barbarossa with his fleet of eighty sail, and no one knew where he would next appear, or what city would fall a prey to his resistless attack.

But the life of L'Isle Adam was drawing to a close, and his end was hastened by events which caused him the keenest and most bitter distress. The homeless condition of the Order had led to much relaxation of discipline; and, in spite of the Grand Master's efforts, scandals and disorders arose which culminated at last in a pitched battle between the knights of Italy and those of France. Severe punishment was unsparingly and fearlessly dealt out to the offenders; but the brave old soldier took to his bed in shame and grief.

Another misfortune also did its work, and broke the heart of the veteran Master. Henry VIII. of England had suppressed all the Religious Orders in his kingdom and seized their property. The convents

of the Hospitallers had fallen with the rest. Many knights who had fought and bled for the defence of Christendom, were imprisoned and put to death, and the English *Lange* was extinguished. L'Isle Adam did not long survive these misfortunes.

He died on August 21, 1534. "He was," says Vertot, "a prince highly deserving for his uncommon bravery, for his heroic constancy, and for the wisdom and mildness of his government; virtues which he possessed in a most eminent degree, and which his knights afterwards endeavoured to represent by these few words which were engraved upon his monument:—

"Hic jacet Virtus victrix Fortunæ."
(*Here lies Virtue victorious over Fortune.*)

CHAPTER 14

Acts of Bravery

A curse shall light upon the limbs of men;
Blood and destruction shall be so in use,
And dreadful objects so familiar,
That mothers shall but smile when they behold
Their infants quartered with the hands of war;
All pity choked with custom of fell deeds.

One of the most prominent names in Europe during the middle of
the sixteenth century was that of Barbarossa. There were two brothers
of this name. They were men of obscure birth, natives of Mitylene, and
from their youth they had been pirates. Full of courage and daring,
and entirely unscrupulous, they rapidly acquired money and power,
and soon had a fleet of vessels under their command, with which
they made attacks upon ships and seaport towns, and became terrible
throughout the Mediterranean. Solyman, the Turkish Sultan, offered
them the command of his fleet, and with these increased forces they
waged successful war against the European sovereigns. They made
themselves masters of Algiers and Tunis, and from these ports their pi-
ratical galleys issued in greater or less numbers, carrying fire and sword
into every place that was not too strong for them.

The elder Barbarossa, Horruc, was slain in one of these expedi-
tions, but his brother Airadin carried on the same course of piracy and
plunder, sacking town after town, and carrying away the surviving
inhabitants into miserable slavery.

To put a stop to this, the Emperor Charles V., in conjunction
with the Pope and the Knights of Malta, got together a fleet of three
hundred sail, and an army of twenty-five thousand infantry, and two
thousand cavalry. They set sail in June, 1535, under the command of

the famous Andrew Doria, and laid siege to Goletta, a fortified place near Tunis. After much obstinate fighting, in which, we are told, the Knights of Malta distinguished themselves by their bravery, the place was taken, and the attack was transferred to Tunis.

There were in the city no less than six thousand Christian slaves, who had been captured in the numerous piratical raids of the Barbarossas. Among these was a young knight of St. John, named Simeoni, who managed to get rid of his chains while his keepers were occupied in resisting the Emperor's attack. He immediately released some of his companions; in a short time the whole body were free and armed, and falling upon their oppressors, soon turned the tide of victory in favour of the besiegers, who discovering by signals that they had friends within the city, rushed to the attack, and speedily became masters of Tunis.

The horrible cruelties inflicted by Barbarossa for many years upon unoffending towns and their peaceful inhabitants probably roused the victors to a desire for vengeance, and made them forgetful of all Christian duty. It is certain, however, that the town was given up to pillage, and that shameful excesses were committed by the soldiery.

The naval power of the knights continued to increase, and their ships were unrivalled both for size and for their seagoing powers. When other vessels fled to port for fear of the impending gale, the galleys of the knights were seen bravely standing on their course, trusting to good seamanship and their excellent construction for safety.

The great ship of the Order, we are told, was of enormous size, and was made shot-proof by being sheathed with iron plates.

Piracy was suppressed, and no *corsair* dared sail where the white cross of the Hospitallers was seen floating at the mast-head of their ships.

A long course of warfare broke the power of the robber chiefs who sheltered in the ports of northern Africa, and the Order continued true to its principles in protecting Christendom against the dreaded advance of the Mahometan powers.

But while the Turkish arms were thus kept at bay in the Mediterranean they were achieving alarming successes on the eastern side of Europe.

The King of Hungary was defeated by the Sultan in August, 1526, and his whole country became a prey to the conqueror. Cities were taken and sacked, and the inhabitants put to death, or carried away into slavery; and in September, 1529, an immense Turkish army laid

siege to Vienna.

Happily the fortifications were strong, and the defenders were brave; and after some weeks of fruitless effort, Solyman retired Had Vienna fallen, all western Europe would have been at the mercy of the Turk.

The next great expedition in which the Order took part was the siege of Algiers. This was an undertaking upon which the Emperor Charles V. had for some time set his heart, and as soon as opportunity occurred, he determined to carry it out, notwithstanding the lateness of the season.

The veteran Admiral Andrew Doria tried to dissuade the Emperor from his purpose, and earnestly urged the expediency of delay, saying that they would both probably never survive if they embarked at that stormy season. To which the Emperor only replied, "Two and twenty years of Empire for me, and three score and twelve of life for you, ought to satisfy us, so as to make us both die contented," and he gave orders for embarkation at once.

The fleet encountered a severe storm, but arrived safely at its destination, and the siege was begun. An eyewitness, who sent a report to the Pope, speaks with admiration of the serried ranks of the Knights of St. John, and of the noble appearance they presented with their crimson velvet vests, marked with a white cross over their armour, and of their bravery in every attack.

On one occasion a French knight, being wounded by a Moor, leaped upon the crupper of his enemy's horse, and stabbed him in the back.

Another knight, having advanced as far as the city gates, stuck his dagger into them, and left it there, being unable to go any further.

Another, though dying from his wounds, by poisoned arrows, refused to give up the standard of the Order, and, supported by a soldier, held it up till he died.

All this bravery, however, was unavailing. A storm destroyed the greater part of the fleet, and the army was left without provisions or protection from the weather, so that a retreat was determined on, and the unfortunate expedition ended in failure.

The Order at this time once more petitioned the Emperor to permit them to abandon Tripoli. They said it could never be made strong, and that it was only a waste of labour and strength to attempt to hold and defend; but the Emperor, looking upon it as a help to the defence of his dominions in Sicily, refused to allow them to give it up, and re-

minded them of the charter by which they had pledged themselves to its defence when they accepted Malta. They were therefore obliged to keep the place in spite of the great risks that it involved; and the command of this dangerous post was entrusted to De Valier, the Marshal of the Order, and a knight of tried valour.

Able men were indeed wanted at this time to defend not only the possessions of the Order, but the very existence of the Christian name.

A new piratical chieftain had appeared, a worthy successor of Barbarossa, in deeds of daring and cruelty.

This was Dragut, who from his youth had been a marauder and corsair, and had finally taken service under the Sultan, and become the scourge of the Christians. Every summer the coasts of Naples and Sicily were ravaged. No Christian ship dared sail from Italy to Spain, for it was sure to be met by a superior force and taken; and when the sea did not furnish him with prizes enough, Dragut made descents upon the coasts, plundered towns and villages, and carried off the inhabitants into slavery.

To put a stop to this the Emperor ordered Andrew Doria, his admiral, to search for Dragut and rid the sea of him at all costs. The old admiral entrusted the command of the expedition to his nephew, Jannetin Doria, who was fortunate enough to catch his enemy unawares on the coast of, Corsica, and having destroyed his fleet, made Dragut prisoner, who was beyond measure enraged at being obliged to surrender to so youthful a commander.

Dragut remained a prisoner for four years, but was at last released at the request of the Genoese, who by restoring him his liberty purchased their deliverance from the Turkish fleet, which was threatening Genoa.

Barbarossa shortly after died, upwards of eighty years of age, and the Sultan appointed Dragut to succeed him in the command of his fleet. Dragut became a formidable adversary to the knights, and a series of bloody and obstinate conflicts took place between them, especially on the African coast, where many valuable lives were sacrificed, and much valour was displayed; but the permanent results were small, and the real advantages gained are hard to discover.

But the Sultan had other and greater schemes which were soon to be made manifest. A large fleet and army were prepared, and the Grand Master heard that its destination was Malta. This he was unwilling to believe, and persuaded himself and others that the attack was

intended to be made upon Naples or Sicily.

Many of the knights were, nevertheless, recalled from Tripoli and elsewhere, and some preparations were made for a siege, but Malta was really by no means in a complete state of defence.

All doubt was removed very shortly, for on July 16, 1551, the Turkish fleet made its appearance off the island, and cast anchor. The inhabitants were seized with terror, knowing the cruelties they might expect at the hands of the Turks, and flying from their houses, sought refuge in the Castle of St. Angelo, and even in the caverns and hiding places among the rocks. A party of the enemy endeavoured to land, in order to explore the island, and find the best place for the disembarkation of the main body, but they were met and beaten off by a small number of the knights with their soldiers, who had watched their proceedings.

The Turkish general, Sinan, was much struck with the natural strength of the Castle of St. Angelo, standing as it did upon an almost inaccessible rock, and reproached Dragut with having deceived him and his master with respect to the prospects of an easy capture of the place; "Is this the castle," he said, "which you told the Sultan might so easily be taken? Surely an eagle would never have chosen the summit of a steeper rock for its nest."

While an old Turk added:

Do you see that bulwark which runs out towards the sea, upon which the knights have planted the great standard of the Order? When I was a slave in Malta, I had to carry the great stones with which it was built upon my shoulders; and before you can demolish that work winter will come on; or, what is more to be feared, some strong succour will come to the besieged.

Dragut was urgent to commence the attack, but Sinan and the other officers were less sanguine, and were apprehensive that while they were engaged, they would be attacked in the rear by some relieving force, which they believed would be sent from the Italian ports under Doria.

A council of war was held, in which the peril of their position was discussed, and it was finally determined that it would not be safe to attack Malta with the forces at their disposal, and that it would be better to make an attempt upon Tripoli.

But before they set sail, they fell upon the small island of Gozo, and took possession without difficulty of the small town upon it, and

either slaughtered, or carried into slavery, all the inhabitants.

Among the latter was a Sicilian who had settled in the island, and who, preferring death to slavery, delivered himself and all his family from the hardships and shame that attend it, after a very tragical manner. He first stabbed his wife and two daughters, and then rushing sword in hand into the midst of the Turks was soon cut to pieces.

Arrived at Tripoli, Sinan sent a messenger to the governor, demanding the surrender of the castle. To this De Valier replied, "The government of Tripoli has been entrusted to me by my Order; I cannot, therefore, surrender it up to anyone but to him whom the Grand Master and the council of the Order shall nominate; and I will defend it against all others to the last drop of my blood."

Tripoli was, as has already been said, a place that could not be made strong, and was incapable of sustaining a siege. Besides, the garrison consisted only of raw recruits upon whom no reliance could be placed; but the demand of the Emperor Charles V. that the place should be held and defended, in order to fulfil the conditions upon which he had granted Malta and Gozo to the Order, obliged the commander to make the best defence he could.

The Turks landed their artillery and speedily battered down part of the wall, which was weak and insufficient. The carnage that resulted was so terrible that the undisciplined soldiers were unwilling to take the place of those who were killed. They absolutely refused to inarch to what they said was certain death, and even plotted to blow up the magazine, and escape in one of the vessels.

Threats, punishments, and promises of increased pay and rewards all failed to inspire the garrison with courage, or a sense of duty, and the governor had no alternative but to capitulate to the enemy.

Sinan demanded reimbursement for all the cost of the expedition, and other terms which it was impossible for the knights to fulfil. But Dragut with his *corsair* cunning and treachery, advised that easy conditions should be substituted, that the place might be given over to them, "For," said he, "when once we are masters of the fortress, we can put such interpretation upon the treaty as best suits our own interests."

The place was therefore surrendered, and the Turks, as usual, broke their word as soon as they got possession of it, sending into slavery all the inhabitants, and all the knights, except De Valier, and a few others who were allowed to go free on the payment of a large ransom.

On their return to Malta they were tried for having given up a

place entrusted to them by the Order, and condemned to imprisonment, notwithstanding the circumstances which they detailed in extenuation of their conduct.

There were, however, many members of the Supreme Council, and other knights of the Order, who considered this judgment harsh and unjustifiable. This and other acts rendered the Grand Master, D'Omedes, unpopular, and created much discontent and opposition within the ranks of the Order for some time.

CHAPTER 15

Constant War With the Turks

The arms are fair,
When the intent of bearing them is just.
 Shakespeare.

The insufficient fortifications of the island caused great anxiety, and it was determined to strengthen them before another attack should be made by the Turks. Skilled masons were hired in Sicily, and considerable works were added to the defences. Among these the most important was a strong castle on Mount Sceberras, which was called the Fort of St. Elmo, in memory of the tower of that name which had served to defend the entrance of the port of Rhode's.

There was also another fortification erected which was called Fort St. Michael.

In order to find money for these costly works the knights contributed money and plate, and those who had no private fortune brought the gold chains which were then worn, and gave them to the treasurer to be turned into money to pay the workmen.

About this time a very unfortunate expedition was made upon Zoara, upon the coast of Barbary. By a mistake of the pilot, the landing was made upon a different part of the coast from that which was intended, and the small army of the knights found themselves unexpectedly in the presence of a body of four thousand Turks. The mistake was discovered too late to avoid a battle. It was only at the cost of the loss of many knights, and a still greater number of common soldiers, that a retreat was effected, and the remains of the army were embarked in their ships.

Soon after this the Order received an envoy from Mary, Queen of England, who sent word to the Grand Master that she intended to

restore to the Order all the convents and estates which had been taken from it when all the English monasteries were suppressed by her father, Henry VIII. The Queen was unable to persuade the nobility and others who had received grants of the abbey lands to restore them; but she herself gave up all that remained in the possession of the Crown.

The Priory of St. John, Clerkenwell, was once more occupied by the knights; but the accession of Queen Elizabeth caused the re-establishment of Protestantism, and the Knights of St. John, together with all other Religious Orders, were once more suppressed, and their property taken from them.

About this time the Emperor gravely proposed to the Grand Master that the headquarters of the Order should be transferred from Malta to some place upon the northern coast of Africa.

It was soon seen, however, that the sole motive that induced the Emperor to make this proposal was the desire by this means to protect the kingdom of Tunis, which was at that time a fief of the Crown of Castile; and the idea was rejected by the council.

The next important event recorded in the chronicles of the Order was a tremendous hurricane which swept over the island of Malta and the neighbourhood. Many ships belonging to the Order were wrecked, and their crews lost, and much damage was done to the houses and other buildings. The Pope, the Emperor, and other European sovereigns, hearing of this disaster, sent ships, money, and men to help to repair it; and the ever-watchful Dragut, taking advantage of the misfortunes of the knights, made an attack, with a considerable force, upon the island; but was met and beaten off by the galleys of the knights.

The Grand Master having died, John de la Valette was unanimously elected in August, 1557. This brave and noble knight had never left Malta since his reception into the Order. He had already filled many important offices, and had won the highest estimation for his bravery, his administrative power, and his spotless rectitude of conduct, so that, when the vacancy occurred, he was at once and without opposition appointed Grand Master,

He found plenty to do. The Reformation had cut off many sources of supply from the Order, and it was known that the Sultan was meditating another and more serious attack upon the island.

La Valette found himself therefore occupied as much with diplomatic negotiations with the European sovereigns, as with exertions to strengthen the fortifications of the island, to raise money, and to

recruit his army and navy.

It was also determined to make an attempt to recover Tripoli from the Turks, and a considerable armament was sent out to besiege the place, which had been rendered strong and formidable by Dragut, who had made it his headquarters.

A landing was effected; but the heat of the climate and the bad supply of water soon caused sickness to break out among the men. While in this condition the fleet was attacked by a superior force of the enemy and almost entirely destroyed. Nearly fourteen thousand men perished in this unhappy expedition, either killed, or dying of disease, or in slavery.

The archives of the Order contain many records of other conflicts with the Turks, both by sea and land, and of minor struggles with the corsairs who infested the Mediterranean. Several strong places on the coast of Barbary, which were the retreats of these wretches, were attacked, and either destroyed or taken possession of by the knights, and many valuable trading vessels belonging to the Sultan were captured with their cargoes. One of these had on board some beautiful girls which had been purchased for the Sultan's *harem*. The loss of these seems to have irritated him exceedingly, and made him determine to hasten on the expedition which he had long contemplated against Malta.

He therefore called a council, which met according to the Turkish custom at that time, and deliberated on horseback in the open air. It was at once determined unanimously that Malta should be besieged, and two of the Sultan's favourite *pashas*, Piali and Mustapha, were entrusted with the command of the expedition. Piali was probably of Christian origin. He had been found a helpless infant lying upon the ground, after the siege of Belgrade, and Solyman had ordered him to be taken care of and educated. He passed through the various grades in the army, and was finally appointed *pasha* of the fleet, and married to one of the Sultan's grand-daughters.

Mustapha was a veteran who had spent all his life in the service of the Sultan; he was a close friend of Dragut, and a bitter enemy of the Christians.

By means of spies the Grand Master became acquainted with what was going on at Constantinople, and made great efforts to meet the coming danger. The knights were summoned to Malta from the various commanderies throughout Christendom. Troops were enlisted in Italy, Sicily, and elsewhere. Arms, ammunition, and supplies of food

were transported to Malta by the ships of the Order, and urgent appeals were sent to the Christian sovereigns of Europe for aid in the defence of this outpost and bulwark of Christendom.

But, as usual, the people of the various European countries were too much occupied with their own immediate and national interests to take much heed to the appeals of La Valette, and the dangers which menaced the Christian religion.

France was occupied with civil war. Catholic against Huguenot; Germany was divided against itself, and could not act in unison; England, under Elizabeth, was ready to enter into alliance with the Mahometans rather than with any one who was in communion with the Pope; and Philip II. of Spain was so dilatory and cautious that his aid came too late to be of any use.

A general chapter of the Order was called, and about 500 knights were present. The Grand Master addressed them as follows: "A formidable army and an infinite multitude of barbarians are coming to thunder down upon us; they are the enemies of Jesus Christ; it is our business to stand up manfully in defence of the faith; and if the Gospel must submit to the Koran on this occasion, then the life which we have each devoted to God by our profession is demanded of us; thrice happy they who shall first fall a sacrifice to so good a cause! But in order to make ourselves worthy of that honour, let us go, my brethren, to the altar, there to renew our vows, and partake of the blessed Sacrament, and let the Blood of the Saviour of mankind inspire us with such a noble contempt of death as can alone make us invincible."

It was in this spirit that the Knights of St. John prepared to meet their enemies, and the enemies of the religion of Jesus Christ.

The number of the forces under the command of the Grand Master, when the siege actually began, is variously stated by different authorities; but probably Vertot is not far wrong when he says that there were seven hundred knights, besides serving brothers, and eight thousand five hundred rank and file.

The principal port of Malta, now called Valetta, after the noble Grand Master who so nobly conducted its defence, was divided into two unequal parts by a promontory, upon the extremity of which the strong fortress of St. Elmo had been built.

There were also two other forts, St. Angelo and La Sangle, within the greater harbour; and a third, called St. Michael, made up the principal defences of the place. A huge chain, supported on empty casks and timbers, was drawn across the mouth of the harbour.

Admiral de Monte, with the Italian knights, undertook the defence of La Sangle. The Knights of Aragon, Navarre, and Catalonia took charge of the quarter next the gate of Bormola. The Portuguese and German knights, with part of those of Castile, and the one English knight who alone represented his nation, were posted upon the mole towards the town, and extended themselves as far as the ditch of the Castle of St. Angelo. Fifty knights, under the commander Garzeranos, and five hundred soldiers, held the castle.

The city, in the centre of the island, was defended by Mesguita, a Portuguese knight. Romegas, who had long distinguished himself by his exploits in the Mediterranean, undertook, with the soldiers and crews of his galleys, to defend the entrance of the larger harbour; while Guiral, a Castilian knight, erected and commanded a battery for the protection of the iron chain across the harbour. Deguerras, Bailiff of Negropont, with sixty other knights, held the Fort of St. Elmo, which was further garrisoned by a considerable body of Spanish troops. The island of Gozo was entrusted to Torreglias, a Majorcan, whose valour and intrepidity had been proved on many occasions; while Copier, a knight of Auvergne, commanded a flying squadron, which was to watch the enemy from the sea, and co-operate with the land forces as opportunity occurred.

La Valette himself superintended every part of the defences, visiting every post, giving directions, and encouraging every one by his calm intrepidity and quiet confidence.

The island by this time presented a very different appearance from that which it bore when it came into the possession of the Order. Industry and wise culture had done wonders. Earth had been brought and laid upon the rocky terraces; artificial irrigation bad been introduced, and an almost tropical verdure clothed the gardens. The results of the labours of these Christian colonists remain even to this day.[1]

But everything else was now obliged to give way to preparations for defence. The aged, and most of the women and children, were shipped off to Sicily, for the enemy was daily expected.

1. The late Earl of Carlisle, after visiting both Rhodes and Malta, said, "We are told that when L'Isle Adam and his brave companions first landed on the island of Malta, their spirits sank within them at the contrast its dry and barren surface presented to their delicious lost Rhodes. I have qualified myself for adjudging that in most respects the tables are now turned between the two islands, and they certainly afford a very decisive criterion of the results of Turkish and Christian dominion."

CHAPTER 16

St. Elmo Attacked

All furnished, all in arms,
All plumed like estridges that wing the wind;
Baited like eagles having lately bathed;
Glittering in golden coats like images.
Shakespeare.

On May 18, 1565, the Turkish fleet was discovered bearing down upon the island. It consisted of about one hundred and sixty ships of the largest size, besides transports and a multitude of smaller vessels.

The army numbered thirty thousand men, all seasoned and experienced soldiers, who had already won victories under the standard of the Crescent. The train of siege artillery was of formidable strength, many of the guns being able to throw a marble shot of fifty-six pounds weight, and some even carried shot of one hundred and twelve pounds weight.

Solyman had taxed the utmost resources of his empire to fit out this expedition, and everything was the best that money, skill, and labour could produce. After some ineffectual opposition from Copier's squadron, the Turks effected a landing.

They were narrowly watched by small detachments hidden among the rocks, and stragglers were speedily cut off. One of these detachments was under the command of a Portuguese knight, named La Riviere. In a skirmish with the enemy this officer was taken prisoner, and immediately carried off to the Turkish commander, who, finding he could get no information from him respecting the strength of the garrison and nature of the fortifications, cruelly put him to the torture.

La Riviere bore it for some time with wonderful courage, but at

last hit upon the plan of releasing himself by a clever deception. He professed his willingness to give information, and, with every appearance of candour, said that the most likely way to capture Malta would be to attack the fortifications at the post of Castile, where the defences were the weakest. This led the Turks into a trap, and the general, finding he had been deceived, caused La Riviere to be executed.

The Turkish generals now held a council of war to determine the best method of conducting the siege, and, after much discussion, determined to commence by the siege of Fort St. Elmo.

This was no easy task. All the surrounding space was rock, and it was not possible to construct trenches and approaches in the usual way. Timber, earth, and stones were used to protect the attacking force, but they suffered greatly from the guns of the fort, and made but slow progress.

By dint, however, of constant labour night and day, and by the lavish sacrifice of life, some batteries were erected, the heavy guns were got into position and began to play upon the walls of St. Elmo. The enormous shot fired continually soon began to tell upon the masonry; it was evident that all would soon be reduced to ruin, and the way open to the enemy.

A messenger was sent, therefore, to La Valette, to tell him of the danger of the garrison. The Grand Master replied, "But what are your losses up to this time, that you so soon come for aid?" To this it was answered, "Sir, the castle is like a sick man reduced so low that he cannot be kept alive without continual remedies and cordials."

"I myself," cried La Valette, "will be the physician, and will take those with me who, if they cannot prevail so far as to cure you of your fear, will at least, by their bravery, keep these infidels out of the place." And he would have gone at once to this post of danger, but that the council prevailed on him to remain at headquarters, where his presence was indispensable to the safety of the whole island. He consented, therefore, to remain, and to send some of his most trusted knights to reinforce the threatened outwork.

Next day, another and more determined attack was made upon St. Elmo. The Turks did not wait for a breach to be made, but relying upon the mere force of overwhelming numbers, rushed upon the outer defences with scaling-ladders to place against the walls, and trees, wool-sacks, and gabions to fill up the ditches.

The artillery and musketry of the besieged mowed them down in files, but others immediately filled up the vacant places, and the

tumultuous mass still pressed on. The wind blew the smoke into the faces of the Christians, and hid from the anxious spectators on the mainland what was being done in the isolated fortress. All the outer defences were taken by the Turks, who even planted their ladders against the walls of the fort, and attempted to climb by them over the battlements.

Here, however, they were stopped; an incessant fire was maintained by the besieged; stones, boiling oil, and pitch were rained upon the heads of the frantic stormers; their ladders were broken or thrown down, and, after all their efforts, they were forced to retire when night came on.

One hundred men, and twenty knights, were lost by the small garrison, while so reckless and foolhardy had the attack been, that it is said three thousand dead Turks strewed the ditch and rocks around St. Elmo.

Many instances of bravery and endurance are recorded. One young knight, Abel de Bridiers, being badly wounded by a musket ball, some of his comrades ran to help him to the rear, that his wound might be dressed; but he waved them off, saying, "Leave me, I am a dead man, you are wanted in the front." He crawled with difficulty to the chapel, leaving a trail of blood behind him, and lying down before the altar, was found there dead.

The garrison managed to communicate with the Grand Master during the night, and urged him to abandon St. Elmo. They said that all the approaches were in the hands of the enemy, who could walk up to the very walls; that the enormous cannon shot were crumbling down the walls themselves, and that certain death threatened everyone within the fortress.

La Valette was much moved at this report, and acknowledged that the condition was a desperate one, but at the same time he would not give up the castle. He daily hoped for reinforcements, and so long as St. Elmo held out, the mainland could not be attacked. He called for volunteers to defend this forlorn hope; numbers responded, and offered themselves. He then proposed that any that chose might retire from St. Elmo, and be replaced by the volunteers.

This had its effect. No one would yield the place of danger, and every one determined to die at his post.

Day by day the attacks were repeated; a new instrument of defence was invented by the besieged. Large hoops were covered with combustible materials saturated with oil and saltpetre. When the dense

masses of the Turks rushed up to the walls, these hoops were set on fire and hurled among them; the fire catching their flowing robes, and the hoops entangling them, so that they could not escape, till this novel weapon became more dreaded than all the guns and swords together.

The 16th of June was fixed upon by Mustapha for another and final attack upon St. Elmo. For days before the cannon had played upon it from all sides incessantly, till the walls were in some places mere heaps of stones, which ran down into and nearly filled up the ditch. The fleet was now moved nearer, that its guns might be brought to bear upon the devoted fortress, and at a given signal the troops rushed with tremendous shouts to the attack.

For six hours the unequal conflict was maintained. The Turks advanced so close that the fight was hand to hand, sword and pike taking the place of cannon and musket. Once more a terrible carnage took place among the Turks, who lost ten times as many as the Christians, as they had no shelter and exposed themselves in the most reckless manner.

But the greatest loss they sustained was by the death of Dragut, who was mortally wounded by a splinter of stone, and died shortly after.

The little garrison also suffered severely, and the smallness of its numbers rendered these losses most serious. La Valette, however, managed to send in reinforcements during the night.

But the end was near. St. Elmo was now entirely invested, and all communication with the mainland was cut off. A battery also was erected, that commanded the approach by water, so that no boats could get near without being destroyed.

This was not effected without resistance. Sallies were made, and the works destroyed, but they were repaired again; the overwhelming numbers of the Turks enabling the commanders to sacrifice a multitude of lives in order to gain a desired end.

The besieged were now cut off from all help from without, and knew that nothing remained for them but to fight and die at their posts. They received the Holy Communion during the night, and at dawn were upon the remains of the walls waiting for the enemy. Even the wounded, who could not walk, were carried thither, and sat or lay, sword in hand, determined to die in harness rather than be massacred in their beds.

La Valette had watched with deepening anxiety and sorrow the approaching fate of his faithful companions in arms. He made one

more gallant effort to throw reinforcements into. the doomed fort. A flotilla of boats was manned and armed, and, under cover of a heavy cannonade from St. Angelo and the batteries, launched forth towards St. Elmo.

But it was in vain; numberless guns had been got into position, and commanded the whole course; while an overwhelming force of the enemy, armed with muskets, was placed in boats to prevent a landing being effected. The knights were obliged to retire after having suffered severely, and nothing more could be done to save the devoted fort.

All night long the cannonade was kept up by the Turks, to prevent any repair of the shattered and crumbling walls.

A solemn service was held in the great church of the island, in which La Valette and all the knights joined, not so much to seek aid from heaven, which could not now be given except by miracle, as to commend the garrison of St. Elmo to God, since their death was inevitable and imminent.

On June 23, the Vigil of St. John Baptist, the patron saint of the Order, the final assault was made. It seemed impossible that the small and enfeebled garrison could defend for a moment the walls which were now scarcely walls at all, but shapeless heaps of stones. But for four hours there stood a small but firm and resolute phalanx of knights, and kept at bay the surging masses of Turks that rushed up the ruinous slope of stones, like the waves of an angry sea, like it, too, to fall back baffled and broken.

But fresh troops were ready to renew the assault, and there remained now but sixty wounded and weary knights to hold the breach. On came the hosts of the enemy with shouts, and now by the sheer force and weight of numbers they swept away the barrier, and poured into the fort. Most of the knights died sword in hand at the breach; one or two who were wounded were taken prisoners by those who had an eye to ransom; while others were hung up by the feet or crucified.

As the smoke of the cannonade gradually lessened, La Valette saw the standard of the Crescent floating where the Cross of St. John had waved so long, and he knew that all was over. St. Elmo was taken.

Never did valour and endurance do more; and when the Turkish general entered and saw the smallness of the place, the insignificance of the force by which it had been so long and so obstinately defended, and remembered the enormous losses that his own troops had sustained, he felt almost in despair of taking the greater fortifications that

remained, and exclaimed, "What will not the father cost us, when the son, who is so small, has cost us the bravest of our soldiers? "

It is believed that eight thousand Turks fell before the walls of St. Elmo, and the consumption of ammunition was enormous.

As soon as the place was taken, the Turkish fleet, with flags flying, and bands playing, and cannons firing, sailed round into the harbour, and took up a new position, so as to command the town.

A brave and generous enemy would have respected a fallen foe who had displayed such heroic bravery. But chivalrous feelings are not felt in the savage bosom of the Turk in any age. Mustapha having got possession of the fort, ordered the wounded knights who yet lived to be tortured, and put to ignominious deaths. Some were flayed alive, others were slashed on the breast in the form of a cross, and while the heads of the dead were put upon poles upon the walls, the palpitating bodies of the dying survivors were nailed to huge crosses, and launched into the harbour that the tide might carry them to the foot of the walls of St. Angelo!

The defence of St. Elmo saved the island for a whole month, but it cost its defenders fifteen hundred men, of whom one hundred and twenty-three were knights of the Order. La Valette mourned the loss of some of his best warriors and dearest friends; but he had the satisfaction of knowing that the spirit of his Order was still active and vigorous, that his knights were sacrificed for the defence of Christianity and civilization, that the hated and degrading dominion of the Turk was held in check, and Europe safe so long as Malta held out.

Chapter 17

Victory of the Knights

High on the works the mingling hosts engage,
The battle kindled into tenfold rage,
With showers of bullets, and with storms of fire,
Bombs in full fury; heaps on heaps expire.

Addison.

The loss of eight thousand men and his best general made Mustapha anxious to avoid further waste of life; he therefore sent a slave with a flag of truce, demanding the surrender of the whole island, which he declared could no longer be defended, now that St. Elmo was in his possession. La Valette would not condescend to return any answer, but ordered the messenger to be conducted to one of the deep ditches that surrounded St. Angelo, and informed that there was room there to bury his master and all his troops!

At this time a most welcome reinforcement was received from Sicily. About seven hundred soldiers and forty knights arrived in four galleys. The commander of the expedition, Don Juan de Cardona, had been ordered by the Viceroy of Sicily not to land the troops if St. Elmo were taken; and he was in so much fear of the Turkish fleet that he made no attempt to do so for some time. At length he sent a knight ashore upon a distant part of the island to obtain information. He soon found that St. Elmo had fallen, but concealed the fact from Don Juan, and the troops were landed.

It was, however, a matter of no small difficulty to get them into the town without the knowledge of the Turks. Fortunately, a thick fog set in, and under cover of this, the welcome reinforcement was enabled to join the main body without loss, and even without striking a blow.

Help was sorely needed, but as no further aid was to be looked for,

La Valette set himself to make the best use he could of the resources at his command. He recalled the troops from other parts of the island that all his forces might be concentrated at the present point of attack. He removed the guns from the ships, and mounted them upon the walls. He assigned the command of the principal defences to his best officers. He made a general search for provisions, caused all to be placed under supervision, and their distribution to be regulated with a due regard to economy.

Nor were these measures unnecessary. Mustapha seeing that there was no hope of getting possession of Malta except by main force, after a brief interval of repose set to work in earnest to prosecute the siege. Trenches were dug where it was possible, and where there was nothing but rock, walls were built so as to invest St. Angelo and St. Michael on every side.

In order to avoid the fire of the former fortress, the bold expedient was resorted to, of dragging a number of galleys across the land, and launching them in the harbour near St. Michael. No less than seventy vessels, some of them of great size, were thus conveyed over rough and hilly ground by the forced labour of the unhappy Christian slaves.

At this time La Valette received timely and valuable information of the plans of the enemy from a deserter, an officer named Lascaris, a Greek of an illustrious family, who had been taken by the Turks in his childhood, and brought up as a Moslem. But he had retained reminiscences of his early Christian education, and, in spite of high position and command, felt restless, and determined to return to the faith of his baptism.

At great risk he managed to communicate with some of the outposts of the Christians, and finally escaped, by the aid of two Maltese, who were excellent swimmers. In consequence of the information received from Lascaris, the Grand Master caused a heavy iron chain, and a strong bar made of ships' masts and spars, to be laid across the harbour, so as to prevent any sudden attack by the enemy's boats.

On the 5th of July, a general attack was made by the Turks. Batteries had been constructed on all sides, and they now opened fire upon the town and castle with great fury. The Christian guns returned the fire, and eyewitnesses relate that so tremendous was the cannonade that the whole island seemed to be transformed into a volcano, and the noise was distinctly heard in Sicily.

In the meantime La Valette had sent to the Viceroy of Sicily, remonstrating with him for not sending him succour in his extreme

need and danger.

Admiral Doria was ready and willing to lead an expedition, and showed that with a body of two thousand men, and an adequate fleet, he could break through the Turkish forces and relieve Malta. But the Viceroy hesitated, receiving no orders from his master, the slow and procrastinating Philip II., and so time went on, and nothing was done.

But if no succour was sent to the Christians, the Turks received an important reinforcement by the arrival of Hassem, Viceroy of Algiers, with two thousand five hundred men. This man was a son of Barbarossa, and son-in-law of Dragut, and was anxious to have an opportunity of earning for himself a name worthy of his ancestors. He therefore solicited from Mustapha the command of the next attack, boasting that his soldiers would make short work of the enemy, and intimating that if he had been there St. Elmo would not have held out so long.

The attack was made on the 15th of July, and is thus described by Prescott:—

> Two cannon in the Ottoman lines, from opposite sides of the great port, gave the signal for the assault. Hassem prepared to lead it in person on the land side. The attack by water he entrusted to an Algerine *corsair*, his lieutenant.
>
> Before the report of the cannon had died away a great number of boats were seen by the garrison of St. Michael, putting off from the opposite shore. They were filled with troops, and among them, to judge from their dress, were many persons of condition. . . .
>
> It was a gay spectacle, these Moslem chiefs, in their rich Oriental costumes, with their gaudy-coloured turbans, and their loose flowing mantles of crimson, or of cloth of gold and silver, the beams of the rising sun glancing on their polished weapons, their bows of delicate workmanship, their scimitars from the forges of Alexandria and Damascus, their muskets of *Fez*. . . .
>
> In advance of the squadron came two or three boats, bearing persons whose venerable aspect and dark-coloured robes proclaimed them to be the religious men of the Moslems. They seemed to be reading from a volume before them, and muttering what might be prayers to Allah, possibly invoking his vengeance on the infidel. But these soon dropped astern, leaving the way open for the rest of the flotilla, which steered for

the palisades, with the intention evidently of forcing a passage. But the barrier proved too strong for their efforts, and chafed by the musketry, which now opened on them from the bastion, the Algerine commander threw himself into the water, which was somewhat above his girdle, and, followed by his men, advanced boldly towards the shore. Two mortars were mounted on the ramparts. But, through some mismanagement, they were not worked; and the assailants were allowed to reach the foot of the bastion, which they prepared to carry by escalade.

Applying their ladders they speedily began to mount; when they were assailed by showers of stones, hand grenades, and combustibles of various kinds; while huge fragments of rock were rolled over the parapet, crushing men and ladders, and scattering them in ruin below. The ramparts were covered with knights and soldiers, among whom the stately form of Antonio de Zanoguerra, the commander of the post, was conspicuous, towering above his comrades, and cheering them on to the fight.

Meantime the assailants, mustering like a swarm of hornets to the attack, were soon seen replacing the broken ladders, and again clambering up the walls. The leading files were pushed upward by those below; yet scarcely had the bold adventurers risen above the parapet, when they were pierced by the pikes of the soldiers, or struck down by the swords and battle-axes of the knights. At this crisis, a spark unfortunately falling into the magazine of combustibles, it took fire, and blew up with a terrific explosion, killing and maiming numbers of the garrison, and rolling volumes of blinding smoke along the bastion. The besiegers profited by the confusion to gain a footing on the ramparts; and when the clouds of vapour began to dissipate, the garrison were astonished to find their enemies at their side, and a number of small banners, such as the Turks usually bore into the fight, planted on the walls.

The contest now raged fiercer than ever, as the parties fought on more equal terms; the Mussulmans smarting under their wounds, and the Christians fired with the recollection of St. Elmo, and the desire of avenging their slaughtered brethren. The struggle continued long after the sun, rising high in the heavens, poured down a flood of heat on the combatants; and the garrison, pressed by superior numbers, weary and faint with

wounds, were hardly able to keep their footing on the slippery ground, saturated with their own blood and that of their enemies.

Still the cheering battle-cry of St. John rose in the air; and their brave leader, Zanoguerra, at the head of his knights, was to be seen in the thickest of the fight. There, too, was Brother Robert, an ecclesiastic of the Order, with a sword in one hand, and a crucifix in the other, though wounded himself, rushing among the ranks, and exhorting the men 'to fight for the faith of Jesus Christ, and to die in its defence!'

At this crisis, the commander, Zanoguerra, though clad in armour of proof, was hit by a random musket shot, which stretched him lifeless on the rampart. At his fall the besiegers set up a shout of triumph, and redoubled their efforts.

It would now have gone hard with the garrison, had it not been for a timely reinforcement which arrived from Il Borgo. It was sent by La Valette, who had learned the perilous state of the bastion. He had not long before this, caused a floating bridge to be laid across the Port of Galleys, thus connecting the two peninsulas with each other, and affording a much readier means of communication than before existed.

While this was going on, a powerful reinforcement was on its way to the support of the assailants. Ten boats of the largest size, having a thousand *Janizaries* on board, were seen advancing across the Great Harbour from the opposite shore. Taking warning by the fate of their countrymen, they avoided the palisades, and, pursuing a more northerly course, stood for the extreme point of the Spur. By so doing they exposed themselves to the fire of a battery in St. Angelo, sunk down almost to the water's level.

It was this depressed condition of the work that secured it from the notice of the Turks. The battery, mounted with five guns, was commanded by the Chevalier de Guiral, who coolly waited till the enemy had come within range of his shot, when he gave the word to fire. The pieces were loaded with heavy balls, and with bags filled with chain and bits of iron.

The effect of the discharge was terrible. Nine of the barges were shattered to pieces, and immediately sank. The water was covered with the splinters of the vessels, with mutilated trunks, dissevered limbs, fragments of clothes, and quantities of provi-

sions; for the enemy came prepared to take up their quarters permanently in the fortress.

Amidst the dismal wreck, a few wretches were to be seen struggling with the waves, and calling on their comrades for help. But those in the surviving boat, when they had recovered from the shock of the explosion, had no mind to remain longer in so perilous a position, but made the best of their way back to the shore, leaving their companions to their fate.

Day after day the waves threw upon the strand the corpses of the drowned men; and the Maltese divers long continued to drag up from the bottom rich articles of wearing apparel, ornaments, and even purses of money, which had been upon the persons of the *Janizaries.*

Eight hundred are said to have perished by this disaster, which may not improbably have decided the fate of the fortress; for the strength of the reinforcement would have been more than a match for that sent by La Valette to the support of the garrison.

Meanwhile, the succours detached by the Grand Master had no sooner entered the bastion than, seeing their brethren so hard beset, and the Moslem flags planted along the parapet, they cried their war-cry, and fell furiously on the enemy. In this they were well supported by the garrison, who gathered strength at the sight of the reinforcement.

The Turks now, pressed on all sides, gave way. Some succeeded in making their escape by the ladders, as they had entered; others were hurled down on the rocks below. Most, turning on their assailants, fell fighting on the rampart which they had so nearly won. Those who escaped hurried to the shore, hoping to gain the boats, which lay off at some distance; when a detachment, sallying from the bastion, intercepted their flight. Thus at bay, they had no alternative but to fight.

But their spirit was gone; and they were easily hewed down by their pursuers. Some, throwing themselves on their knees, piteously begged for mercy. 'Such mercy,' shouted the victors, 'as you showed at St. Elmo!' and buried their daggers in their bodies.

While the fight was thus going on at the Spur, Hassem was storming the breach of Fort St. Michael, on the opposite quarter. The storming-party, consisting of both Moors and Turks,

rushed to the assault with their usual intrepidity; but they found a very different enemy from the spectral forms which, wasted by toil and suffering, had opposed so ineffectual a resistance in the last days of St. Elmo.

In vain did the rushing tide of assailants endeavour to force an opening through the stern array of warriors, which, like a wall of iron, now filled up the breach. Recoiling in confusion, the leading files fell back upon the rear, and all was disorder. But Hassem soon re-formed his ranks, and again led them to the charge. Again they were repulsed with loss; but, as fresh troops came to their aid, the little garrison must have been borne down by numbers, had not their comrades, flushed with their recent victory at the bastion, hurried to their support, and sweeping like a whirlwind through the breach, driven the enemy with dreadful carnage along the slope, and compelled him to take refuge in his trenches.

Thus ended the first assault of the besiegers since the fall of St. Elmo. The success of the Christians was complete. Between three and four thousand Mussulmans fell in the two attacks upon the fortress and the bastion.

The loss of the Christians did not exceed two hundred. Even this was a heavy loss to the besieged, and included some of their best knights, to say nothing of others disabled by their wounds.

Still it was a signal victory; and its influence was felt in raising the spirits of the besieged, and in inspiring them with confidence. La Valette was careful to cherish these feelings. The knights, followed by the whole population of Il Borgo, went in solemn procession to the great church of St. Lawrence, where the Te Deum was chanted, while the colours taken from the infidel were suspended from the walls as glorious trophies of the victory.—*Philip II.* vol. 2.

CHAPTER 18

Death of La Valette

Still pressing forward to the fight, they broke
Through flames of sulphur, and a night of smoke.
Till slaughtered legions filled the trench below,
And bore their fierce avengers to the foe.

Addison.

Mustapha, finding his losses so great and his success so small, determined not to attempt another assault for some time, and turned his attention entirely to battering down the defences with incessant cannonading. He erected new batteries which poured a continual storm of iron and marble shot upon the fortifications, and into the town itself. Many non-combatants, including women, were thus killed in the streets; but this fresh danger seems to have roused a spirit of resistance which pervaded all classes. A corps of two hundred boys was organized who, armed with slings, hurled a shower of stones whenever there was seen a knot of the enemy. Women carried stones up to the ramparts, and prepared vessels and fires to boil water and oil, to be poured on the heads of those who attempted to scale the walls, or worked side by side with the men in repairing the breaches made in the walls.

La Valette directed all. He seemed to be endowed with ubiquity. He was seen by one kneeling at prayer in the church; by another directing the construction of some defence; he was now in the council chamber; now upon the walls exposing himself without hesitation like a common soldier; presently he was at the bedside of some wounded or dying knight in the hospital, and last, not least, he was sending urgent messages to the Viceroy of Sicily, imploring him no longer to delay in sending the much-needed reinforcements.

He never spared himself. He despatched his own nephew, to whom

he was tenderly attached, to command a forlorn hope sent out to destroy a new work which the Turks were constructing, and the brave young knight was shot down as he was hewing away at some timber that formed part of the work.

An attempt was at once made by the Turks to secure his body; for the *pasha* gave a reward for every knight's head brought in; but his comrades who had retreated rushed out and carried the remains of their brother safely into their lines. When La Valette heard of the death of his nephew, he said, "All the knights are alike dear to me, I consider them all my children; the death of any is equally sad to me. After all, my nephew has but got the start of us for a few days; for, if the Sicilian succour does not come soon, we must die to a man, and be buried under the ruins of Malta."

On another occasion, being told through a deserter that Mustapha had sworn that, when he took the place, he would put every knight to death except the Grand Master, whom he should carry to the Sultan, he replied, "I shall take good care to prevent that, for, if it comes to the last extremity, rather than that a Grand Master of Malta should be taken in chains to Constantinople, I will dress myself like a common soldier, rush into the midst of the enemy, and die among my brethren unknown."

After a fortnight's incessant cannonading, by which the walls were terribly shattered, and several yawning breaches were made, another general assault was commenced. Mustapha commanded in person, and all his officers freely exposed themselves in leading on their men.

All day the fight continued; but still the Christians kept their enemies at bay, though with sad loss, and at the greatest sacrifices, having to contend incessantly with superior forces, fresh detachments of whom came on, as others were wearied or beaten.

Night alone put an end to the unequal contest, and next day it was renewed. No one could leave the walls; provisions were carried there, and men ate and drank, sword in hand, and rushed back to the fray.

This went on till August 7, when a mine was suddenly sprung under the bastion of Castile, and in a few moments the Turks were mounting the breach by hundreds, and their standards were upon the walls. But La Valette and his knights were soon on the spot, and a fierce and bloody hand to hand fight ensued. The church bells were rung, and every one rushed to defend the castle or to die; even the sick rose from their beds and tottered to the scene of the struggle. Inch by inch the ground was contested; but gradually the Christians advanced, the

Turks fell back; and Malta was saved once more.

But La Valette would not retire, believing that the attack would be renewed during the night. His anticipations proved correct. A sudden assault was made, favoured by darkness, and, after a fierce struggle, was successfully resisted.

But this could not go on indefinitely. The fortifications were knocked to pieces; many of the best knights were slain; the garrison was growing smaller, and insufficient to man the walls; the hospitals were full of the sick and dying; the ammunition was coming to an end.

And, while the besieged were thus crippled, the besiegers were also in a miserable condition. Their losses had been enormous. Disease was carrying off as many as the sword; provisions were becoming scarce; for the ships that should have brought fresh supplies had been intercepted and taken. Commanders and soldiers were dispirited, and were ready to give" up the attempt upon Malta as hopeless.

One more desperate assault was made towards the end of August, but with the same result as the others. Bravery on both sides, slaughter, obstinate contests, attack renewed, met, resisted, baffled. At the end of the day the Christians still held the bloodstained and tottering walls.

But the end had now come. At the beginning of September, the long-desired Sicilian fleet was seen steering for Malta. Diplomacy, selfishness, hesitation, had had their full sway in the counsels of the Viceroy; but a better mind had come at last, and when succour was despaired of, it came. Twenty-eight ships, with eleven thousand Spanish troops on board, among whom were two hundred knights of the Order from different countries, after suffering much from storms, anchored off the further side of the island.

Mustapha at once saw that his only safety was flight. His wearied and diminished forces were no match for these fresh troops, whose numbers were magnified in the reports he received. St. Elmo was at once abandoned; even the cannon were left behind; and La Valette immediately caused the trenches to be filled up and the castle occupied by his troops, who speedily raised once more the banner of St. John upon the battered walls.

Mustapha, however, fearing the wrath of his master, made yet one more effort to recover his position. He moved round to St. Paul's Bay, and disembarked his army once more.

No sooner did the newly-arrived troops hear of this than they clamoured to be led against the enemy.

A battle ensued, in which the Turks were completely defeated by the impetuous attack of the knights and Spanish and Sicilian army, eager to share in the honours of their brethren, and to strike a blow against their enemies. The Turks were driven back with great slaughter; and the remnant escaped on board their ships and set sail.

Thus ended the famous Siege of Malta, one of the most memorable in history. Whether we consider the heroic resistance by a small garrison against a vastly superior force, or the important results to the religion and liberties of Europe, we must see that the successful defence of Malta by its Knights, and especially by the genius and singular ability of La Valette, deserves a place in the memory of all who respect courage and endurance, and of all who call themselves Christians, and know what desolation ever follows the footsteps of the Turk wherever he holds dominion. Had Malta fallen, Sicily and Italy would soon have been attacked, and the Mediterranean would have seen the Crescent domineering over many of its fair cities.

The victory had nevertheless been purchased at heavy cost. Two hundred knights fell, and about three thousand soldiers, besides seven thousand of the inhabitants of the island. Everywhere there was ruin and desolation.

When the newly-arrived knights met their brethren who had survived the siege, they saw them pale, haggard, half starved, and worn out with want of sleep. They found an empty treasury, ruined fortifications, and scarcely a house in the town that was not in danger of falling. But La Valette received them and entertained them hospitably.

The Viceroy of Sicily shortly after visited the island, and was beyond measure astonished, seeing the utterly ruined condition of the defences, that the place had held out as it had. He renamed the town *Vittoriosa*, "The Victorious," a title which still belongs to it.

When the danger was over, the crowned heads of Europe, who had sent La Valette no aid in the time of his dire necessity, lavished praises and presents upon him. For these he cared little; but, fearing that the Turks would return to avenge their losses and defeat, he begged for aid to rebuild his fortifications, and prepare for future attacks.

This appeal was not unsuccessful, and aid in men and money came in liberally.

La Valette, profiting by the experience the siege had given him, determined to transfer his capital to a more secure position. He selected the high ground of Mount Sceberras which commanded both harbours, and there erected the convent and other buildings, surrounding

all with very strong walls and other defences.

The first stone was laid with great ceremony and state on March 28, 1566, and the new city was called in honour of its founder, *Valetta*, though La Valette himself selected the name or title of *Umillima*, "most humble."

St. Elmo was not forgotten. The castle was enlarged and much strengthened, and batteries were erected upon the peninsula and adjoining rocks.

So eager was La Valette to get these works finished, which he considered the key of the whole island, that he spent his time entirely among the workpeople, even taking his meals on the spot, in the midst of carpenters and masons, and receiving ambassadors and deputations, for two whole years.

He was, however, so short of money to meet these costly undertakings, that he was obliged to coin brass tokens of nominal value with which to pay the workmen. These pieces bore on one side the arms of the Order, and on the other the legend, *non æs sed fides*. As funds came in, these tokens were honourably exchanged for their full value.

A fruitful source of revenue was derived from the navy of the knights. Their ships, well armed and manned, and navigated with all the skill of the period, constantly made attacks upon the vessels and territories of the Turks and Moors, and almost always with success, returning home laden with treasure.

Solyman died soon after the return of his fleet from the disastrous expedition against Malta. A fire, which destroyed the dockyard and ships at Constantinople, put it out of the power of the Turks to make another attack by sea, and they devoted their attention to a campaign against Hungary.

La Valette died in 1568. With his death the more striking incidents in the history of the Order end. But for more than two centuries it maintained its independence, and continued to follow its traditional rule, of making war on the enemies of the Christian faith, "and while empires rose and crumbled around them, this little brotherhood of warlike monks, after a lapse of more than seven centuries from its foundation, still maintained a separate and independent existence."

CHAPTER 19

Malta Again Attacked by the Turks

He razed towns, and threw down towers and all;
Cities he sacked, and realms that whilom flowered
In honour, glory, and rule above the rest.
He overwhelmed, and all their fame devoured,
Consumed, destroyed, wasted, and never ceased
Till he their wealth, their name, and all oppressed.
 Sackville.

In 1571 the decisive battle of Lepanto was fought, in which the ships of the Order took part.

This battle has been deservedly reckoned as one of the "decisive battles" of the world's history. It put a final check upon the advance of the Turkish power in Europe, and was a turning point in the history of that power, which from that time has been steadily losing strength, and falling into decrepitude. So much so, that those who merely know it from its present condition, and who do not read its history, are unable to judge of the debt that it owes to Europe through the dreadful injuries done to Christianity, to liberty, civilization, and progress for centuries, by the depredations of its armies, and the ruinous policy of its government.

The awful cruelties perpetrated by the Turks on the capture of Cyprus (1570-71) stirred up all Europe, except England, to prevent the onward progress of the Moslem superstition.

The Turkish general, Mustapha, after long resistance, having gained possession of Cyprus, which was then held by the Venetians, notwithstanding his solemn promise that no one should be injured, first massacred every one of the garrison in cold blood, after they had laid down their arms, and then gave up the whole island to unrestrained

pillage. The old men and women and a multitude of children were gathered into one of the public squares and burnt alive.

"Women threw themselves from the house-tops to escape from their pursuers; mothers slew their daughters rather than that they should fall into the power of the brutal foe. More than twenty thousand human beings were slaughtered on the day of the assault."

The whole history of Turkish conquests is marked by scenes such as this. To put a stop to these atrocities a league was formed, and a large fleet equipped, including galleys from Malta. The Turkish navy was met at Lepanto, and, after an obstinate and bloody battle, a decisive victory was obtained by the allies. The enemy lost most of his ships, and thirty thousand men. The commander was killed, his two sons, and five thousand officers and men were taken prisoners. Twenty thousand Christians, who had been made prisoners, and compelled to row the galleys of their enemies, were happily released, and Europe rejoiced to find herself freed from a deadly enemy.

For centuries the Grand Masters of the Order of St. John had urged the European sovereigns to lay aside their party quarrels, and unite in opposing the common foe of their religion and civilization, but in vain. The battle of Lepanto was a tardy proof of the wisdom of their advice, and of its practicability.

In the same year, 1571, the new city of Valetta was finished, and the Order took up its residence in it with much pomp and ceremony.

In 1574 the Sultan Selim II. threatened another siege of Malta, but finding it so strongly fortified, gave up the idea, and sent his fleet against Tunis.

The records of the Order chronicle a variety of disputes with the Pope, with the Venetians, with France, and other powers, but nothing of historical interest seems to have transpired for some years.

The Sultan appears never to have altogether abandoned the idea of capturing Malta, seeing in it the key to European conquest.

On one occasion the Sultan, while conversing with an ambassador from one of the European powers, who was a Knight of Malta, showed him a plan of the fortifications, and asked him if it were correct; to which he replied, "Sir, he who drew this plan forgot the chief fortification, which consists in the courage and valour of a thousand knights, who are ever ready to fight to the last drop of their blood in defence of the place."

In 1615 a fleet of sixty Turkish ships appeared off Malta, and landed a body of troops. Their object was to capture some of the inhabitants,

and make them slaves, but they were, happily, unable to effect their purpose, and retired.

During the seventeenth century several disputes occurred between the Order and the Popes, who infringed upon the liberty and privileges of the knights by conferring commanderies in Italy and elsewhere upon their nominees.

A list of the members of a general chapter, held in May, 1631, is given by Vertot, and is interesting as showing the extent of the Order at this period:—

Grand Master.
The Most Serene Lord Francis Anthony de Paule.

Prior of the Church.
The Most Eeverend Imbroll.

Conventual Bailiffs.
Br. Claude Durré Ventarob, Great Commander.

Br. Francis Cremeaux, Great Marshal.

Br. Tussin de Ternez Boistrigault, Great Hospitaller.

Br. Philip de Gaetan, Great Admiral.

Br. Lewis de Moncada, Great Conservator.

Grand Priors.
Br. Juste de Fay Gerlande, Prior of Auverge.

Br. George de Castellane d'Alnis, Prior of Toulouse.

Br. Antonio Maria de Ciaia, Prior of Lombardy.

Br. Nicolas Cavaretta, Prior of Venice.

Br. Nicolas de la Marra, Prior of Messina.

Br. Philip Bardaxi, Prior of Emposta.

Capitulary Bailiffs.
Br. Signorin Gattenara, Bailiff of St. Euphemia.

Br. Francis Seno, Bailiff of Negropont.

Br. Caesar Feretti, Bailiff of St. Stephen's.

Br. Alexander Bensi, Bailiff of St. Trinity, of Venusia.

Br. Antonio Bracaccio, Bailiff of St. John, near Naples.

Br. Humphrey de l'Hospital, Bailiff of Majorca.

Br. Francis Paget Chessael, Bailiff of Manosque.

Br. Juste de Brun Laliege, Bailiff of Leon.

Br. De Rosbach, Bailiff of Brandenburg.

Br. John de Bernoi Villeneuve, Bailiff of L'Aigle.

Br. Laurence de Figueroa, Bailiff of St. Sepulchre.

Br. Lucius Grimaldi, Bailiff of Pavia.

Br. Lewis of Britto Mascarnay, Bailiff of Acre.

Br. James Christopher Abandlau, Bailiff of ——.

Br. Alexander Orsi, Bailiff of ——.

Lieutenants of the Conventual Bailiffs.

Br. Matthias James Phirt, Lieutenant of the Bailiff of Germany.

Br. Thomas Hozis, Lieutenant of the Great Chancellor.

Proxies of the Priors.

Br. Biagio Brandoa, for the Most Serene Ferdinand Cardinal Infant, Administrator of the Priory of Portugal.

Br. Francis Buonaroti, for the Most Illustrious Don John Charles de Medicis, Prior of Pisa.

Br. Anthony Scalamonte, for the Illustrious Br. Aldobrandino Aldobrandini, Prior of Rome.

Br. Triston de Villeneuve, for Br. James de Mauleon la Bustide, Prior of St. Giles.

Br. Robert de Viole Soulere, for Br. William de Meaux Baudrau, Prior of France.

Br. Charles de Vanjure, for Br. Peter de Beaujeu, Prior of Champagne.

Br. Julio Amali, for Br. Peter Vintimiglia, Prior of Capua.

Br. Martin de Redin, Prior of Navarre (appeared in person) .

Br. Policarpe de Casteloi, for Br. Peter George Pridorsila, Prior of Catalonia.

Br. Lewis Melzi, for Br. Frederic Huntd, Prior of Ireland.

Br. Anthony Pontremoli, for Br. Arteman, Prior of Hungary.

Br. Eberard, Baron d'Estain, for Br. Theodore Rolman, Prior of Denmark.

Br. Don John de Zuinga, for Don Bernardin de Zuinga, Prior of Castile and Leon.

Proxies of the Capitular Bailiffs.

Br. John Baptiste Calderari, for the Eminence Cardinal Comaro, Great Commander of Cyprus.

Br. Baldassar de Marzilla, for Br. Lapert de Arbiza, Bailiff of Caspe.

Br. Francis de Godoi, for Br. Don Diego du Guzman, Bailiff of Lora.

Br. Joachim de Challemaison, for Br. James de Chenu de Bellai. Bailiff of Armenia.

Br. Gabriel Dorin de Ligny, for Br. James du Liege Charault, Treasurer-General.

Br. Don Lewis de Cardenas, for the Illustrious Bailiff, Br. Ca-

raffa.

Br. Gaspard de Maisonseule, for Br. Achilles d'Estampes Valençay.

Proxies of the Languages.

Provence: Br. Francis Bagarris.

Auvergne: Br. Charles de Fay Gerlande.

France: Br. Alexander de Grimonval.

Italy: Br. Octavio Ceoli.

Aragon, Catalonia, and Navarre: Br. Gerome Bardaxi.

Germany: Br. John James de Welthause.

Castile and Portugal: Br. Gabriel d'Angulo.

England: (suppressed.)

Proxies of the Commanders of the Priories.

St. Giles: Br. Henry de Latis Entragnes.

Toulouse: Br. Francis de Crotes de la Menardie.

Auvergne: Br. Peter Lewis Chautelot la Chese.

France: Br. Peter de Carvel de Merai.

Champagne: Br. Joachim de Senuevoi.

Rome: Br. Curtius Bombino.

Lombardy: Br. Alphonso Castel de St. Pierre.

Venice: Br. Fiorni Borso.

Pisa: Br. Ugolin Grisoni.

Barletto: Br. Gerolamo Zato.

Messina: Br. Philip Morletti.

Capua: Br. Alphonso Dura.

The Castellany of Emposta: Br. Peter Marzella.

Catalonia: Br. Melchior Duretta.

Navarre: Br. Francis Torreblanca.

Germany: Br. John de Repach.

Castile and Leon: Br. Alphonso de Angulo.

Companions of the Grand Master.

Provence, Br. Girolamo de Merle Beauchamps, Cavalcadour of the Grand Master, and Br. Peter de Bernana Hornolach.

Auvergne: Br. Baldasser d'Alben, and Br. Foucand de St. Hilare.

France: Br. Adrian de Contremoulins, and Br. Francis de la Grange.

Italy: Br. John Minutolo, and Br. Mario Alliata.

Aragon, Catalonia, and Navarre, N.N.

England: Br. John Baptisto Macedonio, and Br. Stephen del

Portico.

Germany: Br. William Henry de Wasperg.

Castile and Portugal: Br. Gondisalvo de Albernoz, and Br. Don Bernardin de Norogna.

The principal officers of the Order were usually assigned as follows:—

Grand Commander,	the Bailiff of	Provence.
Marshal	,,	Auvergne.
Grand Hospitaller	,,	France.
Admiral	,,	Italy.
Grand Conservator	,,	Aragon.
Turcopolier[1]	,,	England.
High Bailiff	,,	Germany
High Chancellor	,,	Castile.

In 1632, a census of the inhabitants of Malta and Gozo was taken, and it was found that the population amounted to fifty-one thousand seven hundred and fifty, men, women, and children, besides the knights of the Order, and the clergy.

In 1645, in consequence of frequent losses inflicted upon the Turkish trading vessels by the galleys of the Order, the Sultan declared war against it. Great preparations were made at Malta for the expected attack, but it never came; the Sultan sending an expedition against Candia instead.

In 1647 the Pope, Innocent X., again gave away commanderies belonging to the Order, against which vigorous protests were made.

The progress of Reformation in Germany deprived the Order of many of their commanderies there.

In 1650 a library was founded at Malta, and a law passed that all books belonging to the knights should at their deaths become the property of the Order.

In 1675 the King of England, Charles II., declared war against the pirates of Tripoli, and his ships were received and assisted in the ports of Malta. The king afterwards wrote to thank the Grand Master for his courtesy.

In 1676 a dreadful plague carried off many of the knights, and

1. The Turcomans gave the name Turcopoles to such children as were born of a Greek mother and a Turcoman father. It was afterwards a title of military dignity in the kingdom of Cyprus, from whence it was adopted into the Order of St. John, where it was used for the colonel-general of the infantry.

other inhabitants of Malta. During this century the fortifications of the island were continually increased and strengthened; war was perpetually maintained with the Moslems; difficulties and disputes occurred respecting the appointment of officers in the different European countries, and in obtaining corn and other supplies, which the island cannot produce. Disputes arose at the election of Grand Masters, and with the Pope, on account of the arbitrary appointment of his friends to important and lucrative posts in the Order. Reports were more than once received that the Sultan had prepared large armaments for attacking Malta, but they proved incorrect; the signal defeat of the Turkish forces before Vienna and other causes having greatly weakened the Ottoman power.

Complaints were made of the assumptions of the Inquisition in Malta, their pretensions being found inconsistent with the rights and liberties of the Grand Master and the knights; and in consequence the power of the inquisitors was much curtailed and limited.

The pirates of Algiers and other places continued to be very troublesome, and to make raids upon the towns of the Italian coast and other parts of the Mediterranean, and also upon the merchant shipping, carrying off many persons into slavery. The galleys of the knights were consequently incessantly at sea, pursuing and taking the pirates, and releasing the unfortunate Christian captives. But these conflicts cost them many valuable lives, and often the loss of their ships.

In 1723 the Turks again attacked Malta, but finding the place so strong, retired, after cannonading the town and forts for some time, without attempting to land any troops, or to commence a regular siege.

In 1783 a terrible earthquake laid the city of Messina in ruins, and the sufferings of the surviving inhabitants were terrible. In this great calamity the knights of the Order devoted themselves to the care and relief of the sufferers, thus exhibiting in the last years of their corporate existence, the same Christian charity which had distinguished them from the time of their foundation six hundred years before.

CHAPTER 20

Napoleon Bonaparte

A fouler vision yet; an age of light,
Light without love, glares on the aching sight.

Christian Year.

But a new order of things was coming. The Revolution that broke out in Paris at the end of the eighteenth century, not only swept away the Throne and the Church, with all its dependent corporations and associations in France, but speedily spread itself over Europe.

The Republican armies everywhere abolished public worship and the profession of Christianity. Gradually, as one Government after another ran its short course, and was supplanted by another, the power was more and more concentrated in the hands of a few; and step by step Napoleon Bonaparte rose to the height of authority, till he became Emperor, the despotic and autocratic ruler of France, which had so lately and so emphatically declared itself eternally republican.

The Revolution abolished the *ancien régime* in France, and indirectly in every country in Europe. The French armies swept over the continent, kings were dethroned, national boundaries were changed, rulers and states were abolished, the whole face of Europe was entirely altered. Napoleon was not satisfied with being the master of France; he aspired to rule the world, to map out its countries according to his will, and subject all people to his dictation.

It was not to be expected that such an old-world institution as the Order of St. John would escape, when thrones were falling, and when "times and laws were changed."

In September, 1792, a decree was passed, by which the estates and property of the Order of St. John in France were annexed to the state. Many of the knights were seized, imprisoned, and executed as aristo-

140

crats. The principal house of the Order in Paris, called the Temple, was converted into a prison, and there the unfortunate Louis XVI. and his family were incarcerated.

The Directory also did its best to destroy the Order in Germany and Italy; and the requirements of war led to the heavy taxation of its property in Spain, Portugal, Naples, Sicily, and Piedmont, so that the revenue was reduced by two-thirds of its amount, and it was found necessary to melt down the plate and coin money to pay the sailors, and to buy corn.

All this time the Directory had agents in Malta, who were propagating revolutionary doctrines, and stirring up the lowest of the people to rebellion and violence.

There were in the island 332 knights (of whom many, however, were aged and infirm), and about 6000 troops.

On June 9, 1798, the French fleet appeared before Malta, with Napoleon himself on board, and a few days after troops were landed, and began pillaging the country. They were at first successfully opposed by the soldiers of the Grand Master, but the seeds of sedition, which had been so freely sown, began to bear fruit, and the soldiers mutinied, and refused to obey their officers. All the outlying forts were taken, and the knights who commanded them, who were all French, were dragged before Napoleon.

He accused them of taking up arms against their country, and declared that he would have them shot as traitors.

Meanwhile sedition was rampant within the city. The people rose and attacked the palace of the Grand Master, and murdered several of the knights. They demanded that the island should be given up to the French, and finally opened the gates, and admitted Napoleon and his troops.

After some delay, articles of capitulation were agreed upon, Malta was declared part of France, and all the knights were required to quit the island within three days.

Napoleon sailed for Egypt on June 19, taking with him all the silver, gold, and jewels that could be collected from the churches and the treasury, together with a vast number of trophies and historic relics belonging to the Order, most of which were lost shortly after, when the ships that carried them were blown up at the battle of the Nile.

In the following September, 1798, Nelson besieged, and quickly obtained possession of the island, which has ever since remained in the hands of the English.

In this way the ancient Order of St. John ceased to be a sovereign power, and practically its history came to an end.

The last Grand Master, Baron Ferdinand von Hompesch, after the loss of Malta, retired to Trieste, and shortly afterwards abdicated and died at Montpelier, in 1805.

Many of the knights, however, had in the meantime gone to Russia, and before the abdication of Hompesch, they elected the Emperor Paul Grand Master, who had for some time been protector of the Order. This election was undoubtedly irregular and void.

By the terms of the Treaty of Amiens in 1802, it was stipulated that Malta should be restored to the Order, but that there should be neither French nor English knights. But before the treaty could be carried into effect Napoleon returned from Elba, and war broke out again. By the treaty of Paris in 1814, Malta was ceded to England.

At the death of the Emperor Paul, in 1801, the Emperor Alexander proclaimed himself Protector of the Order of St. John of Jerusalem, and appointed Count Nicholas de Soltykoff, lieutenant.

In 1801, the assembly of the Knights at St. Petersburg took the title of "The Sovereign Council of the Order of St. John of Jerusalem," and petitioned Pope Pius VII. to select a Grand Master from certain names which they sent. This he declined to do, but, some time afterwards, at the request of the Emperor Alexander, and the King of Naples, and without consulting the knights, the Pope appointed Count Giovanni di Tommasi Grand Master. He died in 1805, and no Grand Master has been since appointed.

On his deathbed, Tommasi nominated the bailiff, Guevara Suardo, Lieutenant Master. He was succeeded, in 1814, by Giovanni y Centellès; by Count Antoine Busca, in 1821; by Prince de Candida, in 1834; by Count Colleredo, in 1845; by Count Alexander Borgia, in 1865; and by the Marquis de Santa Croce, in 1872.

These lieutenants have presided over an association of titular knights at Rome, which is styled "the Sacred Council."

In 1814, the French knights assembled at Paris and elected a capitulary commission for the government of the Order. This act was confirmed by Pope Pius VII., and recognized by the Lieutenant Master, the Sacred Council, the Kings of France and Spain, and by the Knights of Spain and Portugal, who had refused to be incorporated into a new royal Order.

Thus five-sixths of the divisions of the Order were represented and acted unanimously. George IV. of England accepted the badge of the

Order from the chapter in Paris.

In or about the year 1826, the English *Lange* of the Order of the Knights of Malta was revived. Two knights of the French branch of the Order, the Chevalier Victor Comte de Totemps Feuillasse, and the Chevalier Comte Philippe de Chastelani, came as delegates and invested with the functions and authority of Grand Prior of England the Rev. Sir Robert Peat, who attended at the Court of Queen's Bench, and took the oaths as Lord Prior of St. John in Great Britain.

A regular succession of Priors has been continued to the present time, and the Duke of Manchester is the present Prior.

The members of the Order devote themselves to relieving the poor, and assisting hospitals.

In London they have largely assisted the poor outpatients of Charing Cross, and King's College Hospitals, by providing them with nourishing food.

A Convalescent Hospital has also been founded and maintained by them at Ashford, in Kent.

They give medals and certificates for bravery in saving life, especially in such cases as are not provided for by the *Royal Humane Society*, and the *Society of Protection of Life from Fire*, such as accidents from machinery in mines and railways.

They have provided and maintain a complete ambulance service for use in the mining and colliery districts. They have also founded the *National Society for the Aid of the Sick and Wounded in War*, and an association for providing trained nurses for the sick poor.

At a meeting of the chapter in December, 1871, a code of statutes was adopted, and revised at a chapter in May, 1875.

It is provided that the ancient statutes of the Order are acknowledged so far as they are compatible with the principles of the Church of England, allegiance to the reigning sovereign and the existing state of English society. The English branch is to consist of

Members.
Bailiffs:—The Lord Prior; The Bailiff of Eagle.
 Chevaliers Commanders.
 Chevaliers of Justice:
 Chaplains.
 Ladies of Justice.
 Chevaliers of Grace .
 Esquires.

Associates.

Honorary Associates.

Donats.

Serving Brothers and Sisters.

The object and purposes of the Order are:—

1. Generally the encouragement and promotion of all works of humanity and charity in the relief of sickness, distress, suffering, and danger, and the extension of the great principle of the order, "*Pro utilitate hominum.*"

6. The award of silver and bronze medals for special services on land in the cause of humanity, especially for saving life in mining and colliery accidents.

4. All members of the Order must be of legitimate birth, and of good social position.

9. The Chevaliers of Justice must be in the enjoyment of an honourable position in life, and must give satisfactory proof that they are descended from four grandparents entitled to coat-armour.

12. The Chevaliers of Grace are chosen from persons who possess the same social qualifications as the Chevaliers of Justice, or who by reason of marked services to the Order or in furtherance of its objects, may be considered worthy of admission. They may become Chevaliers of Justice.

14. Any Chevalier of Justice may nominate an esquire as a candidate for admission to that class, on becoming sponsor that he is a Christian, of liberal education, eminent for virtue and morals, in an honourable position in life, and possesses the qualification of legitimacy he has no vote, and is not eligible for office.

15. Persons who are eminent for their philanthropy and charity, or who have devoted their exertions or professional skill in aid of the objects of the Order, or otherwise in the cause of humanity, may be elected honorary associates.

16. Serving brothers and sisters are chosen from amongst those who, from a spirit of charity, devote themselves to the care of the sick, and their energies to the objects of the Order.

18. A general assembly of the Order will be held on St. John Baptist's Day.

The present officers are:—

Lord Prior: the Duke of Manchester.
Bailiff of Eagle: Lord Leigh.
Receiver and Secretary: Sir Edmund A. H. Lechmere.
Chancellor: Sir John St. George.
There are 53 Chevaliers of Justice; 17 Chaplains; 12 Ladies, of whom the Princess of Wales is one; 21 Chevaliers of Grace; 15 Esquires; 29 Honorary Associates of both sexes; 11 Donats, and 2 Serving Brothers.

Among the works undertaken by the Order is the maintenance of an ambulance at Burslem, the providing of nourishing food for outpatients of King's College and Charing Cross Hospitals, and the Worcester Dispensary, and the support of a cottage hospital at Ashford in Kent.

There has also been some assistance given to patients of the hospital at Wolverhampton; and medals for bravery, and saving life in mines, have been bestowed.

Appendix 1

The following is a list of the convents of the Knights of St. John in England.

Bedfordshire: Melchbourne.

Berkshire: Brimpton.

Buckinghamshire: Hogshaw.

Cambridgeshire: Chippenham, Shengay, and Great Wilbraham.

Cheshire: Barrow.

Cornwall: Treby.

Derbyshire: Yeaveley and Waingrif.

Dorsetshire: Fryer-Mayne.

Essex: Temple-Cressing and Little Maplestead.

Gloucestershire; Quennington.

Hampshire: Baddesley and Godesfield.

Herefordshire: Dinmore.

Hertfordshire: Temple-Dynnesley and Standon.

Kent: Peckham, Swingfield, and Sutton.

Leicestershire: Dalby, Heather, Temple-Rothley, and Swinford.

Lincolnshire: Temple-Brewer, Eagle, Wilketon, Mere, Maltby, Witham, Aslackby, and Skirbeck.

Middlesex: Clerkenwell and Hampton.

Norfolk: Carbrooke and Holstone (or Hawston).

Northamptonshire: Dingley.

Oxfordshire: Temple-Cowley (or Sandford) and Gosford.

Somersetshire: Temple-Combe.

Suffolk: Battisford and Gislingham.

Sussex: Poling.

Warwickshire: Warwick and Temple-Balsall.

Wiltshire: Anstey and Temple-Rockley.

Yorkshire: Beverley, Newland, Mount St. John, and Ribstone.

Wales: Selbech.

There was also a convent of Nuns of the Order at Buckland, in Somersetshire.

[Some of the above were Preceptories of the Knights Templars, conveyed to the Knights of St. John at the dissolution of the Order of the Temple.]

Appendix 2

A very touching record of the deaths of the Knights of the Order, compiled from the archives, was published by M. Goussancour.

The following extracts will give some idea of the nature of the work, and by their simple and brief memorials will suggest many thoughts as to the devotion, unknown sufferings, and constancy of these brave men:—

Brother Antoine de Mailly Picard, of the French *Lange*, died in slavery, A.D. 1340. (There are a great many similar entries.)

Brother Antoine Marigny, of the French *Lange*, was killed in battle at sea, A.D. 1557.

Brother Jean Morisot, of Dijon, was attacked, while sailing from Malta to Genoa, by three Algerian brigantines. After an obstinate fight, and much slaughter on both sides, he was taken prisoner, and carried to Algiers by the Corsair Gascon, grievously wounded. After suffering many tortures rather than deny the faith, he died a martyr's death, July 7, 1625.

Br. Jacques Mitte died of the plague at Viterbo, A.D. 1523, having suffered great privations after the loss of Rhodes.

Br. Martin de Marginet was captain of a galley which was captured in 1538 by Barbarossa. Refusing to deny Christ, he was beheaded upon the deck of his own ship.

Br. Gaspard de Poisieaux, of the *Lange* of Auvergne, having built a ship at his own cost, fought many battles. In 1626 he lost his sight, and a part of one arm, and had his thigh broken, and died content to sacrifice his life for God and religion.

Br. Simon Paraire d'Aragon, hearing a number of Turks at Zoara uttering blasphemies against our Saviour, rushed upon them to avenge the honour of his Master, and died A.D. 1552.

Br. Thomas Busquet, a native of Languedoc, was impaled at Constantinople, A.D. 1608.

Br. François Fleurac was one of thirteen who were taken prisoners at the capture of Fort St. Elmo by the Turks in 1565. They were all crucified, their breasts gashed in the form of a cross, and then thrown still living into the sea.

Br. Aloisius Fuentes de Castile, of the Royal house of Aragon, while yet a novice, sought a higher crown than his birth accorded to him, and fell fighting the Turks, A.D. 1602.

Brother George Haultoy was one of those who were crucified head downwards by the Turks A.D. 1562,

PART 2
THE KNIGHTS TEMPLARS

Verily I say unto you, There is no man that hath left house, or brethren, or sisters, or father, or mother, or wife, or children, or lauds, for My sake, and the Gospel's, but he shall receive an hundredfold now in this time, houses, and brethren, and sisters, and mothers, and children, and lands, with persecutions; and in the world to come eternal life.—St. Mark x.

The Second Crusade

The firmest bulwark of Jerusalem was founded on the Knights of the Hospital, and of the Temple, the strange association of a monastic and military life.—Gibbon.

It was during the brief tenure of Jerusalem and the Holy Land by the Christian kings, set up after the successful issue of the First Crusade, that the Order of the Knights Templars had its beginning.

There does not seem to have been in the origin of this Order any special care of pilgrims at Jerusalem, as was the case with the Hospitallers.

It was from the first a purely military foundation; but bound by religious vows, and under the strictest discipline.

The earliest names in connection with the Order are those of Hugh de Payens and Geoffrey de St. Omer, who, with seven other gentlemen, dedicated themselves as the *Poor Soldiers of Jesus Christ*, to fight in defence of the Holy Places, and to keep the roads to them free and safe for pilgrims. In addition to this they took the usual three vows of poverty, chastity, and obedience, after the manner of Canons Regular.

In A.D. 1118, during the reign of Baldwin IL, King of Jerusalem, a house was granted them upon Mount Moriah, where the Temple had stood. From this house they came to be known as the Knights Templars.

The first Templars were brave and tried soldiers, who had already done good service during the Crusade, and their reputation and the honourable object of their brotherhood soon attracted kindred spirits to their side.

At first they were very poor, and their seal represented two knights

riding upon one horse.

St. Bernard was at this time in the zenith of his reputation, and Baldwin, seeing the value of such an Order for the maintenance of the Latin kingdom in the East, sent a deputation of two knights to solicit his intercession with the Pope for the authoritative establishment of the Templars. Bernard gladly assisted the scheme, and through his influence the Order was formally recognized at the Council of Troyes, A.D. 1128.

The rule and statutes of the Order were drawn up by Bernard himself, founded as far as possible upon the Cistercian rule, and were therefore of the strictest and most ascetic character.

The brethren were to be regular and constant in public and private devotions, to speak little, to give alms, to be gentle and courteous to the weak, the aged, the sick, to observe the fast days, and never to have anything but a spare and frugal diet. The garment of the knights was to be white, to remind them "to commend themselves to their Creator by a pure life." No gold or silver was to be upon their bridles, armour, or spurs; no hunting or hawking was permitted. Probationers were to be well tried before they were permitted to enter the Order and take the vows, and no person was to be admitted till he was of years of discretion. Transgressions of the rule were to be punished with severity, by stripes, temporary separation of the offender from his brethren, and other penalties.[1]

After the confirmation of the Order and its rule by the Pope, Hugh de Payens travelled through France and came to England. Noblemen and gentlemen soon joined him, and gifts of money and lands came in freely, and King Stephen himself favoured the Order.

In France men of the highest rank enrolled themselves; but no favour was shown to them on account of their birth and blood; all were equal as Templars, and those who had been guilty of crimes or excesses were required to make reparation and undergo prolonged probation. Some even of royal blood left their dominions and retired to the ranks of the Templars, and almost every country in Europe soon had its house and branch of the Order. Bernard continued his support, and published a treatise, "In praise of the new Chivalry," addressed, "to Hugh, Knight of Christ, and Master of the Knighthood of Christ;

1. Unlike other Religious Orders, they wore their beards long. Their habit was originally white, signifying the purity of life to which they were called, but soon after a red cross was added, to remind them that they must be ready to shed their blood for the defence of the faith and for the servants of Christ.

"in which he contrasts the temper and habits of ordinary knights and their warfare with the high and noble aims and practice of the Knights of the Temple, and concludes with a high-flown apostrophe to Jerusalem as the seat of this Order, "the mistress of the nations, and the glory of the Christian people."

Alas, how often have good men's high hopes and ideals been frustrated and broken down!

"The Templars," says St. Bernard, "live together in an agreeable but frugal manner, without wives or children, or having anything in property to themselves, even so much as their own will. They are never idle, nor rambling abroad; and when they are not in the field marching against the infidels, they are either fitting up their arms and the harness of their horses, or else employing themselves in pious exercises by order of their superior. An insolent expression, immoderate laughter, or the least murmur, does not pass without a severe correction. They detest cards and dice, they are never allowed the diversion of hunting, or useless visits; they abominate all shows, drolleries, discourses, or songs of a loose nature; they bathe but seldom, are generally in an undress, their face burnt with the sun, and their look grave and solemn. When they are entering into an engagement, they arm themselves with faith within and with steel without, having no ornaments, either upon their dress or upon the accoutrements of their horses; their arms are their only finery, and they make use of them with courage, without being daunted, either at the number or force of the barbarians; all their confidence is in the Lord of Hosts; and in fighting for His cause, they seek a sure victory, or a Christian and honourable death."

In A.D. 1129, Hugh de Payens, having seen his Order established in almost every country in Europe, and daily increasing in numbers and influence, returned to Palestine at the head of a considerable body of knights; and plans were immediately arranged for the protection and extension of the Latin kingdom.

Hugh de Payens, the first Grand Master, died in A.D. 1136, and was succeeded by Lord Robert, son-in-law of Anselm, Archbishop of Canterbury, who, after the death of his wife, had taken the vows and habit of the Templars.

But evil times were coming upon the Christians in the East. The Mahometans had found a new and able leader in Zinghis, who, with his son Noureddin, aroused them to fresh activity and aggression.

Several battles were fought, in all of which the Christians were defeated, and city and fortress, one after another, fell into the hands

of the followers of the prophet, till at last the important stronghold of Edessa was captured, and the Christian dominion in Palestine was in the greatest peril.

An appeal was made to the Pope, who commissioned Bernard to preach a Second Crusade. A general chapter of the Templars was held in Paris, A.D. 1146, at which the King of France, Louis VII., the Pope, Eugenius III., and a multitude of bishops, and nobles from every country of Christendom, together with 130 Templars, were present.

It was on this occasion that the Templars placed upon their white habits and mantles the red cross, already referred to, which became henceforth the distinguishing badge of the Order, so that they were commonly called *Red Friars*, or *Red Cross Knights*.

In the following year the Second Crusading army inarched, the rear being protected by the Templars Tinder Everard de Barres, who was now Grand Master, and we are told by the French chronicler, Odo, the king's chaplain, that the whole army was edified by the high and noble example of military discipline, frugality, and temperance set by the Templars.

The campaign began with the siege of Damascus, and Louis, King of France, and Conrad, Emperor of Germany, joined their armies to stem the advancing torrent of the enemy. But the Mahometans were almost everywhere victorious, and the Christians reduced to the greatest straits.

The following extract from a letter sent by the Templars to their Master, who had returned to France with King Louis, will best explain their condition:—

> Since we have been deprived of your beloved presence we have had the misfortune to lose in battle the Prince of Antioch, and all his nobility. To this catastrophe has succeeded another. The infidels invaded the territory of Antioch, and drove all before them. On intelligence of this our brethren assembled in arms, and went to the succour of the desolated province. We could only get together one hundred and twenty knights, and one thousand serving brothers and hired soldiers. Your paternity knows our extreme want of money, cavalry and infantry, and we earnestly implore you to rejoin us as soon as possible, with all the necessary succours for the Eastern Church, our common mother
>
> Scarcely had we arrived in the neighbourhood of Antioch, when we were hemmed in by the Turcomans on the one side,

and the Sultan of Aleppo on the other The greater part of those whom we led are dead We conjure you to bring all our knights and serving brothers, capable of bearing arms. Perchance with all your diligence, you may not find one of us alive. Use therefore all imaginable celerity; pray forget not the necessities of our house, they are such that no tongue can express them.

It is also of the last importance to announce to the Pope, the King of France, and all the princes and prelates of Europe the approaching desolation of the Holy Land, to the intent they may succour us in person, or send us subsidies. Whatever obstacles may be opposed to your departure, we trust to your zeal to surmount them, for now hath arrived the time for perfectly accomplishing our vows in sacrificing ourselves for the defence of the Eastern Church, and the Holy Sepulchre.

On receipt of this melancholy letter, the Master, not feeling himself equal to cope with the difficulties of the situation, resigned his office, and retired to the Monastery of Clairvaux, and Bernard de Tremelay, a nobleman of high rank and distinguished reputation as a soldier was elected to succeed him (A.D. 1151).

In the meantime the Mahometan army advanced upon Jerusalem, and for a time encamped upon the Mount of Olives, till, having been defeated in a pitched battle, they retired again beyond the Jordan.

Shortly after this the Templars attempted, unaided and alone, to storm the city of Ascalon, and having breached the walls, they penetrated to the very centre of the town, but were then overpowered by numbers, and were slaughtered to a man.

CHAPTER 2

The Temple in London

The Knights of the Temple ever maintained their fearless and fanatic character; if they neglected to live, they were prepared to die, in the service of Christ.—Gibbon.

The next Grand Master was Bertrand de Blanquefort, "a pious and God-fearing man," of a noble family in Guienne (A.D. 1154). Again the Templars were always in the forefront of every battle, and performed prodigies of valour, which caused them to be honoured in every country of Europe, and they were styled by the Pope, "the New Maccabees," and St. Bernard thus describes their prowess:

When the conflict has begun they throw aside their former gentleness, exclaiming, 'Do not I hate them, Lord, that hate Thee?' They rush in upon their adversaries, in nowise fearing, though few in number, the fierce barbarism and the immense number of the enemy, so in a wonderful manner they are seen to be more gentle than lambs, and more fierce than lions, so that I almost doubt which I had better call them, monks or soldiers, unless, perhaps, as more fitting, I call them both the one and the other.

Another eyewitness of the exploits of the Templars, Cardinal de Vitry, Bishop of Acre, gives a similar glowing description of their heroic courage:

When summoned to arms, they never demand the number of the enemy, but only where they are; fierce soldiers they are in war, monks in religion; to the enemies of Christ inexorable, to Christians kind and gracious. They carry before to battle a banner half black, and half white, which they call *Beauseant*, because they are fair and favourable to the friends of Christ, but black

and terrible to His enemies.

Amalric, King of Jerusalem, in a letter to the King of France, says,

We earnestly entreat your majesty constantly to extend to the utmost your favour and regard to the Brothers of the Temple, who continually render up their lives for God and the faith, and through whom we do the little that we are able to effect; for in them, indeed, after God, is placed the entire reliance of all in the East.

The Patriarch of Jerusalem, and an eyewitness of the conduct of the Templars in battle, tells us that they were always foremost in the fight, and last in retreat; that they proceeded to battle in the greatest order, and in silence; that when the signal to engage was given by their commander, the trumpets were sounded, and then they sang Psalm 115., "*Not unto us, O Lord,*" etc., and placing their lances in rest they conquered or died. That if any one turned back, or displayed want of courage, the white mantle of his Order was ignominiously stripped off his shoulders, and he was compelled to eat on the ground for the space of a whole year, and be separated from his brethren.

The patriarch concludes, "The Templars do indeed practice a stern religion, living in humble obedience to their master, without property, and spending nearly all their lives under tents in the open fields."

St. Bernard wrote on his deathbed, three letters in behalf of the Order (A.D. 1153).

Indeed, there can be no question that up to this time the Order most literally fulfilled its promise, and was the right arm of the Christians in the East, Over and over again the ranks of the knights were thinned, often not a man survived the battle; but recruits came in, and brave and devoted men from every country in Europe, especially England and France, were ready to join the forlorn hope, to defend the Holy Places, or to die for them.

If courage and self-sacrifice could have saved the Latin kingdom, it would have continued; but the supineness of European monarchs, and their jealousies and quarrels between themselves, soon left the East almost defenceless, till the Crescent supplanted the Cross, and all the blood shed and zeal expended were lost and wasted.

The Order of the Knights Templars had now arrived at its complete organization. It consisted of three ranks, or classes, the knights, the clergy, and the serving brethren.

The knights were required to be men of gentle or noble birth, no

person of low degree being admissible. The priests were the chaplains of the Order, whose duty it was to conduct the services in the churches belonging to its convents, and to follow the camp and minister to the members when they were in the field. The serving brethren acted as esquires to the knights, both in the field and at home.

The Grand Master ranked as a sovereign prince, and had precedence of all ambassadors and peers in the councils of the Church.

Each country had its Grand Prior, and these together formed a chapter whom the Master called together, generally in Paris, when any great business required deliberation and counsel, and local chapters were held in different districts under the care of its Preceptor.

Besides these, the knights had in their pay, and under their command, a large number of troops, both cavalry and infantry.

The government of the Order was vested in the hands of the Grand Master, who resided at the mother house in Jerusalem.

The next in rank to him was the Marshal, who was the Master's lieutenant, the acting general in the field, and the commander of the Order during a vacancy in the office of Grand Master.

The Prior or Preceptor of the kingdom of Jerusalem was the Grand Treasurer of the Order, and the guardian of the chief house in Jerusalem.

The Draper had the charge of the clothing of all the brethren.

The Standard-Bearer carried the banner *Beauseant* to the field of battle.

The Turcopiler was the commander of a body of light horse, called Turcopilers, mostly native Christians of Syria, or half-castes, who were clothed and armed in Asiatic style, and were enrolled, drilled, and officered by the Templars, and being accustomed to the climate, and acquainted with the country and the eastern method of warfare, were valuable as light cavalry.

The Guardian of the chapel had the charge of the portable chapel, which the Templars always carried with them in their campaigns. It was a round tent which was pitched always in the centre of the camp, the quarters of the brethren being disposed round it.

There were also Grand Preceptors of Antioch and Tripoli, and Preceptors of the houses in Syria and elsewhere, all of whom commanded in the field.

William of Tyre says of the Order in his day, when in the zenith of its prosperity, "They have in their convent at Jerusalem more than three hundred knights, besides serving brothers innumerable. Their

possessions are so vast, that there cannot now be a province in Christendom which does not contribute to their support, and their wealth is said to equal that of sovereign princes."

In Palestine, besides their great house at Jerusalem, they had many strongholds in different parts of the country: Gaza, the southern frontier town; Saphet on the north; the Castle of the Pilgrims near Mount Carmel; the fortress of Jaffa, and that of Acre. Indeed, the greater part of the Holy Land was in their hands, or in those of the Hospitallers. They had houses at Aleppo, Laodicea, Beyrout, and many other places. In Apulia and Sicily they held estates, castles, and other property. They had establishments in Lucca, Milan, Perugia, Placentia, Bologna, and in other cities in Italy. In Portugal they had estates and castles, and were constantly in conflict with the Moors.

In Spain they had large possessions, and in the Balearic Islands. In Germany they were settled at Mayence, and other cities on the Rhine. They had footing in Bavaria, Hungary, Bohemia, and Moravia. They had a house in Constantinople, and others in Greece. In France their possessions were so large, and their establishments so numerous, that it would occupy too much space to enumerate them. Holland and the Netherlands also had convents of the Order. In England there were a great many Templar houses, some of which are still traceable by the names of the villages, e.g. Templecombe, Temple Rothley, Temple Newsom, etc. In almost every country they had either Preceptories or estates, and in Scotland and Ireland also they had both.

Besides actual property and convents, they received from kings and princes many privileges, immunities from taxation, tithes, etc. The right of sanctuary was granted to their establishments.

The Master of the Temple in England had a seat in Parliament as a Baron.

The first English convent of the Order was near Southampton Buildings, in Chancery Lane, where some remains of the ruins of the chapel were found some years ago. When the Order increased, they purchased an estate just outside the city gate, and adjacent to the Thames, where a magnificent convent was built; of this nothing remains but the circular part of the church, which was consecrated by Heraclius, Patriarch of Jerusalem, in A.D. 1184, in the reign of King Henry II., shortly after the murder of Thomas à Becket, at Canterbury.[1]

1. The body of the church as it now stands was not consecrated till A.D. 1240, in the reign of Henry III., who was present at the ceremony.

The king often held his court at the Temple, and it was sometimes used as a depository for treasure. The same may be said of the Temple in Paris, which was also a very extensive and magnificent building, all trace of which, however, is gone, except in the names of the streets which occupy its site. Before its destruction, it was used as a prison, and there the unfortunate Louis XVI., and Marie Antoinette were confined, till released by death, and here the still more miserable Dauphin, their son, and the heir to the throne of France, endured the cruelties of the inhuman cobbler, Simon, to whom the Revolution had committed him, to break his spirit and wear out his young life by a system of revolting and degrading barbarities, which slowly tortured him to death.

The power and influence of the Templars in European affairs was now very great. They were employed in all sorts of important negotiations between kings;—treaties, marriages, loans, quarrels religious, private, and political,—the Templars had something to do with all. A multitude of important State papers are dated from the Temple, and the Knights often acted as mediators in the misunderstandings between the Pope and the European sovereigns.

CHAPTER 3

The Third Crusade

"And Vivien frowning in true anger said,
'They ride abroad, redressing human wrongs!
They sit with knife in meat, and wine in horn.
They bound to holy vows of chastity!
Were I not woman, I could tell a tale.
But you are man, you well can understand
The shame that cannot be explained for shame.'

Then answered Merlin, careless of her words,
'You breathe but accusation vast and vague,
Spleen-born, I think, and proofless. If you know.
Set up the charge you know, to stand or fall.'
 Tennyson.

The wealth and power of the Order while they commanded influence throughout Europe, nevertheless aroused jealousies and difficulties, but too sadly foreshadowing the terrible end that was to come by-and-by.

Complaints were made by the bishops of the injuries which were inflicted upon their rights and authority by the withdrawal of the churches of the Order from their jurisdiction; and in some cases acts of violence were charged upon the knights. No doubt there were good grounds for many of these complaints, for the Templars were but men, and where so many were admitted, some must have been unworthy, or have fallen under temptation; and it was natural that the transgressor should look to his Order to defend and uphold him when the consequences of his fault overtook him; then their esprit de corps would lead them to favour him, and however they might punish him themselves, they would shield him from public disgrace and

conviction.

The peculiar privileges and rights granted to the Order, also led to collisions with the civil power; and disputes arose as to the payment of taxes and other levies, many persons claiming exemption through some connection which they had with the Templars,

But we must return to the operations of the Templars in the East.

While Odo de St. Armand was Grand Master, a new and formidable enemy appeared. Saladin was now supreme ruler of the Moslems. He collected an immense army and encountered the Christians at Ascalon, A.D. 1177, but he was defeated, and barely escaped with his life.

In the following year, however, he was again in the field, and another tremendous battle was fought near the Jordan when the Grand Master and all the knights engaged were either killed or taken prisoners. Some of these Saladin ordered to be sawn in sunder! Saladin desired to exchange his nephew, who was a prisoner in the hands of the Templars, for the Grand Master; but the latter declared that a Templar could not submit to this, and he died in prison.

The Christians' position became so critical through the successes of Saladin that a deputation was sent to Europe to rouse the kings and nobles to their defence, but with small success,

A series of most bloody and terrible conflicts continued to be fought in Palestine, in all of which the Knights Templars and Hospitallers took prominent part, but sustained terrible losses, and if wounded, were subjected to most cruel indignities and tortures by their enemies.

At the great battle of Tiberias, Saladin commanded an army of 80,000 men, and the Christians sustained a crushing defeat. The Templars and Hospitallers performed prodigies of valour, but were overwhelmed by numbers; many of them were slain, but the Grand Master, together with the King of Jerusalem and others, were taken prisoners. The day after the battle, Saladin held a review of his victorious army, and then ordered his prisoners out into the midst, and offered them the alternative of apostasy to Mahometanism or death. To a man they chose the latter, and 230 were at once beheaded.

Jerusalem was then besieged, and on October 2, 1187, it was taken, and the Crescent was placed once more upon the Temple buildings, and the Templars made Antioch their central house.

The following letter, written by a Templar, at the time, will give a picture of the state of feeling caused by the defeat at Tiberias:—

Brother Thierri, Grand Preceptor, the poor convent, and whole Order, but now almost reduced to nothing, to all the Preceptors, and all our brethren of the Temple, send greeting, in Him and to Whom we address our groans, and Whom the sun and the moon adore. We cannot, our dearest brethren, express to you by these letters, nor even by tears of blood, all the calamities that our sins have drawn upon our heads. The Turcomans, that barbarous nation, having covered the face of the land, we advanced to relieve the Castle of Tiberias, which those infidels were besieging; an engagement ensued, but the enemy having driven us to rocks and craggy mountains, our troops were cut in pieces; thirty thousand men falling in that fatal day.

The king is taken, and what is still more deplorable, the precious wood of the True Cross is fallen into the hands of the enemy. Saladin, to crown his victory, has cut off the heads of two hundred and thirty of our brethren, who were taken in battle, without reckoning sixty others that were lost in the former engagement. The sovereign of the barbarians is already master of the principal towns of the kingdom. The Christians have nothing left but Jerusalem, Ascalon, Tyre, and Berytus, and the garrisons and chief inhabitants of these places perished in the battle of Tiberias, so that it is impossible, without the assistance of Heaven, and your succour, to preserve them.

The terrible tidings of the loss of Jerusalem filled Europe with consternation and sorrow, and a new enthusiasm was kindled for its recovery. Every country contributed its contingent of men and money. Every Templar was summoned, and in the spring of the year 1189, a large army marched from Tyre to lay siege to Acre. Again battle after battle was fought, and it was computed that 100,000 Christians fell in the year.

In 1191, the Third Crusade was preached, and Philip Augustus, King of France, and Richard Coeur de Lion, King of England, together with a multitude of nobles and their followers from every part of Europe, landed in Palestine, and shortly afterwards Acre was surrendered, and the Templars established their central house there.

Another great battle was fought at Ramleh. An eyewitness gives an interesting account of the Moslem army. He says that it was of enormous strength, and that, as far as eye could reach, on all sides there was nothing to be seen but a very forest of spears, above which floated banners and standards innumerable. The wild Bedouins rushed hither

and thither in flying squadrons, shooting their arrows, and filling the air with their cries, accompanied by trumpets and kettledrums.

The victory, however, remained with the Christian army, and Saladin retired towards Jerusalem, Throughout the campaign the Templars and Hospitallers fought side by side, and their experience and knowledge of the country caused them to be the real leaders and directors of all operations, Coeur de Lion himself seeking and following their advice.

Several strong fortresses were erected at this time by the Templars, the most remarkable of which was called the Pilgrim's Castle, on the coast road from Acre to Jerusalem, near Mount Carmel. Two enormous towers, 100 feet high and 74 feet wide, formed the chief feature. The castle was so extensive that it could shelter 4000 men. There were two walls, fifteen feet thick and forty feet high, and there was a beautiful church within the enclosure.

In A.D. 1218, an expedition was fitted out against Egypt, and the Templars furnished a number of galleys and a considerable force. The Grand Master at this time was William de Chartres, and a letter of his to the Pope describes the condition of the Christian cause in the East.

It is addressed, "To the Very Reverend Father in Christ, the Lord Honorius, by the Providence of God, Chief Pontiff of the Holy Roman Church, by William de Chartres, humble Master of the Poor Chivalry of the Temple."

It states that since the arrival of a large force of Crusaders from Germany and other parts of Christendom, Saladin had remained in Egypt and had made no attack upon any of the Christian possessions in Palestine, and that the Mahometan power was weaker than it had been for many years.

There had been, however, a failure in the crops, and great scarcity of food in consequence, by which they had lost a great number of their horses, and had not sufficient to mount their knights.

No sooner had the Crusading army landed at Damietta than a terrible pestilence broke out, and the Grand Master and many of the knights, together with a vast number of the rank and file of the army, were carried off by it.

The fighting during the campaign was exceedingly fierce and bloody. On one occasion the Saracens surprised the camp, and panic had seized upon all, when the serried ranks of the Templars appeared and stopped the advance of the enemy and the flight of the Chris-

tians.

Sometimes the fighting was upon the Nile itself. In one of these naval engagements a galley belonging to the Templars sank, and all on board were drowned. In the end, however, Damietta was taken.

In the following year a great disaster happened to the Christian army. During a march the enemy cut some of the banks of the canals, and completely surrounded the Christian army with water. Provisions and baggage were lost, many were drowned; and the leaders were obliged to make terms, and they purchased their lives by the hard alternative of the surrender of the city of Damietta which had cost so much blood and labour.

In Palestine the war continued with varying fortune; but all accounts agree in praising the valour and devotion of the Templars and Hospitallers, who constantly fought side by side. On one occasion the Templars were entirely surrounded by a superior force, and, refusing to surrender, they fell to the last man, covered with wounds.

An English knight, Reginald de Argenton, was standard-bearer, and, though dreadfully wounded, bore the banner aloft till he was cut down with all his comrades.

In A.D. 1242, the Christian cause again prevailed, and Jerusalem was recaptured. The Templars and Hospitallers once more occupied their old quarters, and taxed their resources to the utmost to rebuild and strengthen the fortifications of the city. The churches were reopened for divine service, and pilgrims worshipped at the Holy Places after more than fifty years' exclusion. Other fortresses, in different parts of the country, were also rebuilt with enormous defences, as their ruins still testify.

CHAPTER 4

Palestine Lost to the Christians

The loud war-trumpet woke the morn,
The quivering drum, the pealing horn;
From rank to rank the cry is borne,
'Arouse to Death or Victory!'
 Hogg.

But a new enemy now appeared in the Tartars, who everywhere gained victories and massacred the inhabitants of cities and castles.

At the battle of Gaza, the Grand Masters of the Temple and the Hospital were both slain, together with three hundred and twelve Templars and a multitude of soldiers. And, finally, in A.D. 1244, Jerusalem was taken by assault, and the Tartars were found to be infinitely worse enemies than the Saracens had been. The Holy Places which the latter had respected were treated with contempt by the Tartars, and defiled with every insolent sacrilege. Unarmed priests, nuns, and persons of all ages and ranks, were cruelly tortured, outraged, and murdered; even the graves of the dead were violated, and their ashes flung to the winds. The remnant that escaped retired to Acre, whither they were speedily followed and besieged by the enemy.

Again piteous and earnest letters were despatched by the Master to the Christian powers in Europe, imploring aid, and trying to excite their religious zeal and indignation, by describing the ruin of the Christian cause in the East, and the invasion of the Holy Places by degraded and savage Asiatics.

A Council was assembled at Lyons by Pope Innocent IV., and it was resolved that another Crusade should be preached. A truce of four years between all Christian princes was commanded, and contributions levied upon the income of all the clergy, and earnestly solicited

from the laity.

But Bernard was no longer living to preach, the Crusading spirit had cooled down, and there was but a feeble response; so that the Templars and Hospitallers were left almost unsupported to maintain the Christian cause in the East.

In this extremity a truce was agreed upon between the Knights and the Sultan, which caused great dissatisfaction in Europe, and gave the first ground for those charges against the Templars which were soon to become so fatal.

In A.D. 1249, another expedition was fitted out against Egypt, and sailed from Acre, which succeeded in taking Damietta. Joinville gives many details of the campaign, and especially dwells on the exploits of the Templars; for courage and endurance seem ever to have distinguished the Order throughout its whole course, and though the knights were single and there was no hereditary succession, there never was wanting a continuous supply of brave and devoted men of the best families of Europe to join the Templars, and fill up the wide gaps in their ranks made by death upon the battlefield, and disease through unhealthy camps and long marches and terrible privations.

But the end was coming. In A.D. 1262, Bibars, the Sultan of Egypt, invaded Palestine with an immense army. To meet this there remained no forces but those of the Templars and Hospitallers; and though every battle was obstinately contested, and every inch of ground fought for with courage and endurance, yet the power of numbers gradually told, and the Sultan constantly advanced, till nearly every Christian stronghold fell into his hands, the two Orders of military knights were almost annihilated, and the Latin kingdom extinguished.

A brief change of fortune was effected by the arrival of Prince Edward at Acre, but he was soon after recalled to England by the death of his father and his own accession to the throne.

In A.D. 1291 Acre was invested by the Sultan and an almost countless army. No succour had come from Europe, and none was now to be expected.

There was evidently but one end possible; the city must ultimately be taken, and with it would go the last hold of the Christians upon the Holy Land. The Templars and Hospitallers had vessels at their command lying off Acre, and they might have escaped; but, true to their chivalrous vows, they remained to the last, to die when they could not conquer and would not retreat. The aged, the sick, the women and children, were sent to Cyprus, and then the knights set themselves to

the forlorn hope of resisting the overwhelming forces of the besiegers.

For six long weeks the unequal conflict was maintained.

The Sultan seemed to have unlimited supplies of men and materials. Engines and towers were erected against the fortifications; mines were run under the walls. But the brave defenders of the city met mine with countermine, burnt the engines, and made sallies and destroyed the works of the enemy. The King of Cyprus gave up hope, and basely abandoned the city with all his forces; and the garrison being thus weakened, a breach was made in the walls, and the enemy rushed in and penetrated the town, but were then met by the Templars and Hospitallers, and driven by them through the streets with great slaughter, and so the town was saved for that day. A few days longer the contest was continued. A truce was proposed, but the Sultan ordered those who came to negotiate it to be beheaded.

The archives of the Order were despatched to Cyprus, and the small remaining band of knights shut themselves up in the massive tower of the Temple, determined to fight to the last.

Their fate was not long delayed. The Sultan caused mines to be made under the walls, till they fell with a tremendous crash, burying the last defenders of the city and of the Holy Land in the shapeless ruins. With the capture of Acre the Christian dominion in the Holy Land disappeared.

Henceforth the Holy Places became the possession of the Mahometans, and Christian Europe no longer strove to rescue them.

The Templars Arrested in France

But Vivien, deeming Merlin overborne
By instance, recommenced, and let her tongue
Rage like a fire among the noblest names.
Polluting and imputing her own self.
Defaming and defacing, till she left
Not even Lancelot brave, nor Galahad clean.

Tennyson.

The loss of Palestine led indirectly to the ruin of the Order of the Templars. The record is one of the dark episodes of history, encompassed with contradictions, full of surprises, painful to contemplate, whatever view may be taken, whichever side espoused.

It is difficult to understand how an Order of men who for nearly two hundred years earned the thanks and praise of Christendom for their bravery and devotion; who had shed blood like water to defend the places dearest to all Christian hearts; who had been recruited from the noblest families in every country in Europe, and had had princes of royal blood in their ranks; who claimed to act upon the purest and most exalted Christian principles; and who proved the sincerity of their professions by their lives of self-sacrifice, and their deaths for the cause they had taken up; who had been honoured and favoured and dowered with gifts and privileges, in gratitude for their exploits— should suddenly have fallen into the blackest crimes. So it is no less difficult to understand how public opinion should turn against them as it did, and how all Europe should set itself to disgrace and despoil, to malign and execrate, those who had so long been its favourites and its champions.

It is not easy to understand this, and it is painful to read the story

in its sad and miserable details.

But there are other pages of history that more or less correspond with this; and there are well-known characteristics of human nature that explain how such revulsions of feeling come about. It has never been found difficult to get up a case against those whom the great and powerful have made up their minds to destroy. The best men are fallible and have their weak side. Large bodies of men must contain some unworthy members. A long history can hardly be without blots, mistakes, and crimes. No man's life, if narrowly scrutinized by an unfavourable and prejudiced criticism, but will afford ground for accusation. Then, too, facts may be perverted, circumstances may be made to bear a meaning that does not really belong to them, and fear and torture may force the weak to say anything that they are required. And finally, the evidence and the judgment of those who have everything to gain by the condemnation of those whom they accuse, must always be viewed with suspicion by sober and truth-loving minds.

Moreover, in judging the Templars, we must not forget the lapse of time, and the change of circumstances that separates our age from theirs.

After the loss of Acre a chapter of the surviving Templars was gathered, and James de Molay, Preceptor of England, was elected Grand Master.

One more attempt was made to recover a footing in the Holy Land, but it was defeated with great loss to the Order, and all hope of restoring the Latin kingdom in Palestine seems to have been abandoned. The occupation of the Templars was gone. They had been banded together to fight upon the sacred soil of Palestine, and to defend pilgrims, but now they had been driven out of the country, and they could no longer execute their mission or fulfil their vows. We soon hear of them being engaged in civil or international wars, which seems to be a violation of their oath not to draw sword upon any Christian. Thus we read of Templars fighting on the side of the King of England, in the Battle of Falkirk, A.D. 1298, and similar occurrences are recorded in the French wars of the time. Those against whom the Templars fought would not be slow to complain of them.

But the real cause of the downfall of the Templars was probably the enormous wealth of the Order. There had not been wanting indications for some years of covetous eyes and itching hands turned towards the possessions of the knights. Sometimes complaints were made because the rents of their estates were all sent out of the country;

sometimes the grievance alleged was that they were exempted from paying taxes and other levies, civil and ecclesiastical. Sometimes open acts of spoliation were committed upon their property, and that even by Royal hands.

But it was in France that the final attack was made. Philip the Fair was king at this time, a man of bad character and unscrupulous as to the means by which he attained his ends. The country was exhausted and the treasury empty, and the idea seems to have occurred to him, as it did later to Henry VIII. of England, under similar circumstances, that an easy way to fill his own purse was to put his hand into the purses of others.

But even kings cannot appropriate the property of a Religious Order without offering some apology or justification to the world. And so it began to be whispered that the Holy Land would never have been lost to Christendom if its sworn defenders had not failed in their Christian character. The whole blame of the defeat of the Crusades was laid upon the Templars. It was said they had treacherously betrayed the Christian cause, that they had treated with the enemy, and by their personal sins, especially by secret unhallowed rites, had provoked the just wrath of God, and so brought about the ruin of the dominion of the Cross in the East.

When Ahab has determined to put Naboth to death, that he may seize his coveted vineyard, it is not difficult to find witness that he is a blasphemer of God and a traitor to the king; and so Philip found his first tool in a man guilty of a multitude of crimes, who secured his own pardon by a denunciation of the Templars.

But even a king could not ruin a great Religious Order without the aid of the ecclesiastical authorities. The Templars had always been favoured and protected by the Popes, and nothing was in itself so likely to evoke that protection again as an attack upon the Order by the secular powers.

But Philip was prepared for this. The Pope of the day, Clement V., had been a subject of his own. As Bishop of Bordeaux, he owed his election to the Pontificate to Philip's own intrigues, and had been easily induced to quit Rome and live in France, so as to be more completely under the dictation of the king. Moreover, the majority of the Cardinals were also French, and entirely devoted to the king's interests.

Clement V. was one of the worst of those miserable men who have from time to time disgraced the Papal chair, and was guilty of almost

every crime. There are, indeed, authorities worthy of credit who assert that before his election he had been made to promise to perform six favours to the king, and that the last was not to be divulged till the time for its execution came. This last was then found to be the suppression of the Order of the Templars.

There was no difficulty under these circumstances in getting the so-called sanction of the Church for an inquiry into the crimes of which the Templars were accused.

Accordingly, in A.D. 1307, Philip issued letters to his officers throughout the kingdom, commanding them to seize all the Templars on a certain day, that they might be tried for crimes of which he and the Pope had satisfied themselves they were guilty. They had apostatized from the Christian religion, worshipped idols in their secret meetings, and had been guilty of horrible and shameful offences against God, the Church, the State, and humanity itself. Philip professed the most pious horror at what he had discovered, he lamented the grievous necessity laid upon him, and urged upon the guilty men the expediency of a full and immediate confession of their wicked doings as the only way to secure pardon, and escape the just and extreme penalty of such outrageous wickedness.

It was during the night of October 13, 1307, that the king's orders were executed. Every house of the Templars in the dominions of the King of France was suddenly surrounded by a strong force, and all the knights and members of the Order were simultaneously taken prisoners.

At the same time a strenuous endeavour was made to arouse popular indignation against the Order. The regular and secular clergy were commanded to preach against the Templars, and to describe the horrible enormities that were practised amongst them.

It is incredible to us in these days that such charges should be made, and still more that they should actually be believed. It was said that the Templars worshipped some hideous idol in their secret assemblies, that they offered sacrifices to it of infants and young girls, and that although everyone saw them devout, charitable, and regular in their religious duties, people were not to be misled by these things, for this was only a cloak intended to deceive the world and conceal their secret rites and obscene orgies.

It was hoped that some confession of guilt might be readily obtained from some of the weaker brethren in order to receive the pardon which was promised by the king. But no such confession was

made. All the prisoners denied the charges brought against them.

Then the usual mediaeval expedient was resorted to, and torture was used to extort acknowledgments of guilt. The unhappy Templars in Paris were handed over to the tender mercies of the tormentors with the usual results. One hundred and forty were subjected to trial by fire.

The details preserved are almost too horrible to be related. The feet of some were fastened close to a hot fire till the very flesh and even the bones were consumed. Others were suspended by their limbs, and heavy weights attached to them to make the agony more intense. Others were deprived of their teeth; and every cruelty that a horrible ingenuity could invent was used.

While this was going on questions were asked, and offers of pardon were made, if they would acknowledge themselves or others guilty of the monstrous wickednesses which were detailed to them. At the same time forged letters were read, purporting to come from the Grand Master himself, exhorting them to make a full confession, and declarations were made of the confessions which were said to have been already freely given by other members of the Order.

What wonder, then, that the usual consequences followed? Those who had strong will and indomitable courage stood firm and endured the slow martyrdom till death released them, maintaining to the last their own innocence, and the innocence of their Order, of the crimes with which they were charged. But some weaker men broke down. In hope of release from the agony which they could not endure, they confessed anything and everything that was required of them, and these things were at once written down as grave facts and made matter of accusation of others. Often these unhappy men almost immediately recanted, and as soon as the torture ceased withdrew their confessions, and repeated their original denial of the accusations one and all.

We have long ago ceased to set any value upon confessions extorted by torture, and the system has happily been abolished by all civilized nations, but in those days this was not understood; torture was relied upon as a means of extracting truth from unwilling witnesses when all other means failed; indeed, it was simpler and more expeditious than the calling of many witnesses, the testing of evidence by cross-examination, and other surer but slower methods; and especially when conviction, not truth, was the end in view, torture was a welcome and efficacious ally.

All this was but too sadly exemplified in the proceedings against

the Templars in France. No sooner were those who had made confessions of guilt while under torture released from their tormentors, than they disavowed their forced admissions and proclaimed their innocence and the purity of their Order, appealing to history and the testimony of their own day for evidence of their courage and devotion to the catholic faith.

Upon hearing of this Philip immediately ordered the re-arrest of the Templars, and proceeding against them as relapsed heretics, they were condemned to be burned alive. In Paris alone 113 suffered this terrible punishment, and many more were burned in other towns.

In Spain, Portugal, and Germany, proceedings were taken against the Order; their property was confiscated, and in some cases torture was used; but it is remarkable that it was only in France, and in those places where Philip's influence was powerful, that any Templar was actually put to death.

Everywhere else the monstrous charges were declared to be unproved, and the Order was declared innocent of heresy and sacrilegious rites.

Trial of the Templars in London

Bell, book, and candle shall not drive me back,
When gold and silver becks me to come on.

Shakespeare.

In October, A.D. 1311, a council was held at Vienne to dissolve the Order of the Temple, but the majority of the bishops were decidedly opposed to such a proceeding against so ancient and illustrious an Order, till its members had been heard in their own defence in a fair and open trial.

The Pope was furious at this and dismissed the council, and in the following year, A.D. 1312, by a Papal Brief he abolished the Order and forbad its reconstitution.

The property, of the Order in France was nominally made over to the Hospitallers, but Philip laid claim to an immense sum for the expenses of the prosecution, and by this and other means he obtained what he had all along desired, the greatest part of the possessions of the Order.

Similar proceedings took place in other countries. In some, new Orders were founded in the place of the Templars, with the sovereign at their head, by which means the estates came into the possession of the crown as completely as if they had been actually confiscated.

In France the Templars who survived their torture, and the horrors of their prisons, were either executed or left to linger out a miserable existence in their dungeons till death released them. The Grand Master and a few other brethren of the highest rank were thus kept in prison for five years. They were then taken to Notre Dame in Paris, and required to give verbal assent to the confessions which had been extorted from them under torture. But the Grand Master, James de

Molay, the Grand Preceptor, and some others seized the opportunity of declaring their innocence, and disowning the alleged confessions as forgeries. The old veterans stood up in the church before the assembled multitude, and raising their chained hands to heaven, declared that whatever had been confessed to the detriment of the illustrious Order was only forced from them by extreme agony and fear of death, and that they solemnly and finally repudiated and revoked all such admissions.

On hearing of this Philip ordered their immediate execution, and the same evening the last Grand Master of the Temple and his faithful comrades were burnt to death at a slow fire.

Impartial men had formed their own judgment, and a very strong feeling prevailed that justice had not been done. It was remarked that those who had been foremost in the proceedings against the Templars, came to a speedy and miserable end. The Pope, the kings of France and of England, and others, all soon followed their victims and died violent or shameful deaths.

We have somewhat anticipated the order of events, and must return to the earlier stage of the proceedings against the Templars. As soon as Philip had determined upon his own course of action, he desired to find countenance for it by stirring up other sovereigns to imitate it. He therefore wrote letters to the kings of other European states, informing them of his discovery of the guilt of the Templars, and urging them to adopt a similar course in their own dominions. The Pope, too, summoned the Grand Master to France, but with every mark of respect, and so got him into his power before the terrible proceedings against the members of his Order were made public.

The King of England, Edward II., acted with prudence. He expressed his unbounded astonishment at the contents of the French king's letter, and at the particulars detailed to him by an agent specially sent to him by Philip, but he would do no more at the time than promise that the matter should receive his serious attention in due course.

He wrote at the same time to the Kings of Portugal, Aragon, Castile, and Sicily, telling them of the extraordinary information he had received respecting the Templars, and declaring his unwillingness to believe the dreadful charges brought against them. He referred to the services rendered to Christendom by the Order, and to its unblemished reputation ever since it was founded. He urged upon his fellow sovereigns that nothing should be done in haste, but that inquiry

should be made in due and solemn legal form, expressing his belief that the Order was guiltless of the crimes alleged against it, and that the charges were merely the result of slander and envy, and of a desire to appropriate the property of the Order.

At the same time Edward wrote to the Pope in similar terms. He declared that the Templars were universally respected by all classes throughout his dominions as pious and upright men, and begged the Pope to promote a just inquiry which should free the Order from the unjust slander and injuries to which it was being subjected.

But hardly was this letter despatched than Edward received another from the Pope, which had crossed his own on its way, calling upon him to imitate Philip, King of France, in proceeding against the Templars. The Pope professed great distress and astonishment that an Order that had so long enjoyed the respect and gratitude of the Church for its worthy deeds in defence of the faith should have fallen into grievous and perfidious apostasy.

He then narrated the commendable zeal of the King of France, in rooting out the secrets of these men's hidden wickedness, and gave particulars of some of their confessions of the crimes with which they had been charged. He concluded by commanding the King of England to pursue a similar course, to seize and imprison all members of the Order on one day, and to hold in the Pope's name all the property of the Order till it should be determined how it was to be disposed of.

King Edward, notwithstanding his recent declaration of confidence in the integrity of the Templars, yielded obedience to this missive of the Pope. Whether he was overawed by the authority of the Pontiff, and deferred his own opinion to that of so great a personage, or whether, as some suppose, he desired to give the Templars a fair and honourable trial, and the opportunity of clearing themselves; or whether he gave way to the evil counsels of those who whispered that the great wealth of the Templars would be useful to the Crown, and that he might avail himself of the opportunity of taking all, as his predecessors had taken some, of their treasure;—whatever may have been his real motive, and the cause of his change of conduct, it is certain that he issued an order for the arrest of the Templars, and the seizure of all their estates, houses, and property.

The greatest caution and secrecy were adopted. Instructions were sent to all the sheriffs throughout England, to hold themselves in readiness to execute certain orders which would be given to them by

trusty persons on that day.

Similar arrangements were made in Scotland, Ireland, and Wales; and on January 8, A.D. 1308, every Templar was simultaneously arrested.

It was not till October in the following year that any trial took place. All this time the Templars had been suffering the miseries of imprisonment. More than two hundred men of high rank, many of them veterans who had fought and bled in Palestine, and who were now grown old and feeble after a life of hardship and privation, maimed with wounds, bronzed with exposure to the eastern sun, languished under the tender mercies of jailers, with no opportunity of defending themselves or of raising up friends to say a word for them. Some were foreigners who happened to be in England on the business of the Order. A few managed to evade the vigilance of the king's emissaries, notwithstanding the secrecy and suddenness of the arrest, and escaped in various disguises to the wild and remote mountain districts of Scotland, Wales, and Ireland.

The Court appointed by the Pope commenced its proceedings in London, in October, A.D. 1309, under the presidency of the Bishop of London. Several French ecclesiastics had come over to take their seat upon the bench as judges—an ill omen for the English Templars.

After the usual preliminaries, which were long and tedious, the articles of accusation were read. They stated that those who were received into the Order of the Knights of the Temple, did at their reception formally deny Jesus Christ, and renounce all hope of salvation through Him, that they trampled and spat upon the cross; that they worshipped a cat (!); that they denied the sacraments, and looked only to the Grand Master for absolution; that they possessed and worshipped various idols; that they practised a variety of cruel, degrading, and filthy customs and rites; that the Grand Master and many of the brethren had confessed to these things even before they had been arrested.

Such is a very brief summary of the accusation, the original documents of which have happily come down to us.

It is not easy for us to understand how such a farrago of absurdity, profanity, and indecency could ever have been gravely produced in a so-called Court of Justice in England as a State Paper—a bill of indictment against a body of noblemen and gentlemen; against an Order that for 200 years had been the right arm of the Church and the defender of Christianity against its most dangerous and ruthless

enemies. No writer of fiction would have ventured on inventing such a trial, and no one unacquainted with mediaeval history would credit the record that grave prelates and learned judges drew up such a document, and then set themselves to prove the truth of its monstrous allegations by the use of torture!

But students of the middle ages know well that such things were done in those days. They remember Savanarola and Beatrice Cenci in Italy, Joan of Arc in France, Abbot Whiting and others in England; they call to mind the cruelties and exactions practised so often upon the Jews in every country in Europe, and with the contemporary records in their hands, they do not hesitate to accept as undoubted historical fact what would otherwise be rejected as a slander upon humanity and an outrage upon common sense.

If the Templars had been accused of the crimes vulgarly supposed to attach themselves to Religious Orders; if they had been charged with falling into the sins to which poor human nature by its frailty is liable; if erring members had been denounced, men who had entered the Order through disappointment, or from some other unworthy motive, men such as Sir Walter Scott depicts in his imaginary Templar, Brian de Bois Guilbert, in his novel of *Ivanhoe*, we might well believe that some at least of the accusations against them were true.

But it is singular that no such charges are alleged against the Templars, though they were freely brought, two hundred years later, against the regular monks by the commissioners of Henry VIII. This fact has been noticed by most thoughtful historians, and has been considered to tell strongly in the tribunal of equity in favour of the Templars.

Instead of these probable or possible crimes, we find nothing but monstrous charges of sorcery, idolatry, apostasy, and such like, instances of which we know are to be found in those strange times; but which it seems altogether unlikely would infect a large body whose fundamental principle was close adherence to Christianity, a body which was spread all over the world, and which included in its ranks such a multitude and variety of men and of nationalities, among whom there must have been, to say the least, some sincere, upright, and godly men who would have set themselves to root out such miserable errors, or, if they were found to be ineradicable, would have left the Order as no place for them.

Even Voltaire acknowledges that such an indictment destroys itself. It recoils upon its framers, and proves nothing but their intense hatred of their victims, and their total unfitness to sit as judges.

When this extraordinary paper had been read, the prisoners were asked what they had to say to it; and, as might be expected, they at once and unanimously declared that they and their Order were absolutely guiltless of the crimes of which they were accused. After this the prisoners were examined one by one.

Hallam's Judgment

I see the modern Pilate, whom avails
No cruelty to sate, and who unbidden
Into the Temple seta his greedy sails.
 Dante.

It would be tedious to follow the long and wearisome questionings and to record the replies given by the several brethren of the Temple during their trial in London. One and all agreed in denying the existence of the horrible and ridiculous rites which were said to be used at the reception of new members; and whether they had been received in England or abroad, detailed the ceremonies that were used, and showed that they were substantially the same everywhere. The candidate was asked what he desired, and on replying that he desired admission to the Order of the Knights of the Temple, he was warned of the strict and severe life that was demanded of members of the Order; of the three vows of poverty, chastity, and obedience; and, moreover, that he must be ready to go and fight the enemies of Christ even to the death.

Others related details of the interior discipline and regulations of the Order, which were stern and rigorous, as became a body that added to the strictness of the convent the order and system of a military organization.

Many of the brethren had been nearly all their lives in the Order, some more than forty years, a great part of which had been spent in active service in the East.

The witnesses who were summoned were not members of the Order, and had only hearsay evidence to give. They had *heard* this and that report, they *suspected* something else, they had been *told* that certain things had been said or done. Nothing definite could be ob-

tained, and there was no proof whatever of any of the extravagant and incredible charges.

Similar proceedings took place in Lincoln and York, and also in Scotland and Ireland; and in all places the results were the same. And the matter dragged on till October, A.D. 1311.

Hitherto torture had not been resorted to; but now, in accordance with the repeated solicitations of the Pope, King Edward gave orders that the imprisoned Templars should be subjected to the rack, in order that they might be forced to give evidence of their guilt.

Even then there seems to have been reluctance to resort to this cruel and shameful treatment, and a series of delays occurred so that nothing was done till the beginning of the following year.

The Templars having been now three years in prison, chained, half starved, threatened with greater miseries here, and with eternal damnation hereafter, separated from one another, without friend, adviser, or legal defence, were now removed to the various gaols in London and elsewhere, and submitted to torture.

We have no particular record of the horrible details; but some evidence was afterwards adduced which was said to have been obtained from the unhappy victims during their agony. It was such as was desired; an admission of the truth of the monstrous accusations that were detailed to them, which had been obtained, for the most part, from their tortured brethren in France.

In April, A.D. 1311, these depositions were read in the court, in the presence of the Templars, who were required to say what they could allege in their defence. They replied that they were ignorant of the processes of law, and that they were not permitted to have the aid of those whom they trusted and who could advise them, but that they would gladly make a statement of their faith and of the principles of their Order.

This they were permitted to do, and a very simple and touching paper was produced and signed by all the brethren. They declared themselves, one and all, good Christians and faithful members of the Church, and they claimed to be treated as such, and openly and fairly tried if there were any just cause of complaint against them.

But their persecutors were by no means satisfied.

Fresh tortures and cruelties were resorted to to force confessions of guilt from these worn-out and dying men. A few gave way, and said what they were told to say; and these unhappy men were produced in St. Paul's Cathedral shortly afterwards, and made to recant their er-

rors, and were then "reconciled to the Church." A similar scene was enacted at York.

The property of the Templars in England was placed under the charge of a commission at the time that proceedings were commenced against them, and the king very soon treated it as if it were his own, giving away manors and convents at his pleasure. A great part of the possessions of the Order was subsequently made over to the Hospitallers. The convent and church of the Temple in London were granted, in A.D. 1313, to Aymer de Valence, Earl of Pembroke, whose monument is in Westminster Abbey. Other property was pawned by the king to his creditors as security or payment of his debts; but constant litigation and disputes seem to have pursued the holders of the ill-gotten goods.

Some of the surviving Templars retired to monasteries, others returned to the world, and assumed secular habits, for which they incurred the censures of the Pope.

The possession of the lands and estates of the Order of the Templars seems to have entailed misfortune upon its owners. Aymer de Valence, to whom the king granted the Temple in London, was shortly afterwards murdered, and left no descendant. The Duke of Lancaster, who subsequently held it, perished upon the scaffold after his unsuccessful rebellion, Hugh le Despenser, the next owner, also came to a violent end, and was hanged with a crown of nettles on his head.

The Temple then came for a short time into the hands of the Knights Hospitallers, and during the reign of Edward III. it seems to have been occupied by the lawyers, as tenants under the Hospitallers. When that Order was dissolved by Henry VIII., the property passed into the hands of the Crown, the lawyers still holding possession as tenants. This continued till the reign of James I., when a petition was drawn up and presented to the king asking him to assign the property to the legal body in permanence. This was accordingly done by letters patent, in A.D. 1609, and the Benchers of the Inner and Middle Temple received possession of the buildings, on consideration of a small annual payment to the Crown.

So passed away and came to an end, the ancient and noble Order of the Templars. As Fuller says:

The chief cause of the ruin of the Templars was their extraordinary wealth, as Naboth's vineyard was the chiefest ground of his blasphemy, and as in England Sir John Cornwall, Lord Fanhope, said merrily, not he, but his stately house at Ampthill,

185

in Bedfordshire, was guilty of high treason, so certainly their wealth was the principal cause of their overthrow. . . . We may believe that Philip would never have taken away their lives if he might have taken their lands without putting them to death; but the mischief was, he could not get the honey unless he burnt the bees.

It may be wondered why the Hospitallers escaped when the Templars fell. There was much similarity between the two Orders; both were wealthy, both had been founded to defend Palestine, and when that was lost, if one Order was unnecessary, why should the other be preserved, and even be made the inheritor, at least nominally, of the property of the other when it was suppressed?

There are probably several reasons for this seeming contradiction. One is that as the downfall of the Templars was really due to Philip of France, who commenced the outcry against them, there were local causes that gave him a handle against the Templars which were not available against the Hospitallers, Another, and a stronger reason, is that the Hospitallers were still, and for three hundred years afterwards, actively engaged in war with the Mahometans; and so they were useful as standing upon the distant threshold of Christendom, and in keeping back the dreaded enemy from advancing too rapidly upon the fair countries of Europe.

It has been maintained by some that there was probably some ground for the accusation that at his initiation the Templar was required to spit or trample upon the cross.

In those days of symbolism and mystic rites, when attempts were made to realize everything in sacred history, especially when a sharp line was drawn, not only between the Church and the heathen, but between the monastic life and the life even of professing Christians in the world, so that the title *Religious* and the phrase *entering religion* were given to those who became monks or nuns, there may very probably have been peculiar ceremonies used at the admission of a Templar into his Order, as there were, we know, when a monk or a nun made profession. In the latter case, the novice, in some Orders, is treated as a dead person, and lies upon the floor of the church covered with a pall, and is as it were raised to life by admission into the privileged position of a member of the Order.

So it is said the Templar came as a renegade from Christ, having in theory, if not in fact, denied Him by a bad life, and now desired repentance and restoration and to make a new beginning. His former

state was indicated by his spitting or trampling upon the cross, and then he began a new and higher life of penitence and self-sacrifice as a member of this Order.

It is said also that the Templars had some advanced theories respecting man's access to God, in direct opposition to the spirit of the age; that they denied the necessity of the Pope and of Church rites, and approached God as the universal Father; in fact, that they were Protestants before the time—Protestants of the most pronounced views, such as the Quakers or the Unitarians now advocate.

But all this rests upon slight and uncertain grounds, and upon data that may have vastly different meanings.

There is no doubt that their intercourse with the East brought them into contact with many religious opinions and speculations which at that time were unknown in Europe, but which the loss of Constantinople and the immigration of so many Eastern refugees afterwards introduced to the thinking minds of the West. The revival of learning, the study of Greek, the rise of free thought, are by many dated from this event, which led to the importation of Oriental learning and Oriental mysticism into Europe. It does not seem impossible that the Templars may have anticipated something of this in their own Order by long sojourn in Palestine, and by their wider knowledge and more liberal opinions may have alarmed and scandalized the narrower minds of the clergy of the West.

Curious, and in some cases objectionable symbols are found carved in their churches; and antiquarians identify these with signs used by ancient Gnostic sects, and so go on to suppose that the Templars shared the opinions and followed the practices of those sects.

Hallam reviews the controversy, and confesses himself unable to come to a satisfactory conclusion, or to give a final opinion as to the truth or falsehood of all this; and others equally capable of forming a calm judgment hesitate to pronounce one in the case of the Templars.

Probably the matter will never be quite cleared up, but will remain like many other insoluble problems of history, about which men will form and hold their own views, while the generous and charitable will give the accused the benefit of the uncertainty, and count those innocent who have not been proved guilty.

"With the Templars," says Heckethorn, "perished a world; chivalry, the crusades ended with them; even the Papacy received a tremendous shock. Symbolism was deeply affected by it. A greedy and arid trad-

ing spirit rose up. Mysticism, that had sent such a glow through past generations, found the souls of men cold and incredulous."

The following is a list of the Preceptories of the Templars in England:—

Cambridgeshire: Wilbraham.

Essex: Temple Crossing.

Hampshire: South Badesley.

Hertfordshire: Temple Dynnesly.

Kent: Swingfield.

Leicestershire: Temple Rothley.

Lincolnshire: Aslackby, Temple Brewer, Eagle, Maltby, Mere Wilketon, Witham.

Norfolk: Haddiscoe.

Shropshire: Halston.

Suffolk: Gislingham, Dunwich.

Sussex: Saddlescombe.

Warwickshire: Balsall, Warwick.

Yorkshire: North Ferriby, Temple Hurst, Temple Newsome, Pafflete, Flaxflete, Ribston.

The Order also possessed many manors and estates where they had no Preceptories.

PART 3
THE TEUTONIC KNIGHTS.

A knight ther was, and that a worthy man,
That fro the time that he firste began
To riden out, he loved chevalrie,
Trouthe and honour, fredom and cortesie.
Ful worthy was he in his lordes werre,
And therto hadde he ridden, no man ferre,
As wel in Cristendom as in Hethenesse,
And ever honoured for his worthinesse.
At Alisandre he was whan it was wonne.
Ful often time he had the bord begonne
Aboven alle nations in Pruce.
In Lettowe had he reysed, and in Ruce.

Chaucer

Origin of the Teutonic Order of Knighthood

War, of all bad things
Worst, and man's crowning crime; save when for faith
Or freedom waged.

Bailey.

It is not possible to find the exact date of the foundation of the Teutonic Order, but it was probably about A.D. 1190 that it received its full organization as one of the recognized Religious Military Orders.

Its actual commencement, like that of the other Orders, was obscure and humble.

About 1128 or 1129, a wealthy German, who had taken part in the siege and capture of Jerusalem, settled there with his wife, intending to spend the remainder of his life in the practice of religion and in visiting the holy places. His attention and interest were soon excited by the misfortunes of his poorer countrymen, who came in great numbers as pilgrims to Jerusalem. Many fell sick, and endured great miseries and hardships.

Moved with compassion, he received some of the more distressing cases into his own house. But he soon found that the work grew beyond this, and he built a hospital, with a chapel dedicated to the Blessed Virgin.

In this institution he passed the whole of his time, nursing the sick pilgrims; and to their maintenance he devoted the whole of his means.

But still the work enlarged, and his own fortune was insufficient

for the increasing expenditure. He therefore commenced soliciting alms for the continuance and enlargement of his charity, and his wife devoted herself to a similar care of the female pilgrims who were too poor to pay for medical attendance and nursing during sickness.

Many of his wealthier countrymen not only gave him money, but associated themselves with him in actual work. Men of noble family and gentle blood, who had quitted their own homes and country to fight in defence of the Holy Land, banded themselves together, after the pattern of the Order of St. John of Jerusalem, and united the care of the sick and poor with the profession of arms in their defence, under the title of Hospitallers of the Blessed Virgin. This little band put themselves under the direction of the Grand Prior of the Hospitallers of St. John of Jerusalem, although they did not actually join this Order, whose operations they so closely imitated.

The Teutonic Hospitallers continued their work, both in the hospital and in the field, till Jerusalem was besieged and taken by Saladin. This event caused a serious cheek to the development of the Order.

Saladin, struck with the devotion of these men to the suffering and poor, permitted some of their number to remain in Jerusalem and continue their humane ministrations.

It was, however, during the siege of Acre that the Teutonic Order received its final and complete organization as one of the great Military Religious Orders of Europe.

The German soldiers suffered great miseries from sickness and from their wounds, and as their language was not understood by the French and other European contingents of the crusading army, they were left untended and friendless. To meet this want, some citizens of Bremen and Lubeck provided a sort of field hospital, and devoted themselves to the care of their wounded and sick countrymen. These were soon joined by others, and by the brethren of the Hospital of the Blessed Virgin at Jerusalem, whom Saladin had banished from the city, and the little body came to be known by the designation of the Teutonic Knights of the Hospital of the Blessed Virgin at Jerusalem.

It is said that the Order owed its constitution to Frederick, Duke of Suabia; but there is much obscurity, and little authentic record to determine this or to furnish particulars of the transaction.

The Order seems, however, to have been confirmed by Pope Celestine III., the constitution and rules of the Templars and Hospitallers being; taken as the model for the new Order, Henry de Walpot being the first Master.

This appears to have happened about A.D. 1190, though some authorities maintain that it was not till 1191, or even later.

While, therefore, the three great Orders had much in common, there was this difference in their original foundation. The Hospitallers were at first a nursing Order, and gradually became military; the Templars were always purely and solely military; while the Teutonic Knights were from the first both military and nursing.

Contemporary chroniclers compare the Teutonic Knights with the mystic living creature seen by Ezekiel, having the faces of a man and of a lion, the former indicating the charity with which they tended the sick; the latter, the courage and daring with which they met and fought the enemies of Christ.

The Teutonic Knights continued their care of the sick soldiers till Acre was taken in July, 1191, by the united forces of Philip Augustus, King of France, and Richard, Coeur de Lion, King of England.

After the capture of Acre by the Christian army, Henry de Walpot purchased a site within the city, and built a church and hospital for his Order, the first that it possessed. To these buildings were gradually added lodgings for the members of the Order, for pilgrims, and for the soldiers which were enlisted to assist the knights in the field.

All this cost a large sum of money; but, as many wealthy Germans had enrolled themselves as knights, means were not wanting as the occasion for them occurred and the requirements of the Order developed. Among the greatest of the earlier benefactors was Frederick, Duke of Suabia, who contributed money and aided the progress of the Order by his influence, and, when he died at Acre, was interred in the church of the knights. Contemporary writers speak in the highest terms of his virtues, saying that he lived a hero and died a saint.

At this period and for the rest of its history, the constitution of the Teutonic Order embraced two classes of members: 1. The knights; 2. The clergy; both being exclusively of German birth.

The knights were required to be of noble family, and, besides the ordinary threefold monastic vows, took a fourth vow, that they would devote themselves to the care of the sick and to fight the enemies of the faith. Their dress was black, over which a white cloak with a black cross upon the left shoulder was worn.

The clergy were not necessarily of noble birth, their duties being to minister to the Order in their churches, to the sick in the hospitals and on the field of battle.

To these two classes, who constituted the Order, were added serv-

ing brethren, called Heimlike and Soldner, and in Latin, *Familiares*. Many of these gave their services gratuitously from religious motives; others received payment and were really servants.

The knights selected their esquires from among the serving brothers. All these wore a dress of the same colour as the knights, that they might be known at once to belong to the Order.

The original rules of the Order were very severe. All the members lived in common; they slept in dormitories on small and hard beds; they took their meals together in the refectory, and their fare was meagre and of the plainest quality. They were required to attend the daily services in the church, and to recite certain prayers and offices privately. They were not permitted to leave their convent, nor to write or receive letters, without permission of their superior. Their clothes, armour, and the harness of their horses were all of the plainest description; all gold, jewels, and other costly ornaments being strictly forbidden. Arms of the best temper and horses of good breed were provided. When they marched to battle, each knight had three or four horses, and an esquire carried his shield and lance.

The Grand Master was elected from the class of the knights only. Next in rank to him was the Preceptor, or Grand Commander, who had the general supervision of the clergy and serving brethren, and who presided in chapter in the absence of the Grand Master.

Next to the Preceptor came the Marshal, who acted as Lieutenant-General in the field of battle under the Grand Master.

The third dignitary was the Grand Hospitaller, who had the superintendence of the hospitals and of all that related to their management.

The fourth officer was the Trappier, who supplied the knights with their clothing and accoutrements.

And, lastly, there was the Treasurer, who received and paid all the money that passed through the hands of the Order. All these officers were removable, and were commonly changed every year.

As the Order extended, new functionaries were required, and were appointed; *viz.*, provincial masters of the several countries where the Order obtained possessions, who took rank next after the Grand Master; and there were also many local officers as particular circumstances required.

The Grand Master was not absolute, but was obliged to seek the advice of the chapter before taking any important step, and if he were necessarily absent, he appointed a lieutenant to act for him, who also

governed the Order after the death of the Grand Master till his successor was elected.

After the death of Saladin, disputes arose among his sons, and the opportunity was seized of commencing a new crusade, the history of which is well known, and in which the Teutonic Knights took an active part.

At this time, A.D. 1197, Henry VI., Emperor of Germany, gave the knights the monastery of the Cistercians, at Palermo, in Sicily, and several privileges and exemptions—a transaction that caused considerable disagreement between the Pope and the Emperor. The knights were, however, finally con- firmed in possession of the monastery, and it became the Preceptory or chief house of the Order in Sicily, where other property was gradually bestowed upon the knights.

Henry de Walpot, the first Grand Master, died at Acre, in A.D. 1200, and was succeeded by Otho de Kerpen, who was an octogenarian at the time of his election, but full of vigour and energy, which he displayed by devoted attention to the duties of his office, and personal attendance upon the sick in the hospitals.

During the mastership of Otho de Kerpen, an Order of knighthood arose in the north of Europe, which was afterwards incorporated with the Teutonic Order. Livonia, a country situated on the borders of the Baltic, was at this time still pagan. The merchants of Bremen and Lubeck, who had trading relations with the inhabitants, desired to impart to them the truths and blessings of Christianity, and took a monk of the name of Menard to teach them the elements of the faith. The work succeeded, and Menard was consecrated bishop, and fixed his see at Uxhul, which was afterwards transferred to Riga.

The mission, however, as it advanced, aroused the jealousy and suspicion of the pagan nobles, and they attacked and destroyed the new town, with its cathedral and other buildings. The bishop appealed to his countrymen for help. Many responded to his call, and as there was at that time no crusade in progress in Palestine, the Pope (A.D. 1199) was persuaded to accord to those who took up arms for the defence of the Christians in Livonia the same privileges as were given to those who actually went to the Holy Land.

In consequence of these events, a military religious Order was founded, to assist in this war, called the Order of Christ, which was confirmed by Pope Innocent III., in A.D. 1205. The knights wore a white robe, upon which a red sword and a star were emblazoned. They maintained a vigorous and successful conflict with the heathen, till

circumstances rendered it desirable that they should be incorporated with the Teutonic Knights.

In the meantime, the Latins had seized Constantinople, and set up Baldwin, Count of Flanders, as Emperor, and divided the Eastern empire among themselves. The Teutonic Knights received considerable possessions, and a Preceptory was founded in Achaia. Some time afterwards, another was established in Armenia, where also the Order had obtained property and territory in return for service rendered in the field. The Order also received the distinction of adding to their bearings the Cross of Jerusalem.

The valour of the knights, however, and the active part which they took in all the religious wars of the day, cost them dear, and from time to time their numbers were greatly reduced; so much so that when Herman de Salza was elected Grand Master, A.D. 1210, he found the Order so weak that he declared he would gladly sacrifice one of his eyes if he could thereby be assured that he should always have ten knights to follow him to battle with the infidels. The vigour of his administration brought new life to the Order, and he was able to carry on its mission with such success, that at his death there were no less than two thousand German nobles who had assumed the badge of the Order and fought under its banner. Large accessions of property also came at this time to the knights in Hungary, Prussia, Livonia, and elsewhere.

In A.D. 1214, the Emperor Frederick I. decreed that the Grand Master should always be considered a member of the Imperial Court, that whenever he visited it he should be lodged at the Emperor's expense, and that two knights should always have quarters assigned them in the Imperial household.

In A.D. 1221, the Emperor Frederick II., by an Imperial act, took the Teutonic Order under his special protection, including all its property and servants; exempted them from all taxes and dues; and gave its members free use of all pastures, rivers, and forests in his dominions. And in A.D. 1227 Henry commanded that all proceedings in his courts should be conducted without cost to the Order. The King of Hungary also, seeing the valour of the knights, endeavoured to secure his own possessions by giving them charge of several of his frontier towns.

CHAPTER 2

War With the Turks

Religion finds e'en in the stern retreat
Of feudal sway, her own appropriate seat.
Wordsworth.

It would be unnecessary, as it would be tedious, to repeat all the details of the Crusades, the varying successes and defeats, in all of which the Teutonic Knights took part, both in Syria and in Egypt, fighting side by side with their brethren in arms, the Templars and Hospitallers. They continued also their humane services to the sick and wounded, as the following curious contemporary document shows.

It forms part of a charter, obtained by one Schweder, of Utrecht, who says that, being at the siege of Damietta, "he saw the wonderful exertions of the brethren of the Teutonic Order, for the succour of the sick and the care of the soldiers of the army, and was moved to endow the Order with his property in the village of Lankarn."

It was during the siege of Damietta that the famous St. Francis of Assisi visited the crusading army, and endeavoured to settle a dispute that had arisen between the knights and the foot soldiers of the army, the latter being dissatisfied, and declaring that they were unfairly exposed to danger as compared with the mounted knights.

In A.D. 1226, the Grand Master was selected by the Emperor Frederick and Pope Honorius to be arbitrator in a dispute that had arisen between them. So well pleased were they with his honourable and wise counsel that, in recognition of his services, he and his successors were created Princes of the Empire, and the Order was allowed to bear upon its arms the Imperial Eagle. The Emperor also bestowed a very precious ring upon the Master, which was ever afterwards used at the institution of the Grand Master of the Order.

Again, in A.D. 1230, the Grand Master was one of the principal agents in bringing about a reconciliation between the Emperor and Pope Gregory IX., whose dissensions had led to many troubles and calamities.

It has already been mentioned that the King of Hungary bestowed upon the knights some territory on the borders of his dominions, with a view to their defending it from the incursions of the barbarous tribes in the vicinity.

The King's anticipations were amply realized. The knights maintained order in the disturbed districts, and by their presence put an end to the incursions of the predatory bands who came periodically to waste the country with fire and sword. The land soon smiled with harvests, and a settled and contented population lived in peace and quietness.

But no sooner were these happy results attained than the King took a mean advantage of the knights, and resumed possession of the country which they had converted from a desert to a fruitful and valuable district. The consequence was that the wild tribes renewed their invasions, and the reclaimed country once more lapsed into desolation.

Then again the King made the border country over to the knights, who speedily reasserted their rights, and established a settled government and general prosperity in the dominion made over to them. This grant and some others that followed were confirmed to the Order by á bull of Pope Honorius III., A.D. 1222.

A few years after this, the Duke of Poland asked the aid of the Order against the pagan inhabitants of the country that was afterwards Prussia. These people were very savage and barbarous, and constantly committed horrible cruelties upon their more civilized neighbours, laying waste the country, destroying crops, carrying off cattle, burning towns, villages, and convents, and murdering the inhabitants with circumstances of extreme atrocity, often burning their captives alive, as sacrifices to their gods.

The Grand Master consulted with his chapter and with the Emperor on the proposed enterprise, and finally resolved to enter upon it, the Emperor undertaking to secure to the Order any territory that they might be able to conquer and hold in Prussia. Pope Gregory IX., in A.D. 1230, gave his sanction to the expedition, and conferred on those concerned in it all the privileges accorded to Crusaders.

In the following year an army invaded Prussia, and erected a for-

tress at Thorn, on the Vistula, on the site of a grove of enormous oaks, which the inhabitants looked upon as sacred to their god Thor. This was followed, in A.D. 1232, by the foundation of another stronghold at Culm. A successful campaign followed, and the Castle of Marien-werder, lower down the Vistula, was after some reverses and delays successfully built and fortified.

The Grand Master then established a firm system of government over the conquered country, and drew up laws and regulations for the administration of justice, for the coining of money, and other neces-sary elements of civilization. Other fortified places were built which gradually developed into cities and towns. But all this was not effected without many battles and much patient endurance, and frequent de-feats and checks.

Nor did the knights forget the spiritual needs of their heathen subjects. Mission clergy laboured among them, and by their instruc-tion, and still more by their holy, self-denying lives, they succeeded in winning many to forsake their idols and become Christians.

The Order received an important accession to its ranks at this time, A.D. 1237, by the incorporation into it of the ancient Order of Christ, in Livonia, which had considerable possessions. This was fol-lowed shortly afterwards by an agreement between the Order and the King of Denmark, by which the former undertook the defence of the kingdom against its pagan neighbours.

In A.D. 1231, the Order received into its ranks Conrad, Landgrave of Thuringia and Hesse, a man who had led a wicked and violent life, but being brought to see his errors, made an edifying repentance, and became a Teutonic Knight, and afterwards was elected Grand Master.

This Conrad was brother to Louis of Thuringia, who was the hus-band of St. Elizabeth of Hungary.

After the death of Elizabeth, the hospital at Marburg, where she had passed the latter years of her widowhood in the care of the sick, was made over to the Teutonic Knights, and after her canonization, a church was built to receive her remains, and placed under the care of the Order.

In A.D. 1240, the knights received an earnest petition from the Duke of Poland, for aid against the Turks, who were ravaging his do-minions, and by the enormous multitude of their hosts were able to defeat any army he could bring into the field.

The knights accepted the invitation, and took part in a series of bloody and obstinate battles, in which they lost many of their

number.

They had also a new enemy to encounter in the Duke of Pomerania, who had been their ally, but who now sided with the Prussians against them.

In the war that ensued, the Duke was defeated, several of his strongholds were taken, and he was obliged to sue for peace.

A few years afterwards, however, A.D. 1243, the Duke recommenced hostilities, and with more success. Culm was besieged by him, and the greatest miseries were endured by the inhabitants, the slaughter being so great in the numerous conflicts before the walls, that at last very few men remained. The bishop even counselled the widows to marry their servants, that the population of the town might not become extinct.

The war was continued for several years with varying fortune, till a peace was at last concluded, principally through the mediation of the Duke of Austria.

About this time a disputed election caused a schism in the Order, and two rival Grand Masters for several years divided the allegiance of the knights, till Henry de Hohenlohe was recognized by both sides as Master. During his term of office, successful war was carried on in Courland, and other neighbouring countries, which resulted in the spread of Christianity, and the advance of the power of the Order. At the same time, the Teutonic Order took part in the Crusades in Palestine, and shared with the Templars and Hospitallers the successes and reverses which have already been detailed.

It would be tedious to enter upon all the details of the conflicts undertaken by the Order against the Prussians and others; suffice it to say that the knights, though often defeated, steadily advanced their dominion, and secured its permanence by the erection of fortresses, the centres about which cities and towns ultimately arose. Among these were Dantzic, Konigsberg, Elbing, Marienberg, and Thorn.

By the year A.D. 1283 the Order was in possession of all the country between the Vistula and the Memel, Prussia, Courland, part of Livonia, and Samogitia; commanderies were established everywhere to hold it in subjection, and bishoprics and monasteries were founded for the spread of Christianity among the heathen population.

In the contests between the Venetians and the Genoese, the Teutonic Knights aided the former, and in A.D. 1291, after the loss of Acre, the Grand Master took up his residence in Venice.

About this time the Pope originated a scheme for the union of

the three Orders of the Hospitallers, the Templars, and the Teutonic Knights, into one great Order, purposing at the same time to engage the Emperor and the Kings, of Christendom to lay aside all their quarrels, and combine their forces for the recovery once for all of the Holy Land.

Difficulties without number, which proved insuperable, prevented the realization of this scheme. Among these was the objection raised by the Teutonic Knights, that while the Hospitallers and Templars had but one object in view—the recovery of Palestine, their Order had to maintain its conquests in the north of Europe, and to prosecute the spread of the true faith among the still heathen nations.

In A.D. 1309, when all hope of the recovery of the Christian dominion in the East had been abandoned, and no further Crusades seemed probable, it was determined to remove the seat of the Grand Master from Venice to Marienberg.

At a chapter of the Order held there, further regulations were agreed upon for the government of the conquered countries, some of which are very curious, but give an interesting picture of the state of the people and of society at that period. Thus it was commanded that no Jew, necromancer, or sorcerer should be allowed to settle in the country. Masters who had slaves, and generally Prussians, prisoners of war, were obliged to send them to the parish church to be instructed by the clergy in the Christian religion. German alone was to be spoken, and the ancient language of the country was forbidden, to prevent the people hatching conspiracies, and to do away with the old idolatry and heathen superstitions. Prussians were not allowed to open shops or taverns, nor to act as surgeons or *accoucheurs*.

The wages of servants were strictly settled, and no increase or diminution was permitted. Three *marks* and a half a year was the wages of a carpenter or smith, two and a half *marks* of a coachman, a *mark* and a half of a labourer, two *marks* of a domestic servant, and half a *mark* of a nurse. Masters had the right to follow their runaway servants, and to pierce their ears; but if they dismissed a servant before the end of his term of service, they must pay him a year's wages. Servants were not allowed to marry during time of harvest and vintage, under penalty of losing a year's wages and paying a fine of three *marks*. No bargains were to be made on Sundays and festivals, and no shops were to be open on those days till after morning service.

Sumptuary laws of the most stringent nature were passed, some of which appear very singular. At a marriage or other domestic festival,

officers of justice might offer their guests six measures of beer, tradesmen must not give more than four, peasants only two. Playing for money, with dice or cards, was forbidden. Bishops were to visit their dioceses every three years, and to aid missions to the heathen. Those who gave drink to others must drink of the same beverage themselves, to avoid the danger of poisoning, as commonly practised by the heathen Prussians. A new coinage was also issued.

CHAPTER 3

Dismemberment of the Order

The knights' bones are dust,
And their good swords are rust,
Their souls are with the saints we trust.

Coleridge.

The next half-century was a period of general prosperity and advance for the Order. It was engaged almost incessantly in war, either for the retention of its conquests, or for the acquisition of new territory. There were also internal difficulties and dissensions, and contests with the bishops. In A.D. 1308, the Archbishop of Riga appealed to Pope Clement V., making serious charges against the Order, and endeavouring to prevail upon him to suppress it in the same way as the Templars had lately been dealt with. Gerard, Count of Holstein, however, came forward as the defender of the knights. A formal inquiry was opened before the Pope at Avignon, A.D. 1323.

The principal charges brought forward by the Archbishop were, that the Order had not fulfilled the conditions of its sovereignty in defending the Church against its heathen enemies; that it did not regard excommunications; that it had offered insolence to the Archbishop, and seized some of the property of his see, and other similar accusations. The Grand Master explained some of these matters, denied others, and produced an autograph letter of the Archbishop's, in which he secretly endeavoured to stir up the Grand Duke of Lithuania to make a treacherous attack upon some of the fortresses of the knights. The end of the matter was that the case was dismissed, and there is little doubt that there were serious faults on both sides.

The times were indeed full of violence, cruelty, and crime. The annals abound with terrible and shameful records, bloody and desolating

wars, and individual cases of oppression, injustice, and cruelty. Now a Grand Master is assassinated in his chapel during vespers; now a judge is proved to have received bribes, and to have induced a suitor to sacrifice the honour of his wife as the price of a favourable decision. Wealth and power led to luxury and sensuality, the weaker were oppressed, noble and bishop alike showing themselves proud and tyrannical. There are often two contradictory accounts of the same transaction, and it is impossible to decide where the fault really was, when there seems so little to choose between the conduct of either side.

The conclusion seems forced upon us, that human nature was in those days much the same as it is now, and that riches and irresponsible authority scarcely ever fail to lead to pride and to selfish and oppressive treatment of inferiors.

When we gaze upon the magnificent cathedrals that were rising all over Europe at the bidding of the great of those times, we are filled with admiration, and disposed to imagine that piety and a high standard of religious life must have prevailed; but a closer acquaintance with historical facts dissipates the illusion, and we find that then as now good and evil were mingled.

The history of the Order for the next century presents little of interest. In A.D. 1388, two of the knights repaired to England by order of the Grand Master, to make commercial arrangements with this country, which had been rendered necessary by the changes introduced into the trade of Europe by the creation of the Hanseatic League. A second commercial treaty between the King of England and the Order was made in A.D. 1409,

The Order had now reached the summit of its greatness. Besides large possessions in Germany, Italy, and other countries, its sovereignty extended from the Oder to the Gulf of Finland. This country was both wealthy and populous. Prussia is said to have contained 55 large fortified cities, 48 fortresses, and 19,008 towns and villages. The population of the larger cities must have been considerable, for we are told that in A.D. 1352, the plague carried off 13,000 persons in Dantzic, 4000 in Thorn, 6000 at Elbing, and 8000 at Konigsberg. One authority reckons the population of Prussia at this time at 2,140,800. The greater part of these were German immigrants, since the original inhabitants had either perished in the war or retired to Lithuania.

Historians who were either members of the Order or favourably disposed towards it, are loud in their praise of the wisdom and generosity of its government; while others accuse its members and heads of

pride, tyranny, luxury, and cruel exactions.

In A.D. 1410, the Teutonic Order received a most crushing defeat at Tannenberg from the King of Poland, assisted by bodies of Russians, Lithuanians, and Tartars. The Grand Master, Ulric de Jungingen, was slain, with several hundred knights, and many thousand soldiers.

There is said to have been a chapel built at Grünwald, in which an inscription declared that 60,000 Poles and 40,000 of the army of the knights were left dead upon the field of battle. The banner of the Order, its treasury, and a multitude of prisoners fell into the hands of the enemy, who shortly afterwards marched against Marienberg and closely besieged it. Several of the feudatories of the knights sent in their submission to the King of Poland, who began at once to dismember the dominions of the Order and to assign portions to his followers.

But this proved to be premature. The knights found in Henry de Planau a valiant leader, who defended the city with such courage and obstinacy that, after fifty-seven days' siege, the enemy retired, after serious loss from sorties and sickness. A series of battles followed, and finally a treaty of peace was signed, by which the Order gave up some portion of its territory to Poland.

But a new enemy was on its way to inflict upon the Order greater and more lasting injury than that which the sword could effect. The doctrines of Wicklif had for some time been spreading throughout Europe, and had lately received a new impulse from the vigorous efforts of John Huss in Bohemia, who had eagerly embraced them, and set himself to preach them, with additions of his own.

Several knights accepted the teaching of Huss, and either retired from the Order or were forcibly ejected. Differences and disputes also arose within the Order, which ended in the arrest and deposition of the Grand Master, A.D. 1413. But the new doctrines had taken deep root, and a large party within the Order were more or less favourable to them, so much so that at the Council of Constance, A.D. 1415, a strong party demanded the total suppression of the Teutonic Order. This was over-ruled; but it probably induced the Grand Master to commence a series of persecutions against those in his dominions who followed the principles of Huss.

The treaty that had followed the defeat at Tannenberg had been almost from the first disputed by both parties, and for some years appeals were made to the Pope and the Emperor on several points; but the decisions seldom gave satisfaction or commanded obedience. The

general result was the loss to the Order of some further portions of its dominions.

Another outbreak of the plague, in A.D. 1427, inflicted injury upon the Order. In a few weeks no less than 81,746 persons perished.

There were also about this time certain visions of hermits and others, which threatened terrible judgments upon the Order, because, while it professed to exist and fight for the honour of God, the defence of the Church, and the propagation of the faith, it really desired and laboured only for its own aggrandisement.

It was said, too, that it should perish through a goose (*oie*), and as the word "*Huss*" means a goose in Bohemian *patois*, it was said after wards, that the writings of Huss, or more truly perhaps, the work of the goose quill, had fulfilled the prophecy in undermining and finally subverting the Order.

There were also disputes respecting the taxes, which the people declared to be oppressive, and finally, in A.D. 1454, a formidable rebellion took place against the authority of the knights.

Casimir, King of Poland, who had long had hostile intentions against the Order, secretly threw all his weight into the cause of the malcontents, who made such way that the Grand Master was forced to retire to Marienberg, his capital, where he was soon closely besieged. Casimir now openly declared war, and laid claim to the dominions of the knights in Prussia and Pomerania, formally annexing them to the kingdom of Poland.

The Grand Master sent petitions for aid to the neighbouring princes, but without success. The Kings of Denmark and Sweden excused themselves on account of the distance of their dominions from the seat of war. Ladislaus, King of Bohemia and Hungary, was about to marry his sister to Casimir, and the religious dissensions of Bohemia and the attacks of the Turks upon Hungary fully occupied his attention, and demanded the employment of all his troops and treasure; and finally the capture of Constantinople by Mahomet at this very time, A.D. 1458, seemed to paralyze the energies of the European powers.

The Grand Master, Louis d'Erlichshausen, thus found himself deserted in his time of need. He did what he could by raising a considerable body of mercenaries, and with these, his knights, and the regular troops of the Order, he defended himself with courage and wonderful endurance, so that he not only succeeded in holding the city, but recovered several other towns that had revolted.

But his resources were unequal to the demands made upon them,

his enemy overwhelmed him with numbers, his own soldiers clamoured for their pay long overdue, and there was no prospect of aid from without. There was nothing left, therefore, to him but to make the best terms he could. He adopted the somewhat singular plan of making over Marienberg and what remained of the dominions of the Order to the chiefs who had given him aid, in payment for their services, and he himself, with his knights and troops, retired to Konigsberg, which then became the capital of the Order.

Marienberg soon afterwards came into the hands of Casimir; but the knights again captured it, and again lost it, A.D. 1460.

War continued year after year between Poland and the knights, the general result of which was that the latter were defeated and lost one town after another, till, in A.D. 1466, a peace was concluded, by the terms of which the knights ceded to Poland almost all the western part of their dominions, retaining only a part of eastern Prussia, with Konigsberg for their capital, the Grand Master acknowledging himself the vassal of the King of Poland, with the title of Prince and Councillor of the kingdom.

In A.D. 1497, the Order lost its possessions in Sicily through the influence of the Pope and the King of Aragon, who combined to deprive them of them. They still retained a house at Venice, and some other property in Lombardy.

In 1511, Albert de Brandenberg was elected Grand Master. He made strenuous efforts to procure the independence of the Order, and solicited the aid of the Emperor to free it from the authority of Poland, but without success. The Grand Master refused the customary homage to the King of Poland, and, after fruitless negotiations, war was once more declared, which continued till A.D. 1521, when peace was concluded; one of the results of which was the separation of Livonia from the dominion of the Order, and its erection into an independent state.

All this time the doctrines of Luther had been making progress and spreading among all classes in Prussia and Germany. In A.D. 1522, the Grand Master went to Nuremberg to consult with the Lutherans there, and shortly afterwards he visited Luther himself at Wittenberg. Luther's advice was decided and trenchant. He poured contempt upon the rules of the Order, and advised Albeit to break away from it and marry. Melancthon supported Luther's counsels.

Shortly after, Luther wrote a vigorous letter to the knights of the Order, in which he maintained that it was of no use to God or man.

He urged all the members to break their vow of celibacy and to marry, saying that it was impossible for human nature to be chaste in any other way, and that God's law, which commanded man to increase and multiply, was older than the decrees of Councils and the vows of Religious Orders. At the request of the Grand Master, he also sent missionaries into Prussia to preach the reformed doctrines. One or two bishops and many of the clergy accepted them, and they spread rapidly among the people. Services began to be said in the vulgar tongue, and images and other ornaments were pulled down in the churches, especially in the country districts.

In A.D. 1525, Albert met the King of Poland at Cracow, and formally resigned his office as Grand Master of the Teutonic Order, making over his dominions to the King, and receiving from him in return the title of hereditary Duke of Prussia. Shortly afterwards he followed Luther's advice, and married the Princess Dorothea of Denmark. Many of the knights followed his example. The annals and archives of the Order were transferred to the custody of the King of Poland, and were lost or destroyed during the troubles that subsequently came upon that kingdom.

A considerable number of the knights refused to change their religion and abandon their Order, and assembled in chapter at Mergentbeim to consult as to their plans for the future, A.D. 1527. They elected Walter de Cronberg Grand Master, whose appointment was ratified by the Emperor, Charles V.

In the religious wars that followed, the knights fought on the side of the Emperor, against the Protestants.

In A.D. 1595, the Commandery of Venice was sold to the Patriarch, and was converted into a diocesan seminary; and, in A.D. 1637, the Commandery of Utrecht was lost to the Order.

In A.D. 1631, Mergentheim was taken by the Swedes under General Horn.

In the war against the Turks during this period, some of the knights, true to the ancient principles of their Order, took part on the Christian side, both in Hungary and in the Mediterranean.

In the wars of Louis XIV., the Order lost many of its remaining commanderies, and by an edict of the King, in A.D. 1672, the separate existence of the Order was abolished in his dominions, and its possessions were conferred on the Order of St. Lazarus.

When Prussia was erected into a kingdom, in A.D. 1701, the Order issued a solemn protest against the act, asserting its ancient rights over

that country.

The Order maintained its existence in an enfeebled condition till A.D. 1809, when it was formally abolished by Napoleon.

In 1840, Austria instituted an honorary Order called by the same name, and, in 1852, Prussia revived it under the designation of the Order of St. John.

Portuguese and Spanish Orders

Oh, lovely Spain! renowned romantic land!
Where is that standard which Pelagio bore,
When Cava's traitor-sire first called the band
That dyed thy mountain streams with Gothic gore?
Where are those bloody banners which of yore
Waved o'er thy sons, victorious to the gale,
And drove at last the spoilers to their shore?
Red gleamed the Cross, and waned the Crescent pale,
While Afric's echoes thrilled with Moorish matrons' wail.
Byron.

1. THE ORDER OF AVIS

This Order is believed to have originated in Portugal about 1147, during the reign of King Alphonso I. Certain noblemen, it is said, banded themselves together to follow the King in his wars with the Moors, but without any religious vow or profession.

The Order was fully constituted in 1162, and Peter, a peer of France, and of royal blood, was appointed first Grand Master.

The knights followed the rule of St. Benedict, as observed at Citeaux. They were first named the *New Soldiers*, then the Knights of Evora, which place they had taken from the Moors, and afterwards the Knights of Avis, from a fortress where they established themselves, near the Moorish frontier, and from which they carried on constant war with the invaders of their country.

The Order was confirmed by Pope Innocent III., in A.D. 1284, and the Kings of Portugal conferred many privileges and possessions upon the Order.

The Order of Calatrava, in Spain, made over to the Order of Avis

their property in Portugal, on condition that the Grand Master of Calatrava should be the visitor of the Order of Avis. This led to subsequent disputes, which continued till the Council of Basle obliged the Knights of Avis to fulfil the terms of the agreement.

After some years, the Pope placed the government of the Older in the hands of persons nominated by himself, and Pope Paul III. united the Grand Mastership with the crown of Portugal.

2. THE ORDER OF ST. JAMES OF COMPOSTELLA, IN SPAIN

The shrine of St. James, at Compostella, attracted a vast number of pilgrims, but the wild and rocky character of the neighbouring country gave facilities to the Moors to lie in wait, pillage, and maltreat them.

To protect them a body of thirty noblemen and gentlemen formed themselves into a society, undertaking to patrol the roads and keep them open and safe. They received a rule and constitution from the Pope m 1175, and certain border castles, hitherto held by the Templars, were transferred to them. They also acquired large possessions and great wealth.

In 1396, they received permission to marry. In 1493, the Grand Mastership was united to the crown of Spain.

3. THE ORDER OF CALATRAVA.

In 614, the Moors invaded Andalusia, and vanquished the forces of King Rodrigo. They built a strong fortress at Oreto, which they named Calatrava, and held possession of it and of the surrounding country for more than four hundred years.

In 1147, however, Alphonso, King of Castile, besieged and took the place, and made it over to the Knights Templars; but they were able to retain it only eight years, when it once more fell into the hands of the Moors.

King Sancho, who reigned at that time, being unable to recover the place by his own forces, made a proclamation that he would give the city to anyone who could wrest it from the invaders.

But what the warlike Templars could not retain was unlikely to be recovered by anyone else, and the King's offer remained long unaccepted.

At last Velasquez, a Cistercian monk of the Abbey of Fitero, in Navarre, who had formerly been a soldier, persuaded his abbot, Raymond, to beg the city of the King on the terms proposed. He was treated

at first as crazy, but, persisting in his suit, the King at last executed a charter by which he made over the city of Calatrava to the Abbey of Fitero. This was in 1158. A Crusade was immediately preached, the archbishop of Toledo giving his support to the scheme. Many flocked to the standard, and the city was soon in the hands of the Christians. Raymond erected a system of fortifications for its protection, and then set about establishing an Order of Chivalry for its defence, he himself being the first Master. He also persuaded a large number of persons to emigrate to the newly-acquired territory.

The first members of the Order were really Cistercian monks, who assumed the sword and lance and became soldiers; but after the death of Abbot Raymond, they elected one of themselves Grand Master, and petitioned the Pope for the formal recognition and incorporation of the Order. This was done by Pope Alexander III. (A.D. 1164). They also received a habit which was a modification of that of Citeaux, suited to their military vocation. They were bound to keep silence, and to eat meat only three days a week. If they visited Citeaux they were not to be regarded as strangers, nor to be lodged in the guest hall, but were to be admitted within the cloister as brethren of the abbey.

They immediately engaged in warfare with the Moors, and achieved considerable successes and conquests. They received donations of the country they had acquired from the King, and also other castles and states.

Alphonso, King of Aragon, solicited the aid of the knights, and by their assistance waged successful war against the Moors in his dominions, and rewarded the Order by large gifts.

The records of the Order give many curious details of its inner life and discipline at this time.

The Grand Master having put to death a number of Moors who had been taken prisoners, the clergy and many of the knights complained of the act as cruel and unjust, and for a time withdrew their allegiance. An understanding was, however, arrived at, and unity soon afterwards restored. An application was made to Citeaux for the better government of the Order, and some new statutes and regulations were provided. The discipline was rendered more severe. Any knight who struck another was to eat his meals sitting upon the ground for three days, and not to bear arms or mount his horse for six months. The same penalties were exacted for disobedience to the Grand Master. Greater crimes were punished by eating upon the ground for a whole year, fasting on bread and water three days a week, and being scourged

every Friday.

The expeditions against the Moors were continued, and many Christian slaves were released, but in 1193, the Moors, having received large reinforcements from Africa, gained great advantages over the knights, many of whom fell in the numerous battles that were fought.

The tide of war turned against the knights; castle after castle fell into the hands of the enemy, whose superior forces were overwhelming, till at last Calatrava itself was besieged. After an obstinate resistance it was taken, and all the knights and other members of the Order were pitilessly put to the sword.

The headquarters of the Order during the ensuing years were transferred from one place to another, till, in 1212, Calatrava was once more recovered.

In the same year the Portuguese Order of Avis was affiliated to the Order of Calatrava, and in 1218 the Order of Alcantara was brought into connection with it.

A female Order was also instituted.

In 1296, a disputed election of the Grand Master led to confusion and trouble, which lasted for several years.

Then came the civil wars between Peter the Cruel and the Count Tristemare, in which the Order was involved, to its great injury, and to the abandonment of its proper object, war with the Mahometans.

In 1404, another schism occurred, and two Grand Masters were in the field; and in 1445, there were actually three, who divided the possessions and obedience of the knights.

In the meantime, however, the Moorish wars were resumed, and good service was done by the knights.

In 1464, after a long succession of civil wars, the Grand Master, Peter Giron, received a dispensation from the Pope to marry the Infanta Isabella, the heiress of the throne of Castile, his natural son, Rodrigo Tellez Giron, a child of eight years old, being appointed Grand Master. Giron would thus have received the crown as King Consort, but he died four days after his marriage, not without suspicion of poison.

In the wars of Ferdinand and Isabella, the knights took an active part against the Moors, and many acts of bravery are recorded of them.

At this time, in order to avoid a repetition of the unseemly quarrels and schisms that had so often accompanied the election of the Grand Master, the Pope assumed the right to nominate to that office, and in

1523 the right was transferred to the crown, and since that time the Order has gradually merged into a court institution.

The state dress is a white robe, with a red cross on the left breast. The permission to marry has been enjoyed since 1540.

4. THE ORDER OF ALCANTARA.

This Order is said to have been founded in 1156, by two brothers, Suarez and Gomez, who built a fortress on the frontiers of Castile, to serve as a bulwark against the incursions of the Moors.

This fortress received the name of the Castle of St. John du Poirier. A body of knights was organized to defend it, and Odo, Archbishop of Salamanca, gave them a rule. They wore ordinary secular habits, with only a peculiar scapular to distinguish them. Others say that they wore a crimson girdle. But the early history of the Order is involved in obscurity and uncertainty.

Pope Lucius III. constituted this body of knights into a regular Order in 1183, and commanded them to observe the rule of St. Benedict, with certain adaptations and mitigations which their military duties made necessary. At the same time, he exempted them from Episcopal authority. They came into possession of several convents—Raygadas Turpino, Herrera, Colmenar, Almendraseca, and Ponseca, and afterwards gained other possessions from the Moors, and built houses upon them.

In the war between Ferdinand, King of Leon, and Alphonso, King of Portugal, who was in league with the Moors, the knights were summoned by the former to join their forces with his, but they refused on the plea that their statutes forbade them to bear arms against Christians. In later times, however, we find them less scrupulous, and actually at war with their own sovereign.

In 1200, the King of Leon, having taken the city of Alcantara from the Moors, gave it to the Knights of the Order of Calatrava, on condition that they should make this the mother house of the Order for the kingdom of Leon, as Calatrava was for the kingdom of Castile. But the Grand Master, finding Alcantara too remote from Calatrava, and it being difficult to maintain a sufficient garrison there, with the King's consent, made the city over to the Order of St. John du Poirier, on condition that the two Orders should be united.

This union, however, seems never to have been actually carried into effect, but the Knights of St. John du Poirier took possession of the city of Alcantara, and made the convent there their headquarters,

and were thenceforth known by the title of the Knights of the Order of Alcantara.

For upwards of a century they continued true to their vows, and carried on incessant and successful wars with the Moors, but gradually they became involved in state quarrels, took part in civil wars, and fin.dly in 1318, the members of the Order were divided against one another. A dispute arose between the Grand Master and some of the knights. The latter appealed to the Grand Master of the Order of Calatrava, who came as requested, but found the gates of Alcantara closed against him, and his authority to interfere denied by the Grand Master there.

An appeal to arms followed, the city was taken, and a court held by which the Grand Master of Alcantara was deposed. He went to France, and laid his case before the Chapter of Citeaux, the Order of Alcantara and that of Calatrava being affiliated to the Cistercian Order. The sentence of deposition was, however, confirmed, and the ex-Grand Master was ordered to return to Spain, and submit himself to the new Grand Master, who had been elected in his stead. This he did.

Shortly afterwards a disputed election occurred, which led the former Grand Master to resume his office, and the consequence was that there were at the same time three persons claiming to be Grand Masters, and dividing the allegiance of the knights of the Order.

This schism continued for several years, and was not put an end to without bloodshed, and the interference of the King. This occurred in 1336.

But the peace was of short duration. A dispute arose between the King and the Grand Master, Gonsalvo Nunez D'Oviedo, said to have been fomented by the influence of Leonora de Guzman, a favourite of the King's, who was annoyed because her brother had not been appointed Grand Master. The king called upon the Grand Master to submit to an inquiry into his conduct, but instead of obeying, he took up arms, and fortified himself in his castle against the King.

In consequence of this, the King freed the knights from their obedience to Nunez, and commanded them to proceed to the election of another Grand Master, which they accordingly did, and appointed a knight commander of the name of Chamizio.

Once more the Order was divided, and war raged between the two bodies, the King of Portugal espousing one side, and the King of Castile the other.

Finally, Nunez was betrayed by the treachery of some of his own knights, and was beheaded in 1338. The King died soon after, and civil war followed on account of uncertainty as to the legitimacy of some of his sons. The Order was mixed up in the quarrel, and of course made enemies.

After this there was once more a disputed election of Grand Master; then the civil war between the King Peter the Cruel and the Count of Tristemare, which, after varying fortunes, ended in the death of the King, and succession of the count to the united kingdoms of Castile and Leon. His rights were disputed by Ferdinand, King of Portugal, who invaded Castile in 1369, Melen Suarez, who was Grand Master at the time, transferring his allegiance to him.

This act once more divided the Order, and the King of Castile caused another Grand Master to be elected, and the schism continued for some years.

Later, Don Sancho, a child of eight years old, was appointed Grand Master. Then another Grand Master was deposed; another assassinated; another slain in cold blood on the battlefield, where he had fallen from his horse, and appealed for help to a common soldier, who, instead of aiding him, stabbed him as he lay, to get a reward from the opposite faction. The records of the Order tell of little else than disputes, divisions, and unseemly contests.

In 1495 the Grand Mastership was made hereditary in the crown of Spain, and the Order became merely one of the honorary distinctions of the nobility. In 1540 the vow of celibacy was abolished.

The habit of the Knights is a white robe with a green cross on the left breast.

PART 5

English Orders

The monarch he lifted a Damascene blade
O'er the kneeling count's brow on high;
A blow on his shoulder full gently he laid,
And by that little action a knight he is made,
Baptized into chivalry.

'Bear thou this blow,' said the king to the knight,
'But never bear blow again;
For thy sword is to keep thine honour white,
And thine honour must keep thy good sword bright,
And both must be free from stain.'

Old Ballad.

1. THE ORDER OF THE BATH.

The origin of this Order is not known, though it is believed to be of high antiquity.

It was part of the ancient rites connected with knighthood that the candidate for admission should bathe the night before his investiture, to signify the purity which should distinguish the true knight. Just as at baptism, there were sponsors, and a name was given.

The following particulars of the ancient ceremonies that accompanied the investiture of a Knight of the Bath are detailed by W. Segar, honorary King of Arms:—

When an esquire comes to court to receive this Order of knighthood, he shall be very honourably received by the officers of the court. If he comes before dinner, he shall serve the king with water, or with a dish at the first course, and in the evening he shall be led to his chamber, where he shall be shaved

219

and his hair rounded. Then a bath shall be prepared, and decked with linen both within and without, and well covered with carpets and mantles for the cold of the night. Then they shall go to the king and say, 'Sir, it is evening, and the esquire is ready at the bath when it shall please you.' Whereupon the king shall command his chamberlain to convey to the chamber the most gentle and wisest knights to inform, counsel, and instruct the postulant in the order and feats of chivalry. Then they shall unclothe the esquire and put him into the bath, saying, 'Sir, great honour may this bath do unto you,' and they shall pour water upon his shoulder. Then they shall take him out of the bath and lay him in his bed till he be dry, and then he shall rise and apparel himself. Afterwards they shall lead him to the chapel, the esquires singing before him. At their entrance, spices and wine shall be given them. No man shall tarry in the chapel, except the esquire, his governors, the chandler, and the watch.

When day appears, the priest shall say prayers, and the knight shall communicate. At the reading of the gospel, the esquire shall take a wax candle from the governor, and hold it till the gospel is ended; then he shall kneel down and offer money in the honour of God. After which, the prayers being ended, he shall be led to his bed, and lie there till it be far day. Then the king shall command the knights, esquires, and minstrels to go to the chamber to cause him to rise, and bring him to the hall. And one knight shall give him his shirt, another his hose, the third his doublet, another shall apparel him in a kirtle of red tartan. Two shall lift him out of bed.

Then the knights shall mount him on horseback and conduct him to the hall, the music playing before him, his horse saddled with black leather; and a young esquire shall ride before him, who shall bear his sword by the point, with the spurs hanging from the hilt.

When they come to the king's hall, he shall be brought to the uppermost table, and the chamberlain shall take the sword and spurs from the young esquire, and the king shall take the right spur and deliver it to the most noble lord, saying, 'Put this on the esquire's heel.' And he, kneeling on one knee, shall take the esquire by the right leg, and put his foot upon his knee, and make fast the spur to his right heel, and make a cross on his knee and kiss him. Then another lord shall come and fasten the

spur on the other foot in the same manner. And then the king, of his great courtesy, shall take the sword and gird it about the esquire, and put his arm about the esquire's neck, and lift his right hand up and smite the esquire on his shoulder, saying, 'Be a good knight,' and then shall kiss him.

Then the knights shall lead the new knight to the chapel with great melody, where he shall kneel down at the high altar and put his hand upon it and promise to defend the right of the Holy Church during his life.

And at his going out of the chapel, the king's master cook is ready to take away his spurs and have them for his fee, saying, 'I am come from the king, being his master cook, to take the spurs from you, and to show you that, if you do anything against the order of chivalry (which God forbid!), I will cut away the spurs from your heels.' Then they went to dinner.

The Order of the Bath is believed to have been conferred both in England and Normandy in the reign of William the Conqueror, and an account is preserved of the admission of knights to the Order at the coronation of Henry V. Charles II. created, sixty-eight Knights of the Bath at the time of his coronation.

From that time, however, the Order was obsolete, till George I. restored it, the Sovereign being Grand Master, and the number of knights-companions thirty-six. The chapel of Henry VII. in Westminster Abbey was assigned for the ceremonies of installation, and the banners of the knights are suspended over their respective stalls in the same manner and with the same solemnity as is done at St. George's Chapel, Windsor, for the Knights of the Garter.

The badge of the Order is a rose issuing from the *dexter* side, and a thistle from the sinister side of a sceptre, between three imperial crowns. The motto is, *Tria juncta in uno.*

2. THE ORDER OF THE GARTER.

The most commonly received account of the origin of this Order ascribes it to Edward III. of England and France, who handed the Countess of Salisbury the garter she had lost during a ball, with the words, *Honi soit qui mal y pense.*

But great controversy has arisen on the subject; many dispute the circumstances and give other particulars, and no certainty can now be arrived at as to the exact date and reason of the foundation of the Order.

The Order was placed under the protection of Almighty God, the Blessed Virgin, St. George, and St, Edward the Confessor.

Selden says that "it exceeds in majesty, honour, and fame all Chivalrous Orders in the world."

Ashmole finds on the register eight Emperors of Germany, three Kings of Spain, five Kings of France, two Kings of Scotland, five Kings of Denmark, five Kings of Portugal, two Kings of Sweden, one King of Poland, one King of Aragon, and two Kings of Naples.

The members of the Order are the Sovereign and twenty-five companions, called Knights of the Garter.

There is a Prelate of the Order, who is the Bishop of Winchester, who is sworn "to be present at all Chapters, to report all things truly, without favour or fear, to keep secret all counsels of the Order," etc.

The Chancellor is the Bishop of Oxford, and keeps the seal.

The Registrar is the Dean of Windsor. The chapel of Windsor Castle is hung with the banners of the knights, and is the scene of the solemn functions of the Order.

3. THE ORDER OF THE THISTLE.

The adoption of the Cross of St. Andrew by Scotland is said to have originated in the appearance of such a cross in the sky before a battle in 819.

There are also several legends to account for the adoption of the thistle and the motto, *Nemo me impune lacessit*; "*No one provokes me with impunity.*"

An Order of knighthood with these badges existed from early times in Scotland, and after many fluctuations, was reconstituted by letters patent by Queen Anne in 1703, and has ever since continued.

4. THE ORDER OF ST. PATRICK.

This Order was instituted by King George III. of England, in 1783, to do honour to men of distinction and merit in Ireland.

Orders of Knighthood: Legendary, Honorary, and Modern

. . . on the walls,
Betwixt the monstrous horns of elk and deer,
His own forefathers' arms and armour hung.
And 'this,' he said, 'was Hugh's at Agincourt;
And that was old Sir Ralph's at Ascalon:
A good knight he! we keep a chronicle
With all about him'—which he brought, and I
Dived in a hoard of tales that dealt with knights
Half-legend, half-historic, counts and kings
Who laid about them at their wills and died;
And mixt with these, a lady, one that armed
Her own fair head, and sallying thro' the gate,
Had beat her foes with slaughter from the walls.

Tennyson.

As the Middle Ages passed away, and Chivalry disappeared, the various Orders of knighthood in Europe for the most part became extinct. Some of them survived in a modified form, and were converted into honorary distinctions conferred by kings upon those who had done good service to their country, or upon the members of their own and other courts. Many new Orders of this sort were from time to time founded, and as they were the modern representatives of the ancient Religious Military Orders, it has been thought desirable to add a list of them, together with others which are mentioned by different authors. It is evident that there is no historical certainty that all these Orders actually existed. Many of them, doubtless, are merely

legendary. The catalogue has been compiled from Burke, and other authorities.

THE ORDER OF THE GOLDEN ANGEL.

This Order, if we can rely upon the records that remain of it, was the earliest of all the Christian Military Orders. It is said to have been founded by the Emperor Constantine, in 312, after he had seen the vision in the sky of the luminous cross held by an angel. In consequence of this apparition he took the Cross and the Greek letters X, P for his standard, and appointed fifty officers of his army, of equestrian rank, to guard it.

THE ORDER OF ST. ANTHONY IN ETHIOPIA.

Legendary records assert that an Order was established in Ethiopia in the fourth century, which partook of the military and hospitaller characters. The members were to tend and defend the blind and lame, and to fight in defence of Christianity against the surrounding heathen. They were said by some to owe their foundation to the famous Prester John, of whom so much was said by ancient Christian writers.

An Order with the same name existed in Europe in the thirteenth century, and is believed to have been transported from Constantinople.

KNIGHTS OF THE SACRED VASE OR VIAL.

Early French writers speak of an Order of knights created by Clovis at the end of the fifth century, whose duty it was to protect the Sacred Vase containing the oil with which the king was anointed at his coronation. This vase was supposed to have been miraculously brought to St. Remy by a dove. The whole of the events and circumstances are only legendary.

THE ORDER OF THE SWAN.

Great uncertainty exists as to the history of this Order. Some assert that it was instituted in Flanders about the year 500; others doubt whether there ever was an Order with this title.

There was an Order of this name in Brandenburg in the fifteenth century, which became extinct at the Reformation, but was revived in a modified form by Frederick William, King of Prussia, in 1843.

THE ORDER OF THE DOG AND COCK.

It is said that an Order of knighthood was founded in France about

the year 500, by the ancestor of the Montmorency family, whose crest was a dog.

There was also in the time of Philip I. an Order of the Cock, and these two Orders seem to have been united. But nothing certain is known about one or the other.

THE KNIGHTS OF THE ROUND TABLE.

The well-known legend of this primitive Order of knighthood needs only to be alluded to for the sake of completeness. There is no proof that such an Order ever existed. King Arthur is said to have associated with himself twenty-four nobles of his kingdom to maintain it against the heathen, who sat with him at a round table, that all might be equal.

THE ORDER OF THE OAK.

About the year 722, a luminous cross is said to have appeared to the Christian army, under Garcia Ximenes, when about to attack an army of Moors in Spain, and an Order of knighthood was subsequently instituted to commemorate the apparition.

THE ORDER OF LA CALZA, OR THE STOCKING.

This Order is said by some authorities to have been founded in 737, while others put it as late as 1400. In the sixteenth century it numbered some of the highest nobility of Europe among its members, and its centre was at Venice.

The knights wore an elaborately embroidered stocking upon one leg, and a plain one on the other.

THE ORDER OF THE GOLDEN STOLE.

Little is known of the origin and history of this Order, except that it existed at one time at Venice, and that the badge was a scarf worn over the shoulder.

THE ORDER OF ST. MARK.

The date of the foundation of this Order is un- known. It existed in Venice, whither the relics of St. Mark were brought from Alexandria in the ninth century.

THE ORDER OF THE GENNET.

After the signal victory of Charles Martel over the Saracens, in or about the year 726, he gave a distinction to his officers in memory of the success, and some affirm that an Order of knighthood was instituted. There is, however, great uncertainty about all the circumstances.

THE ORDER OF FRIESLAND, OR OF THE CROWN.

The Frisons afforded great help to Charlemagne in his wars, and to show his sense of their valour and devotion he gave their officers, in 802, a special decoration, and enrolled them into an Order of knighthood, whose badge was an imperial crown.

THE ORDER OF ST. COSMAS AND ST. DAMIAN.

St. Cosmas and St. Damian were primitive saints, who devoted themselves to the care of the sick, and were consequently taken as patrons of those who followed their good example. Some authorities affirm, though others deny, that there was an Order of men, in very early times, with this designation at Jerusalem, which devoted itself to the care of sick pilgrims, and their protection on their way.

THE ORDER OF OUR LADY OF THE LILY.

Garcia VI., King of Navarre, instituted this Order in memory of his unexpected recovery from a dangerous sickness in 1048. He himself became its head, and members of the noblest families in his kingdom were enrolled among its knights.

THE ORDER OF ST. CATHERINE OF MOUNT SINAI.

This Order was instituted in 1063, to protect the shrine of St. Catherine and the pilgrims who resorted to it.

THE ORDER OF ST. SAVIOUR.

In order to encourage the nobles to assist him in his efforts to drive the Moors out of his country, Alphonso IV., King of Aragon, founded an Order of knighthood, in 1118, whose members should be pledged to fight against these invaders.

The Order flourished and gained considerable territorial possessions, but was suppressed in 1665.

THE ORDER OF THE HOLY SEPULCHRE.

It is affirmed by many writers of antiquity, that when St. Helena, the mother of the Emperor Constantine, had discovered the Holy Sepulchre, and had built a church over and around it, she not only established there a monastery of Canons Regular of St. Augustine, but founded an Order of knighthood, to whose care she committed the defence of the Holy Sepulchre, and of the pilgrims who came to visit it. Some, not content with this early origin of Military Religious Orders, maintain that such an Order was actually founded by St. James, the first Bishop of Jerusalem, himself.

Others assure us that Godfrey de Bouillon established such an Order, which was in reality only a revival of one or other of these primitive institutions, and certain statutes and other documents are quoted in proof of this, which are said to have existed, but which have since perished.

All this is, however, of extreme improbability, and, till more proof is produced, must be looked upon merely as legendary. There is nothing certain respecting such an Order till 1489, when Pope Innocent mentions its existence in France, and proposes to merge it into the Order of the Hospitallers. In 1496 Pope Alexander VI. became its Grand Master, and from that time it has had but a nominal existence, as an honorary distinction conferred by the Pope.

THE ORDER OF ST. LAZARUS AND ST. MAURICE.

A very high antiquity is claimed for the Order of St. Lazarus. It is said to have been founded in apostolic times—indeed, not long after the Ascension of our Lord—for the defence and protection of His disciples from the persecution of the Jews! Such a legend hardly demands serious attention.

There seems more reason in the assertion that St. Basil founded an hospital at Caesarea, about 370, for lepers and others, which was dedicated to St. Lazarus, and which was the cradle of the Order. A similar hospital was opened at Jerusalem, and it is believed by some that it was there that the original Hospitallers began their care of the sick, before the idea was conceived of the establishment of an Order of knighthood.

It is said that their Grand Master was always himself a leper, till Palestine was lost to the Christians. The Order obtained recognition from the Pope and the European sovereigns, and had convents, hospitals, and estates in France, Italy, and other countries.

In 1572 Pope Gregory XIII. united the Order with that of St. Maurice in Savoy, which had been recently founded to protect the country from the attacks of the Calvinists of Geneva. These knights were permitted to marry, under certain restrictions. Henry IV. of France united them with the Order of Mount Carmel.

The Order has continued, in a modified form, to the present day. New statutes were given to the Order in 1818, and revised in 1831, by which it was assimilated to the Legion of Honour in France. There are five classes of members, who receive decoration or pensions as rewards for military or civil service in Italy.

THE ORDER OF ST. BLAISE.

This Order was founded in Armenia in the twelfth century.

THE ORDER OF THE TORCH.

Don Raymond, of Barcelona, having in the year 1149 taken the city of Tortosa from the Moors, they soon afterwards laid siege to the place. The inhabitants were reduced to extremities, and the men were deliberating as to the terms of surrender, when the women not only opposed the project, but, dressing themselves in men's clothes, aided the soldiers so materially that the Moors were defeated, and retired.

In memory of this, Raymond instituted an Order into which these brave women were admitted, with the right of transmitting the honour to their descendants.

He also ordered that on all public occasions the women should have precedence of the men; that they should be exempted from all taxes, and that all the apparel and jewels left by their husbands at their death should be their own.

THE ORDER OF THE WING OF ST. MICHAEL.

In the year 1172, Albarac, the Moorish King of Seville, made war upon Alphonso, King of Portugal, and during a battle the Archangel Michael appeared leading on the Christian army, which gained a complete victory. In remembrance of this an Order of knighthood was instituted, which, besides fighting the Moors, was intended to relieve widows and orphans.

This Order has ceased to exist, but the King of Portugal is still titular Grand Master.

THE ORDER OF ST. JAMES OF THE SWORD was founded by King Alphonso I. of Portugal, in 1177.

THE ORDER OF MONT-JOYE.

The title of this Order was taken from a mountain near Jerusalem, where it had its mother house. There were also houses in Spain, where the knights carried on war against the Moors.

The Order was ultimately incorporated with that of Calatrava.

THE ORDER OF ST. GEREON.

St. Gereon is said to have suffered martyrdom in primitive times, with three hundred other Christians, at Cologne. In 1228, the Emperor Barbarossa instituted an Order of knighthood in his honour. The members were required to be of German birth.

THE ORDER OF THE SWORD, OR OF CHRIST, OR OF SILENCE.

When Palestine fell into the hands of the Saracens, a large body of Christians retired to Cyprus, under Guy of Lusignan, King of Jerusalem, who founded an Order of knighthood, which continued to exist till the Turks gained possession of the island.

THE ORDER OF THE HOLY GHOST.

This Order originated at Montpellier, in France, and undertook the care of the sick, and of foundlings and wayfarers. It was afterwards united with a similar Order in Rome, in 1198, and had a magnificent hospital there.

THE ORDER OF KNIGHTS SWORD-BEARERS, OR PORTES GLAIVES, OR OF THE TWO SWORDS, OR ENSIFERI, OR GLADIFERI FRATRES.

In 1186, Mesuardus, a devout German nobleman, began a mission to the heathen in Livonia. He founded a bishopric at Riga, and associated a body of men with him under the Cistercian rule. This Order was for a time united with the Teutonic Knights, but afterwards separated again, and in 1561 the Order was dissolved, the Grand Master, Gothard de Ketler, being created Duke of Courland.

THE ORDER OF OUR LADY OF THE ROSARY.

Roderick, Archbishop of Toledo, instituted an Order of knighthood, in 1212, to resist the encroachments of the Moors.

THE ORDER OF THE BEAR, OR OF ST. GALL.

Frederick, Duke of Suabia, having been elected Emperor in 1213, while visiting the Abbey of St. Gall, in Switzerland, instituted an Order to honour and reward those by whose assistance he had obtained the imperial dignity. The patron saint of the Order was St. Ursus, one of the Theban Legion, who had been martyred at Soleure, and whose body was enshrined in the Abbey church of St. Gall. The Order was dissolved when Switzerland became independent.

THE ORDER OF OUR LADY OF MERCY.

James I., King of Aragon, having been made prisoner in France by Simon, Count of Montfort, on his release, remembering the hardships he had suffered, desired to help the Christian captives who were enduring the miseries of slavery among the Moors. He established an Order at Barcelona, in 1218, whose members spent their lives in collecting alms and redeeming Christian slaves. In the first six years four hundred were restored to liberty and to their country.

Disputes arose subsequently between the lay and clerical members of the Order, and the former seceded and joined the Order of Montesa. Later they co-operated with the Trinitarians, or Mathurins.

There was a female branch of this Order.

THE ORDER OF THE CROSS OF JESUS CHRIST, OR THE KNIGHTS OF THE MILITIA OF ST. DOMINIC.

St. Dominic brought about the foundation of this Order, in 1206, to resist the progress of the Albigenses in France and Italy. There was a similar association for ladies.

THE ORDER OF THE KNIGHTS OF THE MOTHER OF GOD.

Bartholomew, Bishop of Vicenza, instituted, in 1233, a society for the protection and support of widows and orphans, and for the healing of domestic quarrels.

THE ORDER OF THE BROOM-FLOWER.

Louis IX. of France instituted this Order on the occasion of his Queen's coronation, in 1234.

THE ORDER OF ST. JOHN OF ACRE.

This Order was created to receive and defend pilgrims. When Palestine was lost it was transferred to Spain, and incorporated with that of the Templars.

THE ORDER OF THE CRESCENT.

Charles, King of Naples and Sicily, founded this Order, but it seems to have gradually decayed, till it was revived by René, Duke of Anjou, in 1464, who placed it under the patronage of St. Maurice of the Theban Legion. Its members were necessarily soldiers who had distinguished themselves in battle.

THE ORDER OF THE SHIP AND SHELL.

Louis IX. of France instituted this Order during his crusade to Palestine. It seems never to have spread or flourished.

THE ORDER OF ST. GEORGE.

Rudolph, Count of Hapsburg, when elected Emperor, established this Order to protect the frontiers from the inroads of the Turks, and gave them the Benedictine Abbey of Milestead, in Carinthia. The Grand Master was a Prince of the Empire.

THE ORDER OF ST. JAMES.

Florentius, Earl of Holland, Zealand, and Friesland, instituted this

Order at the Hague, in 1290, to reward some of his nobility who had done him good service.

THE ORDER OF ST. GEORGE OF ALFAMA was instituted in Spain in 1201, and united to that of Montesa in 1399.

THE ORDER OF MONTESA.

After the dissolution of the Templars this Order was founded in Spain, in 1317, to take their place. The principal convent was at Montesa, in Valencia.

THE ORDER OF THE SCALE was created by John II., King of Castile, about the year 1316, to defend the country against the Moors, but never attained to any great importance.

THE ORDER OF CHRIST was founded in Portugal, in 1319. When the Order of the Templars was suppressed, Dionysius, King of Portugal, refused to allow the Papal decree to have effect in his dominions, and the Templars continued to enjoy their property and rights. After a few years, to satisfy the Pope, the name of the Order was changed to that of the Order of Christ.

THE ORDER OF JESUS CHRIST was instituted by Pope John XXII. at Avignon, in 1320, but has not attained any celebrity.

THE ORDER OF THE WHITE EAGLE was created by Uladislaus V. on the occasion of the marriage of his son Casimer to Anne, daughter of Gedimir, Duke of Lithuania, in 1325. It was revived by Frederick Augustus I. in 1702. In 1726 the Empress of Russia was invested with the insignia.

THE ORDER OF LA BANDA, OR THE SCARF, was commenced by Alphonso XI., King of Leon and Castile, in 1332, for the protection of himself and his kingdom. Each knight before his admission into the Order was required to watch and pray all night in a church; he was bound always to defend the king by word and deed; always to be ready with arms, armour, and horses, to take up service for the king; never to cry out from the pain of his wounds; if he met any lady of the court, he must alight from his horse and offer her his services; he must not eat alone; he must continually exercise himself in the use of his arms; he must be married or betrothed; he must appear armed before the king on the first Sunday in each month, ready to perform any action at the king's pleasure.

THE ORDER OF THE SERAPHIM, OR OF JESUS.

There is some uncertainty as to the date of the foundation of this Order, but it is most probable that it commenced in 1334, after the siege of Upsal. It was abolished at the Reformation, but reconstituted by Frederick I. of Sweden, in 1748.

THE ORDER OF THE STAR was instituted by John II., King of France, in imitation of the English Order of the Garter, but was abolished by Charles VIII.

THE ORDER OF THE EAR OF CORN AND ERMINE was created by Francis I. of France, in 1351.

THE ORDER OF THE STAR IN SICILY.

In 1351, the princes of the house of Anjou being driven out of Naples by the King of Aragon, this Order was erected instead of that of the Crescent. It did not last long.

THE ORDER OF THE KNOT was instituted at Naples in 1351, and had only a short existence.

THE ORDER OF THE ANNUNCIATION.

Amadeus, Count of Savoy, instituted this Order in 1392.

THE ORDER OF THE ARGONAUTS is said to have been founded by Charles III., King of Naples, in 1382, to encourage trade and navigation, but it existed only during the life of its founder.

THE ORDER OF FOOLS was instituted by Adolphus, Count of Cleves, in 1380. No satisfactory explanation of its curious title can be given.

THE ORDER OF BRICIAN KNIGHTS OF SWEDEN was erected in 1366. The members were bound to defend the Christian religion, to protect the kingdom, to bury the dead, to succour the widow and fatherless, and to practise hospitality.

THE ORDER OF THE GOLDEN SHIELD was instituted in 1370, by Louis, Duke of Bourbon.

THE ORDER OF ST. ANTHONY was formed in 1382, by Albert, Duke of Bavaria and Earl of Hainault and Holland, to aid an expedition against the Turks.

THE ORDER OF THE REALE, OR OF THE LIONESS, came into existence during the civil wars of Naples, between Ladislaus and Louis, Duke of Anjou.

THE ORDER OF THE DOVE, OR OF THE HOLY GHOST, was com-

menced in 1379, by John I., King of Castile, and did not long survive his death.

The Order of the Passion of Jesus Christ.

On the conclusion of peace between Richard II. of England and Charles VI. of France, they united to institute this Order, with a view of protecting and giving relief to the Christians, who, after the loss of the Holy Places, were most cruelly oppressed in Palestine, and all other regions of the Levant, by the pride of the Saracens, the treachery of the Moors, and sometimes by the jealousy of the Greeks. Philip de Maisiere, who was Chancellor of the Island of Cyprus, gives the following account of the reasons which prompted the two monarchs to erect this Order:

> Forasmuch as, by reason of the three deadly sins which began to reign among Christians, namely, pride, covetousness, and luxury, God permitted the Saracens, enemies of the faith, to overcome Jerusalem and the Holy Land, to the shame and disgrace of Christendom; therefore to renew the memory of the Passion of Christ, thereby to extirpate those deadly sins, and to make way for the conquest of Jerusalem and the Holy Places, and the overthrow and confusion of the enemies of the faith, this Order was erected.

The number of knights exceeded a thousand. The habit was white; the badge, a red cross edged with gold, and charged in the centre with a shield, upon which was an Agnus Dei.

The Order of St. George in Burgundy was a small and local institution, founded by Philibert de Miolaus in 1400, to guard some relics of St. George the Martyr, which he had brought from the East, and deposited in a church at Rougemont.

There was a female branch.

The badge was St. George on horseback killing the dragon, similar to that of the Order of the Garter.

The Order of the Porcupine was founded by Louis, second son of Charles V. of France, on the occasion of the birth of his son Charles. The object of the Order was the unworthy one of obtaining revenge against his rival, John, Duke of Burgundy. This was intimated in the badge, which was a porcupine, and in the motto, *Cominus et eminus*, or in French, *De pres et de loin*. There were twenty-five knights. Each received at his admission a cameo ring, engraved with the figure of a

porcupine. Hence it was sometimes called the Order of the Cameo,

THE ORDER OF THE DRAGON OVERTHROWN.

The Emperor Sigismund, in order to perpetuate the memory of the condemnation of John Huss and Jerome of Prague, at the Council of Constance, instituted this Order in 1418.

THE ORDER OF LA JARA, OR THE LILY, was instituted by Ferdinand, King of Aragon, in 1403, on the occasion of a great victory over the Moors.

It is said to have been called also the Order of the Looking-Glass of the Blessed Virgin.

THE ORDER OF THE GOLDEN FLEECE, OR TOISON D'OR.

Philip, surnamed the Good, Duke of Burgundy, instituted this Order on the occasion of his marriage with Elizabeth, daughter of John, King of Portugal, in 1429. The name had reference to the great profits and revenue obtained by the wool trade in the Low Countries. Charles V. increased the number of the knights from twenty-four to fifty, in 1516. The motto was, *Pretium non vile laboris*; "*Not an unworthy reward for our labour.*"

Many explanations of the Fleece have been given by different writers, besides that stated above. It is said to refer to Gideon's Fleece; to the fleeces of Jacob's parti-coloured sheep; and to the Golden Fleece that Jason fetched from Colchis.

Another account states that in 1430, so magnificent a harvest was gathered in throughout France, that the Order was founded in memory of it. And as the word Jason is formed by the initials of the months July, August, September, October, November, Philip was by this reminded of the Golden Fleece, and so took it for his emblem.

Disputes arose after the death of Charles V., between Austria and Spain, as to the nationality of the Order. It is now naturalized in both countries.

THE ORDER OF ST. HUBERT was instituted by Gerard, Duke of Juliers, in memory of a victory which he gained over Arnold of Egmont, on St. Hubert's Day, 1447.

After becoming extinct, it was revived by John William, Elector Palatine of the Rhine, in 1709. The motto was, *Keep firm in the faith.*

THE ORDER OF THE TOWER AND SWORD was founded by Alphonso V., King of Portugal, in 1459.

THE ORDER OF THE ERMINE was instituted by Ferdinand, King of

Naples, in 1468, upon the discovery of a plot, headed by his brother-in-law, against his life and throne. He not only generously forgave him, but made him the first knight of the Order. The motto was, *Malo mori quam foedari; "I had rather die than be disgraced."*

THE ORDER OF ST. MICHAEL.

The Archangel St. Michael was always much venerated in France as a protector of the country, the kings keeping open court on St. Michael's Day, September 29.

The Order was founded by Louis XI., in 1469. The original number of knights was only thirty-six, but they were gradually increased to three hundred. Many persons of mean extraction, however, having been admitted, Louis XIV. forbade any not of noble blood to bear the insignia.

Mount St. Michael, in Normandy, was originally the principal house of the Order. The motto is, *Immensi terror oceani.*

THE ORDER OF ST. GEORGE AT GENOA was instituted by the Emperor Frederick III., in 1472. The Doge was Grand Master.

THE ORDER OF THE ELEPHANT.

In 1478 Christian I., King of Denmark, founded this Order on the occasion of the marriage of his son John to Christiana, daughter of Ernest, Duke of Saxony. Why the elephant was chosen as the symbol does not appear. Henry VIII. of England was a knight. It now commands as high a respect as the Golden Fleece or Garter.

THE ORDER OF ST. GEORGE AT ROME.

The pirates who infested the Mediterranean and Adriatic doing great injury and causing much misery to the towns on the coast, and to their trade, an Order was founded by Pope Alexander VI., in 1498, or, as others say, by Pope Paul III., for their suppression.

THE ORDER OF ST. PETER AND ST. PAUL AT ROME was founded by Leo X., to protect the Adriatic, and especially Venice, from the depredations of the Turks, in 1520.

THE ORDER OF THE SWORD AND MILITARY BELT IN SWEDEN was instituted by Gustavus I., King of Sweden, in 1525, and was revived by Frederick I. in 1748. It was intended to be a means of rewarding and honouring military service. The motto is *Pro Patria.*

THE ORDER OF THE GOLDEN SPUR.

This Order was created by Pope Pius IV., in 1560. The knights

were styled *Pios*, or *Imperiales*, or *Compensales*, and numbered 375, but were afterwards increased to 535. Their principal office consisted in carrying the Papal chair on their shoulders whenever the Pope went in public.

THE ORDER OF ST. STEPHEN.

Cosmo de Medicis having defeated his enemies at the battle of Marciano, in 1554, on the feast of St. Stephen, Pope and Martyr, founded an Order of knighthood in commemoration of an event that laid the foundation of his greatness.

The members followed the rule of St. Benedict, and the Popes granted them the same privileges as those enjoyed by the Knights Hospitallers.

The Grand Mastership was afterwards made hereditary to the Dukes of Tuscany.

The knights were allowed to marry. They had a convent, church, and seminary at Pisa, and their principal duty was to repel the naval attacks of the Turks upon the seaports of Italy.

THE ORDER OF THE SAVIOUR OF THE WORLD was established by Eric XIII., King of Sweden, either at his coronation, in 1561, or on his marriage with Catherine, sister of Sigismund, King of Poland. It was dissolved at the Reformation.

THE ORDER OF THUSIN OF AUSTRIA, OR THUSINI EQUITES.

Little is known of this Order. It is said to have been begun by the Emperor Albert III., in 1562.

THE ORDER OF THE BURGUNDIAN CROSS owed its origin to the Emperor Charles V., who thus commemorated his victory over Barbarossa at Tunis, in 1535.

THE ORDER OF THE LAMB OF GOD.

John, surnamed the Great, King of Sweden, in order to give *éclat* to the solemnity of his coronation, instituted this Order at Upsal, in 1564. The motto was, *Deus protector noster,* "God our Protector."

The Order of St. Maurice and St. Lazarus in Savoy was instituted by Amadous VII., Duke of Savoy, who afterwards became Pope Felix V. It was refounded by Pope Gregory XIIL, and the Dukes of Savoy were appointed hereditary Grand Masters. The Order was bound to furnish two galleys for the protection of the sea-coast of the Papal dominions.

THE ORDER OF THE HOLY GHOST.

Henry III. of France created this Order in 1579, on account of the three principal events of his life having taken place on Whitsun Day. He also desired by this means to unite the nobility to himself, to one another, and to the Catholic faith, at a time when France was distracted by civil and religious factions. The king was made hereditary Grand Master. The motto was, *Duce et auspice.*

THE ORDER OF OUR LADY OF LORETTO appears to have been constituted by Pope Sixtus V., in 1587, to stimulate the Italian nobility to defend the dominions of the Pope. It was abolished by Pope Gregory XIII.

THE ORDER OF THE YELLOW STRING, OR CORDON JAUNE, was instituted by the Duke of Nevers in France, in 1606, and abolished in the same year.

THE ORDER OF OUR LADY OF MOUNT CARMEL AND OF ST. LAZARUS.

Henry IV. of France, on his conversion to the Roman Church, founded an Order, in 1608, under the denomination of the Blessed Virgin Mary of Mount Carmel, and shortly afterwards attached to it the houses of the Order of St. Lazarus that were in his dominions. The knights were sworn to protect the King and the Pope.

THE ORDER OF THE PRECIOUS BLOOD OF OUR SAVIOUR JESUS CHRIST was instituted in 1608, at Mantua, by Vincenzio de Gonzagna, in honour of the marriage of his son Francis with Margaret of Savoy. The motto was, *Doniine, probasti me.*

THE ORDER OF JESUS AND MARY was founded by Pope Paul V, in 1615, for the defence of the Papal dominions.

THE ORDER OF THE CONCEPTION OF THE VIRGIN MARY was created by Charles de Gonzagne of Cleves, Duke of Nivernois, in 1618, in honour of the Immaculate Conception of the Blessed Virgin.

THE ORDER OF THE VIRGIN, ALSO CALLED THE ORDER OF THE ANNUNCIADE AND THE CHRISTIAN MILITIA, was instituted in Italy, in 1618, by three brothers, Peter, John Baptist, and Bernard Petrigna.

THE ORDER OF THE CELESTIAL COLLAR OF THE HOLY ROSARY.

The French nobility being much divided by factions, Queen Anne of Austria, widow of Louis XIII. and mother of Louis XIV., by the advice of the Dominican Friar Arnold, instituted this Order for ladies

only, in the hope of healing the divisions that separated their families.

THE ORDER OF THE DEATH'S HEAD

was both for men and women, to remind them of the certainty of death, and so to keep them from evil ways. It was founded by Silvius, Duke of Wurtemburg, in 1662, and revived in 1709, by Louisa, his widowed daughter. The motto was. *Memento mori.*

THE ORDER OF THE AMARANTHA was instituted in 1645 or 1653, by Christiana, Queen of Sweden, daughter of Gustavus Adolphus, in honour of a friend, a lady of great beauty, courage, and piety. The motto was, *Dolce nella memoria;* "*Of sweet memory.*"

THE ORDER OF CONCORD owed its origin to Christian Ernest, Margrave of Brandenburg, in 1660.

THE ORDER OF THE LADIES SLAVES TO VIRTUE was instituted by the Empress Eleanor at Vienna, in 1662, with a view to promote piety among the ladies of her court.

THE ORDER OF DANEBROG is said to have been instituted in 1219, in commemoration of a miraculous banner that appeared in the army of Wildeman II., King of Denmark, during a battle with the Livonians. It was revived by Christian V. in 1671.

THE ORDER OF GENEROSITY was instituted by Frederick III., Prince of Brandenburg, in 1685; converted into a military Order of Merit in 1810; civil Order added in 1842.

THE ORDER OF THE STAR CROSS was founded in 1668, by the Empress Eleonore of Austria, after a narrow escape from being burned to death in a fire in the Imperial palace at Vienna. It is for ladies. The motto is, *Salus et Gloria.*

THE ORDER OF ST. ANNE AT WURZBURG was founded in 1683, by the Countess Anne Maria. The members were to be unmarried ladies of the Franconian nobility, and were to live in a convent under an abbess. Sixteen generations of nobility were required. It has been much altered in later times.

THE ORDER OF ST. LOUIS.

Henry III. founded an institution for maimed and wounded officers and soldiers. This foundation was revived and enlarged by Louis XIV., in 1693, who built the hotel and church of the Invalids in Paris, in part expiation for the wars he had engaged in, to the injury of his country and the ruin of so many families. At the same time he insti-

tuted the Order of St. Louis, to do honour to the brave soldiers who fought the battles of France. The badge was a Maltese cross, and the motto, *Bellieæ virtutis præmium.*

THE ST. MICHAEL ORDER OF MERIT was created in 1693, by Joseph, Duke of Bavaria, and has been continued with modifications to the present time. The motto is, *Quis ut Deus?*

THE ORDER OF ST. ANDREW was founded in 1698, by Peter the Great, Czar of Russia. The members receive pensions.

THE ORDER OF THE BLACK EAGLE was created by Frederick I. of Prussia, in 1701. The motto is, *Suum cuique.*

THE ORDER OF ST. RUPERT was originated by John Ernest de Thun, Archbishop of Salzburg, in honour of St. Rupert, who was Bishop of Salzburg, and to reward military and civil service. It was confirmed by Leopold I. in 1701.

THE ORDER OF THE CHASE, OR GRAND ORDER OF WURTEM-BURG, was instituted by the Duke Everhard Louis, in 1702, as Grand Huntsman of the Empire. The motto was, *Amicitiæ virtutisque fœdus.*

THE ORDER OF THE BEE IN FRANCE was instituted in 1703, by Louisa de Bourbon, wife of the Duke of Maine, both for men and women. The badge contained a portrait of the foundress on one side, and on the other a bee, with the motto, *Je suis petite, mais mes blessures sont profondes.*

THE ORDER OF THE NOBLE PASSION was created in 1704, by John, Duke of Saxony, Weissenfels. Its motto was, *J'aime l'honneur qui vient par la vertu.*

THE ORDER OF NEIGHBOURLY LOVE was instituted in Germany in 1708, by the Empress Christiana.

THE FAMILY ORDER OF LOYALTY was founded in 1715, by Charles William, Grand Duke of Baden. The motto was, *Fidelitas.*

THE ORDER OF ALEXANDER NEWSKY was instituted by Peter I. of Russia, in 1722. The members are pensioned.

THE ORDER OF ST. CATHARINE was instituted by the Czar Peter I. of Russia, in 1714, for men and women. The motto was, *Pour l'amour et la fidelite envers la patrie.*

THE ORDER OF ST. GEORGE, DEFENDER OF THE IMMACULATE CONCEPTION OF THE BLESSED VIRGIN MARY, was founded in 1729,

by Albert, Elector of Bavaria. Five generations of gentility must be proved on both the father's and mother's side by the candidate for admission. The motto was. *In fide, justitia et fortitudine.*

THE ORDER OF ST. CONSTANTINE, OR OF ST. ANGELICUS, OR OF ST. GEORGE, claims the highest antiquity. It is said by some to have been founded by the Emperor Constantine, but by others is said to have been founded in 1190 by the Emperor Isaac Comnenus. After the fall of the Comneni, the Grand Mastership was sold to Francis I., Duke of Parma, in 1699. In 1731 it was transferred to Naples.

THE ORDER OF THE WHITE FALCON, OR OF VIGILANCE, was founded by Ernest Augustus, Duke of Saxe Weimar and Eisenach, in 1732, and was remodelled in 1815. The motto is, *Vigilando ascendimus.*

THE ORDER OF FIDELITY, OR PERFECT UNION, was instituted by Sophia, Queen of Christian VI. of Denmark, but it was shortly afterwards dissolved.

THE ORDER OF ST. JANUARIUS was instituted at Naples in 1738, by the Infant Don Carlos, then King of the Two Sicilies. The motto is. *Sanguine fœdus.*

THE ORDER OF ST. ANNE OF SLESWICK-HOLSTEIN was founded in 1788, by Charles VI., Emperor of Russia. The motto was, *Amantibus justitium, pietatem, fidem.*

THE MILITARY ORDER OF ST. HENRY was originated by Augustus III., King of Poland and Elector of Saxony, in 1739.

THE ORDER OF MERIT was constituted in 1740, by Frederick II., King of Prussia, being a modification of the "*Order de la Générosité.*"

THE ORDER OF THE SWORD, OR OF THE YELLOW RIBBON, is believed to have been founded by King Gustavus Vasa, of Sweden. It was revived by King Frederick I. in 1748. The members receive pensions.

THE ORDER OF THE POLAR STAR was created in 1748, by Frederick I. of Sweden, the regulations and statutes being similar to those of the Seraphim and the Sword. The king and the princes of the blood are members by right, and there are besides twenty-four knights and twelve commanders. The motto is, *Nescit occasum.*

THE ORDER OF MARIA THERESA was founded by the Empress of that name in 1757. It was composed of three classes, the grand crosses, the commanders, and the knights. The Emperor was Grand Master. The motto is *Fortitudini.*

THE ORDER OF ELIZABETH THERESA was founded in 1750, by the widow of Charles VI., Emperor of Austria. The members receive pensions.

THE MILITARY ORDER OF MERIT was founded by Charles Eugene, Duke of Wurtemburg, in 1759. It was first called the "Order of St. Charles."

THE APOSTOLIC ORDER OF ST. STEPHEN was founded by the Empress Maria Theresa in 1764.

THE ORDER OF MILITARY MERIT was instituted by Louis XV. of France, in 1759, for those of his subjects whose Protestant opinions prevented their entering the other Orders of knighthood. The motto was, *Pro virtute bellica.*

THE ORDER OF ST. STANISLAUS was founded by Stanislaus, King of Poland, in 1765, with the motto, *Præmiando incitat.*

THE ORDER OF CHARLES III. OF SPAIN was founded by that monarch in 1771, on the birth of his son. There are four classes of members. The motto is, *Virtuti et merito.* Most of its members were pensioned.

THE ORDER OF VASA was founded by Gustavus III., King of Sweden, in 1772.

THE ORDER OF ST. ELIZABETH was founded in 1766, by Elizabeth, wife of the Elector Charles Theodore of Bavaria, for ladies. Sixteen generations of noble descent are required for candidates.

THE MILITARY ORDER OF MERIT was founded in 1769, by Frederick II., Landgrave of Hesse.

THE MILITARY ORDER OF ST. GEORGE was founded by Catherine IL, Empress of Russia, in 1769. There are at present upwards of ten thousand members.

THE ORDER OF ST. VLADIMIR, also founded by Catherine II., Empress of Russia, in 1782, and reconstituted by the Emperor Paul I. It is an Order of general merit in military or civil life, in literary, artistic, or scientific studies.

THE ORDER OF MARIA LOUISA was founded in 1792, by Charles IV. of Spain, for ladies.

THE ORDER OF ST. ANN was founded in 1784, by Maria Ann Sophia, widow of Maximilian III., Elector of Bavaria, for single ladies of noble descent during sixteen generations. The members lived at first in

community, but a pension has been substituted.

THE ORDER OF THE GOLDEN LION was founded, in 1790, by Frederick II,, Landgrave of Hesse.

THE ORDER OF THE RED EAGLE was founded originally in 1705, and in its present form by Frederick William II., King of Prussia.

THE MILITARY ORDER OF MAXIMILIAN JOSEPH was founded in 1797, by the Elector Charles Theodore, and transformed into a royal Order by King Maximilian Joseph, in 1806. The members receive pensions.

THE ORDER OF FERDINAND.

This Order was created by the King of Naples to do honour to Lord Nelson, whose religious convictions prevented his acceptance of the Order of St. Januarius, which was offered to him by the king. This Order was instituted in 1800, and Lord Nelson was immediately admitted a Knight Grand Cross.

THE ORDER OF ST. ISABELLA was founded in 1801, for ladies only, by the Prince Regent of Portugal.

THE ORDER OF THE CRESCENT was created by the Sultan of Turkey, Selim III., in 1799, to reward the English officers who had distinguished themselves in defence of the Ottoman Empire. It was also conferred on ambassadors and other persons of distinction.

THE ORDER OF THE FISH.

Though very different from European and Christian Orders in their original form, this Order may be mentioned, for completeness' sake, among modern Orders which have no longer any religious character or military obligations, but are merely distinctions awarded for services rendered, or to confer honour upon persons of rank or merit. This Order was founded in 1804, by the Mogul Emperor, Shah Allum, in India, to do honour to the officers of the English army. There were no badges, mottoes, or robes as in the European Orders, but, in accordance with Asiatic customs, certain mystical emblems were borne before the members of the Order on public occasions. Among these was the Fish.

THE ORDER OF THE IRON CROWN OF LOMBARDY.

In 1805 Napoleon Bonaparte was crowned King of Italy at Milan, with the famous crown which is said to contain one of the nails with which our Lord was crucified, and which is called the Iron Crown

of Lombardy. Instead of submitting to coronation at the hands of the archbishop, as is the ordinary custom, he placed the crown on his own head, with the words, *Dieu me la donné, gare a qui la touche;* "*God gives it me; woe to him who meddles with it.*" He immediately after instituted the Order of the Iron Crown for the kingdom of Italy, with this motto. There were in it sixty great officers of state, one hundred commanders, and five hundred knights. Some authorities assert that such an Order had existed in early times.

THE ORDER OF THE TOWER AND SWORD IN BRAZIL was founded by the Prince of Brazil and Regent of Portugal, in 1808, to commemorate his safe conduct under the English flag from Portugal to Brazil, when the former country was threatened by the armies of Napoleon I.

THE CHARLES FREDERICK ORDER OF MILITARY MERIT was founded by the Grand Duke of Baden of that name, in 1807.

THE ORDER OF LOUIS was founded by the Grand Duke Louis I. of Hesse, as a civil and military distinction, in 1807.

THE ORDER OF THE RUE CROWN was commenced in 1807, when Saxony became a kingdom. Its motto is, *Providentiæ memor.*

THE ORDER OF LEOPOLD was founded in 1808, by Francis I., Emperor of Austria, for all meritorious persons, irrespective of rank. The motto of the badge is, *Integritate et merito.* There are three classes in the Order.

THE CIVIL ORDER OF MERIT OF THE BAVARIAN CROWN was founded by King Maximilian Joseph in 1808. The distinction carries with it a pension. The motto is, *Virtus et Honor.*

THE ORDER OF THE LION OF ZAEHRINGEN was founded by the Grand Duke Charles of Baden, in 1812.

THE ORDER OF THE IRON CROSS was instituted in 1813, by Frederick William III., King of Prussia, for civil and military distinction.

THE ORDER OF THE IRON HELMET was founded by the Elector William I. of Hesse, in 1814, as a reward for military distinction.

THE ORDER OF LOUISA, FOR LADIES, was founded in 1814 in Prussia, and is given to those who have rendered services in military hospitals.

THE ROYAL MILITARY ORDER OF SAVOY was founded by King Victor Emanuel in 1815. The decoration carries with it a pension.

THE CIVIL ORDER OF SAVOY was founded by King Charles Albert in 1831. Pensions are given to the members.

THE MILITARY ORDER OF WILLIAM was founded by William L, King of Holland, in 1815.

THE CIVIL ORDER OF THE BELGIAN OR NETHERLANDS LION was founded by William I., King of Holland, in 1815, for merit in civil life.

THE GUELPHIC ORDER was founded by the Prince Regent, George of England, in 1815, for Hanover.

THE ORDER OF MERIT was founded by Frederick Augustus, King of Saxony, on the occasion of his restoration to his kingdom in 1815, for those who have rendered services to the state.

THE ORDER OF ST. GEORGE OF THE REUNION.

In 1808 Joseph Bonaparte founded the "Order of the Two Sicilies." On the restoration of King Ferdinand in 1815, this Order was modified and received the above title.

THE ORDER OF THE LION AND THE SUN is a distinction conferred by the Shah of Persia on Europeans, and was founded in 1808. An Order for Ladies was added in 1873.

THE MILITARY ORDER OF ST. FERDINAND was founded in 1811 by the Spanish Cortes, and was confirmed by King Ferdinand on his restoration, in 1815. Pensions are given to members.

THE ROYAL AMERICAN ORDER OF ISABELLA THE CATHOLIC was founded by Ferdinand VII. of Spain, in 1815, as a reward for loyalty and defence of Spanish possessions in America.

THE ORDER OF MARIA ISABELLA LOUISA was founded also by Ferdinand VII., for the army and navy of Spain.

THE MILITARY ORDER OF ST. HERMENGILDE was founded in 1814 by Ferdinand VII. of Spain, for officers in the army and navy. The senior members are pensioned.

THE ORDER OF OUR LADY OF THE CONCEPTION OF VILLA VICOSA was founded in 1818 by King John VI. of Portugal. No one is admitted but nobles of high rank.

THE ORDER OF ST. MICHAEL AND ST. GEORGE was founded in 1818 by William IV., King of England, in consequence of the cession of Malta to Great Britain, for natives of Malta and the Ionian Islands,

and British subjects.

THE ORDER OF THE CROWN OF WURTEMBERG was founded in 1818 by King William, in place of the Order of the "Golden Eagle," and the "Bugle."

THE ORDER OF FREDERICK was also founded by the same king, as a reward for military and civil services.

THE ORDER OF ST. JOSEPH was founded by Ferdinand III., Grand Duke of Tuscany, in 1807.

THE ORDER OF THE WHITE CROSS was founded by the same duke in 1814.

THE ORDER OF MILITARY MERIT was founded by Leopold, Grand Duke of Tuscany, in 1850.

THE ORDER OF CHARLES XIII. was founded by the King of Sweden of that name in 1811, specially for Freemasons.

THE ORDER OF THE NICHAN IN TUNIS. The origin of this Order is not known.

THE ORDER OF THE MEDJIDIE was founded in Turkey in 1852, for state services.

THE ORDER OF THE CROSS OF THE SOUTH was instituted in 1822 by Pedro I., Emperor of Brazil, for persons of either sex.

THE ORDER OF THE ROSE was founded in 1829 by the same emperor, on the occasion of his marriage, and was intended to be a reward for civil and military merit.

THE ROYAL LOUIS ORDER was founded in 1827 by Louis, King of Bavaria, for those who had served the state during fifty years.

THE ORDER OF THERESA was founded in 1827 by Theresa, Queen of Bavaria, for unmarried noble ladies. Pensions were granted to the members.

THE ORDER OF FRANCIS I. was founded by the King of the Two Sicilies of that name, in 1829, as a reward for civil merit.

THE ORDER OF SAXE-ERNEST was originally founded by Frederick I., Duke of Saxe-Gotha and Altenburg, in 1690, under the title of the "Order of German Integrity," and was renovated in 1825.

THE ORDER OF THE WHITE EAGLE was founded in 1713, upon the basis of another Order which had fallen into abeyance, "the Order

of the Immaculate Virgin," in Poland. It became a distinctly Russian Order in 1831.

THE ORDER OF ST. STANISLAUS was also originally a Polish Order, and was made Russian by the Emperor Nicholas in 1831. Most of the members receive pensions.

THE ORDER OF MILITARY MERIT was created in Poland in 1792, and became a Russian Order in 1831.

THE ORDER OF LEOPOLD was founded, in 1832, in Belgium for civil and military distinction.

THE ORDER OF THE REDEEMER was founded, in 1833, by Otho, King of Greece, to commemorate the independence of that country.

THE ORDER OF ST. GEORGE was founded by Charles Louis, Duke of Lucca, in 1833, for military merit.

THE ORDER OF ST. LOUIS, FOR CIVIL MERIT, was founded by Duke Charles Louis of Lucca, in 1836.

THE ORDER OF HENRY THE LION was founded by William, Duke of Brunswick, in 1834, "to reward those who have distinguished themselves in military or civil service."

THE ORDER OF ALBERT THE BEAR was founded by Prince Sigismund I., about 1382, and renewed, in 1836, in Hainhault. It has various classes of members.

THE ORDER OF MERIT AND OF THE DUCAL HOUSE OF PETER FREDERICK LOUIS, was founded, in 1838, by Paul Frederick, Duke of Oldenburg, for civil merit.

THE ORDER OF ST. GEORGE was founded, in 1839, in Hanover, with the motto *Nunquam retrorsum*.

THE ORDER OF MERIT AND OF THE HOUSE PHILIPPE-LE-BON was founded, in 1840, by the Grand Duke Louis II. of Hesse.

THE ORDER OF THE OAKEN CROWN was founded by William II., King of the Netherlands, in 1841, for civil and military merit.

THE ORDER OF BRAZIL was founded, in 1842, by Don Pedro I., Emperor of Brazil, at first for Sovereigns only, afterwards for three classes of members.

THE ORDER OF ST. OLAF was founded, in 1847, by Oscar, King of Norway, for persons of all classes.

THE ORDER OF PIUS was founded, in 1847, by Pope Pius IX.

THE ORDER OF THE GOLDEN SPURS is said to have been founded by Constantine. The knights formerly bore the title of "Lateran Court Palatines," and had numerous privileges, and were ranked before the Maltese and Teutonic Knights.

In later times it has merely been a distinction conferred by the Pope upon members of his household.

THE ORDER OF FRANCIS JOSEPH was founded, in 1849, by the Emperor of Austria of that name. Its motto is *Viribus unitis*.

THE ORDER OF ST. LOUIS was founded, in 1849, by Charles III., Duke of Parma, for civil and military merit.

THE ORDER OF ST. FAUSTIN was founded by the Emperor of Haiti, in 1849.

THE ORDER OF ALBERT was founded by Frederick Augustus, King of Saxony, in 1850, and is conferred on persons of merit—civil, military, literary, or scientific.

THE ROYAL ORDER OF THE HOUSE HOHENZOLLERN, which originally belonged to the principalities, Hohenzollern, was incorporated as a Prussian Order in 1851.

THE ORDER OF MAXIMILIAN FOR ART AND SCIENCE was founded by King Maximilian II., of Bavaria, in 1853.

THE ORDER OF THE MADONNA OF GUADALOUPE was founded, in 1853, in Mexico.

THE LEGION OF HONOUR was the creation of Napoleon Bonaparte, in 1802, while first consul. It was intended to reward not only military, but civil service and merit in France, and to supersede all the old Orders. The honour was for life, but was not hereditary. A pension was attached to the distinction; each great officer had an allowance of 5000 *francs*, each commander 2000, each officer 1000, and each legionary 250. Each person who was admitted to the Order was sworn to devote himself to the service of the Republic, and to combat by all means, all and every enterprise tending to re-establish the feudal system, or to revive ancient titles. The motto was *Honneur et Patrie*. The first admission of members took place with great ceremony at the Church of the Invalids, in 1804, after Napoleon had become Emperor.

THE ORDER OF THE INDIAN EMPIRE was instituted by the Queen of England as Empress of India, in 1878, for services performed to the

government of India.

THE ORDER OF THE IMPERIAL CROWN OF INDIA was instituted, at the same time as the above, for ladies.

THE ORDER OF THE STAR OF INDIA was founded by Queen Victoria, as Empress of India, in 1861, for natives of that country, and those Englishmen who have distinguished themselves by their services there.

THE ORDER OF THE CROWN, created by William I., King of Prussia, in 1861.

THE ORDER OF OSMANIÉ was founded by the Sultan Abdul- Aziz, in 1861.

THE ORDER OF THE DRAGON IN CHINA was created in 1863, to reward the officers of the imperial army.

THE ORDER OF THE CROWN was instituted by Victor Emmanuel, King of Italy 1868.

LEONAUR

ALSO FROM LEONAUR

AVAILABLE IN SOFTCOVER OR HARDCOVER WITH DUST JACKET

FARAWAY CAMPAIGN *by F. James*—Experiences of an Indian Army Cavalry Officer in Persia & Russia During the Great War.

REVOLT IN THE DESERT *by T. E. Lawrence*—An account of the experiences of one remarkable British officer's war from his own perspective.

MACHINE-GUN SQUADRON *by A. M. G.*—The 20th Machine Gunners from British Yeomanry Regiments in the Middle East Campaign of the First World War.

A GUNNER'S CRUSADE *by Antony Bluett*—The Campaign in the Desert, Palestine & Syria as Experienced by the Honourable Artillery Company During the Great War .

DESPATCH RIDER *by W. H. L. Watson*—The Experiences of a British Army Motorcycle Despatch Rider During the Opening Battles of the Great War in Europe.

TIGERS ALONG THE TIGRIS *by E. J. Thompson*—The Leicestershire Regiment in Mesopotamia During the First World War.

HEARTS & DRAGONS *by Charles R. M. F. Crutwell*—The 4th Royal Berkshire Regiment in France and Italy During the Great War, 1914-1918.

INFANTRY BRIGADE: 1914 *by John Ward*—The Diary of a Commander of the 15th Infantry Brigade, 5th Division, British Army, During the Retreat from Mons.

DOING OUR 'BIT' *by Ian Hay*—Two Classic Accounts of the Men of Kitchener's 'New Army' During the Great War including *The First 100,000 & All In It*.

AN EYE IN THE STORM *by Arthur Ruhl*—An American War Correspondent's Experiences of the First World War from the Western Front to Gallipoli-and Beyond.

STAND & FALL *by Joe Cassells*—With the Middlesex Regiment Against the Bolsheviks 1918-19.

RIFLEMAN MACGILL'S WAR *by Patrick MacGill*—A Soldier of the London Irish During the Great War in Europe including *The Amateur Army, The Red Horizon & The Great Push*.

WITH THE GUNS *by C. A. Rose & Hugh Dalton*—Two First Hand Accounts of British Gunners at War in Europe During World War 1- Three Years in France with the Guns and With the British Guns in Italy.

THE BUSH WAR DOCTOR *by Robert V. Dolbey*—The Experiences of a British Army Doctor During the East African Campaign of the First World War.

AVAILABLE ONLINE AT www.leonaur.com
AND FROM ALL GOOD BOOK STORES

07/09

LEONAUR

ALSO FROM LEONAUR
AVAILABLE IN SOFTCOVER OR HARDCOVER WITH DUST JACKET

THE 9TH—THE KING'S (LIVERPOOL REGIMENT) IN THE GREAT WAR 1914 - 1918 *by Enos H. G. Roberts*—Mersey to mud—war and Liverpool men.

THE GAMBARDIER *by Mark Severn*—The experiences of a battery of Heavy artillery on the Western Front during the First World War.

FROM MESSINES TO THIRD YPRES *by Thomas Floyd*—A personal account of the First World War on the Western front by a 2/5th Lancashire Fusilier.

THE IRISH GUARDS IN THE GREAT WAR - VOLUME 1 *by Rudyard Kipling*—Edited and Compiled from Their Diaries and Papers—The First Battalion.

THE IRISH GUARDS IN THE GREAT WAR - VOLUME 1 *by Rudyard Kipling*—Edited and Compiled from Their Diaries and Papers—The Second Battalion.

ARMOURED CARS IN EDEN *by K. Roosevelt*—An American President's son serving in Rolls Royce armoured cars with the British in Mesopatamia & with the American Artillery in France during the First World War.

CHASSEUR OF 1914 *by Marcel Dupont*—Experiences of the twilight of the French Light Cavalry by a young officer during the early battles of the great war in Europe.

TROOP HORSE & TRENCH *by R.A. Lloyd*—The experiences of a British Lifeguardsman of the household cavalry fighting on the western front during the First World War 1914-18.

THE EAST AFRICAN MOUNTED RIFLES *by C.J. Wilson*—Experiences of the campaign in the East African bush during the First World War.

THE LONG PATROL *by George Berrie*—A Novel of Light Horsemen from Gallipoli to the Palestine campaign of the First World War.

THE FIGHTING CAMELIERS *by Frank Reid*—The exploits of the Imperial Camel Corps in the desert and Palestine campaigns of the First World War.

STEEL CHARIOTS IN THE DESERT *by S. C. Rolls*—The first world war experiences of a Rolls Royce armoured car driver with the Duke of Westminster in Libya and in Arabia with T.E. Lawrence.

WITH THE IMPERIAL CAMEL CORPS IN THE GREAT WAR *by Geoffrey Inchbald*—The story of a serving officer with the British 2nd battalion against the Senussi and during the Palestine campaign.

AVAILABLE ONLINE AT www.leonaur.com
AND FROM ALL GOOD BOOK STORES

07/09

Lightning Source UK Ltd.
Milton Keynes UK
UKOW04f1830301114

242434UK00001B/122/P